THE WORLD OF ART

OTHER PUBLICATIONS OF PAUL WEISS

BOOKS

The Nature of Systems

Reality

Nature and Man

Man's Freedom

Modes of Being

Our Public Life

WITH OTHERS

American Philosophy Today and Tomorrow

Science, Philosophy and Religion

Moral Principles of Action

American Philosophers at Work

Dimensions of Mind, etc.

EDITOR, with Charles Hartshorne

Collected Papers of Charles Sanders Peirce
 (six volumes)

THE WORLD OF ART

Paul Weiss

SOUTHERN ILLINOIS UNIVERSITY PRESS

CARBONDALE AND EDWARDSVILLE

FEFFER AND SIMONS, INC.

LONDON AND AMSTERDAM

ARCT
URUS
BOOKS ®

IN MEMORY OF JEROME FRANK

PREFACE

THIS book is, in good part, the product of an interest in the arts long ago awakened by Eliseo Vivas. He and I took our first course in philosophy together in the evening session of City College, under John Pickett Turner. At that time I was a somewhat abstract and abstracted logician, while he already was a subtle, wide-ranging, and most knowledgeable student of the arts. He took me in hand, tried to teach me how to look at paintings, and introduced me to *avant-garde* writers and critics. To this day I regret that I never listened enough to him. Had I done so, some of the joy I have recently experienced could have been had for a much longer period. Perhaps, though, this would have meant that I would have neglected that long, lonely but most satisfying study of the perennial problems of philosophy, to which I devoted most of that time. Speculation has its own beauties no less satisfying than those found in nature and in art. In any case, engagement in speculative studies led me to quiet my interest in art for many years.

In the last decade I have benefited from many conversations with the brilliant young poet, scenarist and playwright, Robert Thom. And in the last years I have had the privilege of acting as a guide and critic for some promising young writers, particularly David Slavitt and Scott Sullivan. Scott wanted me to serve primarily as another ear, as an older man, not too familiar with what was accepted as correct or respectable, who would be willing to report immediate reactions. After we had worked together for a while, out of desperation or perhaps pity, he urged me to try my own hand at some art. I would find, he said, that genuine, creative work was more difficult than I was supposing it to be.

I took up the challenge and in the last years have adventured into a number of arts, both as a practitioner and spectator. I am most grateful to Scott Sullivan for pushing me in this direction. Never have I learned so much with so much pleasure. I am now greatly in debt to George Howe, King Lui Wu, Paul Rudolph, Vincent Scully, Erwin Hauer, Robert Engman, James Brooks, Charlotte Parks, C. Marca–Relli, Katrine R. C. Greene, Howard Boatwright, Richard Sewall, Harry Berger, Cleanth Brooks, Frank

Brieff, Janice Rule, Kim Stanley, Curt Conway, Lee Strasberg, Uta Hagen, Alfred Ryder, John Gassner, Eliot Elisofon and my son, Jonathan, for stimulation, instruction and advice. But I am most in debt to Neil Welliver. With unbelievable patience, great flexibility, sympathy, and kindness, this gifted artist taught me the rudiments of painting, and dealt intelligently and illuminatingly with my initial striking ineptitude and my endless barrage of unfocussed and often foolish questions.

My approach to art, through the thick of experience, has been accompanied by a reflection on its nature, provoked, guided and supported by speculations into the essence of existence, freedom and the place that art has among the primary disciplines. The present work makes evident how existence, speculatively dealt with in the *Modes of Being,* acquires concreteness and human pertinence when portrayed and mediated by art. In the course of my transition from a metaphysical account of existence to a concern for it as revealed in art, I have found Susanne Langer's books most helpful. She deals sympathetically with more fields of art than most writers do today. She is interested in the works themselves and not merely in the response they have elicited or the uses to which they can be put. Most important she recognizes that the arts have an integrity of their own, each yielding a result which stands over against the world of every day as well as the world of science. Unfortunately she has adopted rather uncritically Cassirer's neo-Kantianism, with its theory of symbolic forms. This view in effect supposes that art produces only "semblances" conveyed by expressive symbols. To get truth and reality, it is thought, one must remain with the instruments and formulae of science. "All forces that cannot be scientifically established and measured must be regarded, from the philosophical standpoint, as illusory; if therefore, such forces appear to be part of our direct experience, they are 'virtual,' i.e., non-actual resemblances." The central theses of the present work are rooted in an explicit rejection of that view.

Due to the generosity of Mr. Harold Feldman and Mr. John F. Molloy, I was able to make a multilith draft of a previous study of art and send it to various philosophers, artists, and critics. Ellen Haring, Iredell Jenkins, Richard Sewall, Katrine R. C. Greene, Jonathan Weiss, and I. C. Lieb have subjected that draft to a most painstaking examination. In addition, I have had the benefit of comments from Peter Millard, John Gassner, Louis Z. Hammer, Dorothy Walsh, Arthur Drexler, Robert Herbert, Vincent Scully, Philip Johnson, Henri Peyre, V. C. Chappell, Scott Sullivan, Richard Bernstein, Theodore Weiss, James Brooks, Merce Cunningham,

John Cage, and Robert Lowell. I have tried to do justice to their searching criticisms. The present work consequently offers a radically revised version of the original multilithed draft. The book is most defective, I am confident, in just those places where I did not attend sufficiently to the points they made or where I failed to meet the full force of the difficulties they raised. I have had the benefit, too, of being invited to give versions of five of the chapters as the 1959 Gates Lecturer at Grinnell College. Other parts of the book have been exposed to intelligent, highly critical, and perceptive audiences at Lawrence College, the University of Chicago, the University of Illinois, Southern Illinois University, and Springfield College.

The original multilith draft was written in two parts. Though the parts had bearing on one another and constituted a single whole, it soon became quite evident that some readers were more interested in the first part than in the second, while others were more interested in the second than in the first. As the work began to increase in size, it became more and more apparent that it would be desirable to present my reflections on art in two distinct works, each capable of being read alone while nevertheless supporting one another. The present work, consequently, is offered as an independent study, to be supplemented by *Nine Basic Arts,* in which various major arts are examined in some detail.

I am glad that another book of mine is being published by the Southern Illinois University Press. Mr. Vernon Sternberg and his excellent staff once again have demonstrated how considerate and imaginative an excellent publisher can be.

P. W.

New Haven, March, 1960

CONTENTS

THE WORLD OF ART

INTRODUCTION

STATEMENTS about art—even thoughtless and idle observations —usually sting. Quite often they provoke violent argument; sometimes they prompt reassessment, often of others and occasionally of oneself. Like expressions of opinion in politics, sports, and religion, they are felt to touch on questions of vital concern, revealing what excellence is believed to be and therefore what men should do, and what it is they deserve. Implicit in all these expressions of opinion is the judgment that those who disagree must have misconstrued man's achievements and promise, and therefore must be defective in insight, intelligence or virtue. He who says that Communist China should be admitted to the United Nations, that our Olympic team was merely lucky, that the Muslims might be right, or that Kandinsky is a great painter, is felt to offer a judgment, not only about these matters but also about what men ought to do. If Communist China should be admitted, then strategic and optimistic considerations should be given precedence over those that are morally grounded and restrained by caution. If successful teams are merely lucky, the outcome of games has nothing to do with native capacity and self-discipline, and one need not train or work to be victorious. If the Muslims might be right, Christianity could be wrong, and conformity to Christianity's codes and commands, even when buoyed by prayer, might be foolish and even harmful. If Kandinsky is a great painter, he who would be great need not strive for verisimilitude, obtrusive harmony, or the preservation of tradition. *likely*

Judgments expressed on art, politics, sports and religion are highly charged because they relate to issues which are of fundamental importance to all. But politics, sports and religion, while calling on all of a man's energy and attention, do not help him get a better grasp of the world in which he lives. They deal with him primarily as a part

of a society or a culture, or as called upon to submit to a power beyond himself. But the work of art puts him in touch with existence itself. None of these others, moreover, does full justice to man's need to create. Only the work of art does this.

Like religion, art appeals to and involves men's private, innermost being. Like politics, it affects the course of their lives and interests. Like sports, it takes men quite suddenly outside themselves and places them immediately in a vital setting. But unlike any of these enterprises, art enables men to learn basic truths about themselves and the world, and this by attending, not to the world or themselves, but to what they can create.

Works of art are made with the help of emotion. And it takes emotion to appreciate them properly. The activity and outcome of artistic creation can, of course, be looked at with detachment. Much will then be seen that emotion otherwise obscures. One will be able to note details, attend to techniques, and make comparative and quantitative judgments. However, much that emotion discerns will then be overlooked. A good deal of the sweep, the sensuous tone, the qualitative feel, the meaning, and the beauty which art exhibits, will be lost if one is not willing to lose oneself within it.

Each type of judgment, the emotional and the detached, has a distinctive nature and use. Critics and historians of art emphasize detachment, artists and spectators involvement. Since neither type of judgment is ever entirely free of tinges of the other, no man ever entirely misses either the technical or the immediate aspects of art. Still, if art is to be dealt with properly, both types of judgment in their full power are needed. Fortunately, a choice between them need not be made. It is possible to supplement one by the other and sometimes even to combine them in a new type. Ideally, one should exercise both types of judgment, in sequence or in combination, thereby balancing control with sensitivity, distance with immersion. This ideal is approached by outstanding students of individual masters or works. No man, though, can attend to that ideal in many places or for long. Individual works are too diverse and too complex to make it possible for anyone to keep detachment and emotion in more than a momentary equilibrium on a few occasions.

We can approach the ideal of a unity of detachment and emotion

in another way. Art can be made the object of a philosophic study. Here attention is focussed not on individual works but on the constant, essential components of the world of art. These are the process of artistic creativity and the kind of products thereby achieved. Detachment is stressed in the endeavor to grasp clearly the nature of the principles which govern the creative activity and the created works; involvement is demanded when attention is turned to the distinctive achievements of the different arts.

The *World of Art* seeks to isolate the general principles which are exemplified in art, to discover what problems art confronts, what claims it makes, and how its activities and products contrast with those exhibited in other enterprises. The sequel, *Nine Basic Arts*, is devoted to distinguishing and characterizing the major arts. The tasks, importance, and distinctive role of art are thereby made the intersection of a detached, systematic study of the nature of art and of an appreciative immersion in a number of arts. The world of art is found to be at once rational and dynamic, self-sufficient and revelatory. In its newly created realities, discipline and novelty, idea and feeling, man and the world are seen to be united.

There are other enterprises besides art which have roots deep in man's nature. Man has an appetite for an ethical and social life; he struggles to know; he wants to worship. He loves and hates with all his being. But though art exhibits needs and makes use of powers also manifested in nonartistic activities, it nevertheless is to be sharply distinguished from all other endeavors. It is quite different from craftsmanship, no matter how splendid; it is not at all a form of play, no matter how ingenious and enjoyable this may be. Unlike these it demands a fresh and unmistakable act of creativity, terminating in the production of a self-sufficient excellence.

The act of creation has a characteristic objective, goes through a characteristic course, and exhibits a characteristic rationale. It seeks to make an ideal value assume a sensuous guise. Responding readily to the dark promptings and control of the emotions, it inevitably exhibits a variable, unpredictable rhythm. Its rationale is like that of a process of reasoning, though one that is submerged in and radically qualified by the medium in which it is imbedded.

The outcome of the act of creation is a work of art. This is quite

distinct from the content of an aesthetic experience. The work of art is a substantial reality, meaningful, embodying an ideal, telling us something about the world beyond. An aesthetic experience is all surface, and here and now. Its content is sheer quality, the immediate, the intuited, the felt aspect of things. Such experience is open to those who attend to objects in nature as well as to those who attend to works of art. Artists often have a ready appetite for it, but they rarely indulge this, at least in those fields of art where they spend most of their lives. Nor do they stress the aesthetic experince when they confront nature. It is usually those who have less interest in producing art than the artist has, and more interest in enjoyment than the practical man has, who are most occupied with the aesthetic experience which nature affords.

A work of art is also quite distinct from an aesthetic object. An aesthetic object is anything whose space, time or ongoing has been imaginatively isolated from its neighbors and its effects, and infected with human interests and values. Since any object in nature is, by being brought within the ambit of our concerns, at least partly converted into an aesthetic object, nature in the raw is evidently a very difficult thing to see, to remain with, or to report. All the things we can daily note—trees and grass, the sea and the sky—and all the things we daily use—tables and chairs, spoons and plates, streets and automobiles—have an aesthetic side. So do works of art.

We fasten on an aesthetic object when, by a mere shift in attitude, we hold something away from nature and outside the web of conventional needs. Since there is no art unless recalcitrant material has been worked over, an aesthetic object can therefore never be more than a facet of a work of art. However, no one can appreciate a work of art without being aware of it as an aesthetic object.

A stone rolling down a hill is a part of nature; blocking a path it is a conventional object, a source of a plurality of effects. Its enjoyed sheen is content for an aesthetic experience. When its volume, with its lights and shadows, recesses and protuberances, its hollows and holes, curves and grain is attended to, it achieves the role of an aesthetic object. Worked over to yield a newly created space excellently made, it becomes a work of art.

A work of art is an object with which one can live for a while. It does not claim to record, to report, or to represent the familiar things of daily life. Nor does it depend for its being or value on its power to communicate, to educate, to stimulate, or to please. It does these things, and often does them especially well. But it does them best when it is accepted for what it is, as a self-sufficient reality. He who deals with a work of art as a vehicle of pleasure or instruction stresses its practical not its aesthetic side, and inevitably obscures its nature as a work of art.

No work of art, is, of course, absolutely self-sufficient. We cannot stay with it, we ought not to stay with it, forever. Not only must we eat and drink, sleep and work, but we sometimes have needs that can be fulfilled only in other directions. Art is rich, rich beyond all probing, but it does not exhaust the good life. Science, history, religion, politics, ethics and metaphysics yield excellencies art cannot duplicate or replace. But art alone gives emotions expression and satisfaction, at once restructuring and suffering them, encouraging and purifying them, in an excellent, i.e., beautiful work.

Beauty is achieved by making an ideal permeate every part of some material, thereby giving the ideal a sensuous form. Works of art are consequently triply satisfying. Ideals are there made available for enjoyment. In addition, otherwise recalcitrant material is brought under firm control. Most important, substantial realities are produced, capable of standing over against and for a time at least replacing the world of every day.

Nature at times produces works as beautiful as any made by an artist. Its beauties are not unrelated to the beauties found in art; in nature, also, an ideal is given a sensuous guise. But nature acts in a somewhat haphazard, offhand way; the powers it uses are but a feeble form of the powers which an artist employs. Man-made beauty is dramatic—which is of course quite a different thing from being striking or awe-inspiring. Unlike natural beauty, the beauty men create is the expression of a radical freedom, a controlling intelligence, and a willed restraint—this is but to say it is the outcome of a genuinely creative act.

A work of art is a reality. It does not, to be sure, have the vital

ultimacy, the final hard reality of an actual man or woman, or even of a horse or a cabbage. It is not as brute or as obstrusive as a stone. But like them it allows for a host of abstractions. Like them it is a substance. Perceptions, formulae, happenings and values have a locus there, just as they have in other substances. And like other substances a work of art is more organized, more integrally one and self-contained than are the conventional things of common life. Like other substances, too, it stands over against us and over against all else that is. A work of art is a genuine substance, effectively opposed to whatever substances there may be. Each work is part of a new world created by man, as definitively bounded off from the world of illusion as it is from the worlds of nature, daily convention, and practical affairs.

Self-contained though a work of art be, with its own integrity, center of gravity, and excellence, it nevertheless intrudes on us. He who opens himself to it is pulled into it, forced to follow new rhythms, new contours, to live on new terms. Art is man effectively expressed in the form of an attractive yet imperious demand to all that they participate in it. He who accepts its challenge will be remade. More likely than not, he will come out of his experience considerably altered, usually for the better but sometimes for the worse.

Art makes a great difference to man primarily because it is revelatory of the domain of existence which lies beyond him and it. It indirectly reveals what existence is, most evidently through the fact that man's creative powers and emotions, so essential to the production and enjoyment of art, are themselves but guises which existence, for the moment, assumes. Art also tells us indirectly about existence by treating the familiar objects of daily life as cues and clues, thus enabling one to recognize those objects to be avenues through which existence is expressed. But most searchingly, art, through its structure and texture, offers a direct revelation of existence as having a great bearing on man's destiny.

There is no better agency than art for grasping the nature of existence most concretely, with minimal distortion, and as affecting man. We can learn from art what existence is because art is essentially concerned with the creation of a space, a time and a becoming.

These represent the very space, time and dynamics of the existence which lies behind, quickens, and is partially caught in daily experience and is distantly grasped in science and philosophy. No one of these three dimensions of existence can be entirely sundered from the rest, but for the purposes of discourse and classification it is desirable to attend to one of these dimensions more than to the others. By holding them apart from one another, it is also possible to see that the various arts have different concerns. Architecture, sculpture and painting in different ways create a real, new space. Musical composition, story and poetry are primarily arts which create a new time. Musical performances, the theater and the dance create new processes of becoming. All these arts reproduce the structure and texture of existence, thereby enabling man to learn something of the course and nature of what has inescapable and great bearing on the lives of all.

In another place I have offered a detailed examination of the nature of existence, as well as of three other equally ultimate modes of being —actuality, ideality and God. Whatever there is, I urged, is either one of these modes, a subdivision of it, or the outcome of some combination of a number of them. We men are actualities in existence, tensed towards ideal prospects constituting a realm of the possible and normative, and standing over against a God who, though not superior to all others in being, is superior to all in value. Each of these modes of being has its own characteristic features, powers and functions. Actualities are substantial individual sources of action. Ideality is indeterminate, measuring all else. God is unity, preserving whatever he can. And existence is limitless, spatially, temporally and dynamically.

Each mode of being is grasped in a distinctive way, and is the appropriate topic of a distinctive discipline. If we deal with one of them by means of a type of apprehension appropriate to some other, the result will be unduly biased and partial. The nature of actuality, as it enters into experience, is grasped most directly and with the least distortion by means of philosophical concepts. The ideal is most effectively reached through mathematics and ethics. We know God best when we worship. But existence needs the artist.

A philosophic understanding cannot capture the texture of exis-

tence; that texture must be experienced. The philosophical examination of the arts offered in this book must therefore be supplemented not only by the next book, with its insistence on the distinctive achievements of different arts, but by a separate, direct participation in particular works of art in each field. The two books will in fact have accomplished a great deal if they succeed in awakening in their readers a strong desire to participate more fully in slighted arts or to attend to neglected ones.

Each work of art is representative of the world of art, of man, and of the existence that both art and man partly contain, exhibit and portray. Each work, while sharing a number of basic features with the rest, is autonomous and irreducible. All the arts are on a footing in value and difficulty. To be properly enjoyed, each must be lived with. None can be properly evaluated except by those who explore and reflect on it. To be properly understood, one must come to the work of art with a philosophic, speculative grasp of how it can exist in a world already occupied by real, substantial beings. Approached with sensitivity, it will provide a new emotional center for a man, at the same time that it will reveal to him something of the import that existence has for him.

In a word: A work of art is created by shaping resistant material into a new kind of space, time, or way of becoming. The result is a beautiful, self-sufficient substance having a distinctive texture, nature, and being. The creation is guided by an idea, directed at an arresting prospect. In the course of that act deep-rooted emotions are expressed and clarified; as a consequence of that act, man's place in the cosmos is made a little more evident than it had been before.

I. WORK, CRAFTSMANSHIP AND ART

ARISTOTLE's definition of art, "a capacity to make, involving a true course of reasoning," is one of the oldest, most pithy and most influential that we have. In modern times many thinkers have found good grounds for minimizing the role that reasoning plays in art, and some warrant, therefore, for returning to something like one of Plato's positions. There is too much of the unplanned, of the emotional and noncognitive, of the adventurous, experimental, and improvisational in art to make significant a major reference to reasoning in art. As we shall see, it does have a rationale, a logic of its own, but this is neither the product of reasoning nor consciously pursued. We come to know art's rationale only by analyzing creative activity and created works from a position considerably removed from the place where artists, spectators and critics usually stand.

Unlike either Plato or Aristotle, men today have also come to recognize that an adequate understanding of the arts requires one to take seriously the fact that the arts create something, that they exhibit an excellence not found elsewhere, and that they offer themselves as self-sufficient. It is its creativity that distinguishes art from work, its intrinsic excellence that distinguishes it from play, and its self-sufficiency that distinguishes it from the products of mere technique and craftsmanship.

There are other characteristics of art—its capacity to please or satisfy, to teach and illuminate; its immediacy; its qualitative, sensuous character; its expressiveness; its place in the life of man and society. Account must be taken of these before an adequate characterization of art is possible. They are, however, incidental and derivative, not basic, normative or essential. They and other features are properly dealt with after the nature of artistic production has been distinguished from other types of activity, and after the concerns

of art have been distinguished from those characteristic of other creative enterprises.

Work is an activity in which energy is controlled and used for the sake of bringing about some result. Unless there is energy expended we do nothing, employ no means. Unless there is control, we dissipate our energy and fail to achieve our projected outcome. Unless there is a result produced, we have only activity, movement, behavior which may come to an end, may arrive at some point, but which can neither be pertinent to nor direct what in fact is done to get to it. I am merely active when I idly stroll; I could be merely active too when I walk to or from work. It is only when, deprived of car or bus, I make myself spend my energies for the sake of getting to work or home that I can be said to work when I walk to or from work. The work at which most men spend most of their day is environed by work which begins and ends only when they leave and return to their homes.

Where there is a concentration on means, with no concern for or no opportunity to reach a result, work, as Dewey has observed, becomes labor, toil, or drudgery. Labor is activity which is mainly economic in import; toil is fatiguing and disagreeable activity; drudgery is monotonous or trivial activity performed under constraint, tiring the spirit before it does the flesh. Work may be economically valuable, but it need not be. Gardening is work, lifting a weight for exercise is work, teaching a child to walk is work, housebreaking a dog is work. Work too may be fatiguing, but so long as it keeps focussed on the result to be achieved, it is something more than toil. The gardener is weary at the end of the day, but his assistant, who just did what he was told, is weary in quite another way. Like drudgery, work could be disagreeable, demanding, debilitating, but it is enriched by its end, even where this end is minor or valueless, to give the whole a supervening pleasure-tone, with an eventual feeling of accomplishment and well-being.

Art is distinct but not divorced from work—that is why it is correct to speak of a work of art. To produce a work of art it is necessary to work in art. This work differs from that of a worker's in at least two respects—as a process and in its outcome. Where the worker merely works at what he does, the artist works while he does some-

thing more. To produce art, mind and will, attention and energy must be united, preferably without deliberation or prevision, to constitute a single, convergent effort. The artist is involved in the process of producing a work of art in such a way that his thoughts and feelings are caught up in it too. Could one free the term "emotion" from its familiar exclusive association with the ideas of disturbance, distraction, excitement, chaos, irrationality, it would be correct to say that art, but not work, involves the use of the emotions. Work, to be sure, has its moments of excitement, spontaneity and improvisation; it does involve sudden changes in pace and interior stresses, as anything emotionally governed does. But work lacks the urgency, the driving force, the demand to reorganize oneself which is characteristic of the emotions that are at the root of art and come to expression in the creative act.

An artist involves the material, on which he works, in a private world and in the world of man in a way no worker does. The meaning and import of his material is radically altered by being made into the product which is art. The artist enables the material to have new implications and exhibit new relations. He connects part with part, in ways no instrument or machine of any kind could possibly discover, to make a product whose nature can be learned only through an experience of it. The space in a painting curves around this color and dashes towards that; what is distant for a ruler is for the artist and for the sensitive spectator sometimes quite close.

Ordinary work, of course, also takes place inside a human context. It occurs in a society, in a culture, in history. Its results have meaning and values not possible to a merely natural object. But the worker does not give his product this added significance; it accretes this by virtue of the fact that the worker does his work inside a social frame. The artist's product, like the worker's, has a social import; it too has a place in culture and history, but he adds a new dimension to it, gives it a meaning by interrelating its parts in new and supportive ways. His work is his creation, something made by him, not merely in the sense that he worked on it but also in the sense that he enabled it to have a self-contained being over against the being of other things. Unlike the creation traditionally ascribed to God, however, the artist's

creation is not a making out of nothing. There is material encountered by him to which he sensitively responds. Through action and appreciation he makes it carry relations and meanings, textures and beauties that otherwise would not exist.

Those who deal with art from the vantage point of economics, psychology, society, history or theology inevitably see art as a kind of work, an agency for bringing about some end outside it. The Marxists, the Freudians, the Jungians, and even the Aristotelians stop short in their consideration of the work of art in itself to concentrate on what it can do. The art object does have many functions in society, history, and theology. It is even arduous and much occupied with means; its preparation occasionally demands simple drudgery. Despite all this, works of art stand out over against all instrumental devices on the one side, and all involvement in means on the other. They are parts of a new world, distinct from the worlds of nature and machines.

Art seems more like play than work, for play does not look outside its own borders. Play is self-contained activity without serious or definite purpose, productive of but not engaged in for the sake of pleasure or general well-being. It is an expressive use of energy, opening into the world, exhibiting a spontaneity, an exuberance detached from any interest in what lies beyond. Play can of course demand effort, strenuous effort. Strain and even pain accompany it at times. But these are incidental occurrences usurping the unintended but pervasive pleasure which normally ensues. It may have its moments of gracefulness, it may embody value, it may have a structure. But it is on the whole quite awkward and trivial, disorganized, shot through with contingency and randomness, occurring between sudden moments of self-discipline and control.

A child plays, a puppy does. It is rarely that men do. They engage in games, which is play subject to rules; and in sports, which are games in a social context. Like the child, they then are also disengaged from an end. (It follows from this that it is not the object of play, game or sport to win. Winning can provide a motivation; its prospect can give direction and add interest. But should it become the objective of the play, game or sport, these will be turned into forms of work—

as sometimes happens in what is oddly termed "professional" games and sports.)

Art, like play, like games, like sport, does not look to an end beyond itself. That is why it has often been treated as though it were either a kind of play, manifesting an exuberance beyond that normally exhibited, or a kind of rule-dominated use of energy serving to produce pleasure and health. But art, unlike play, is a disciplined, controlled activity. Unlike a game, it does not attempt to conform to rules. While attending to them and even exemplifying them, it subjugates any assigned rules or inherited canons to a transforming creative activity. Unlike the activity of play and sport with their arbitrarily defined closures, full and pure creativity—only partially exhibited by even the best of artists—is self-enclosing, prescribing its own terminus and defining its own completeness. Unlike any of them, it produces something which usually can be held apart from the production of it. In play, game and sport the process is enjoyed, and the outcome is but the terminus of the activity. In art both the process and the outcome are valuable in themselves; and both together exhibit an excellence which defines what is thereafter considered valuable by oneself and others.

Skill is the ability to make a masterly use of instruments and tools so as to reach some end most effectively. Technique is a skill which uses tools and instruments with subtlety, to do maximum justice to the details and nuances of the means. Both enhance the means, giving these a status and value even while they serve to bring about an end. They accentuate the virtues of the means, freeing them from irrelevancy and dross, at the same time that they make them function at their best. Did they merely free means from what is irrelevant, skill and technique would be indistinguishable from work or idle polishing. If they did nothing more than make some means more effective, they would be but ways of working on means to produce other means of a certain type. But they restrain polishing by efficiency, efficiency by polishing. They offer good ways of *enjoying* the grain, color, power of the means as one moves towards the end those means help bring about. (I here follow S. A. Alexander's—*Space, Time and Deity*, vol. 1. p. 12—use of "enjoy": "enjoyment or enjoy . . . has to include

suffering, or any state or process so far as the mind lives through it."
Although he recognizes that his refusal to extend the term to apply
to the way in which objects are lived with goes counter to common
usage, he insists on restricting the application of the term to states
of mind. I think it desirable to use it to refer both to states of mind
and to objects so far as one goes along with them, accepts them with-
out intermediation or qualification, though not necessarily with an
overtone of pleasure. We will then be able to say, as Alexander cannot,
that we enjoy the things we eat. But we will still depart somewhat
from common usage in that we will make it possible to say that a man
enjoys his pain since he consciously experiences it.)

The technician is the master workman, the worker is his helper, his
assistant—and the laborer is their instrument. The craftsman goes
beyond them. He makes skilled use of means to bring about something
desired. Since art involves the skilled use of means to produce what
is excellent, it is tempting to treat art as a kind of craft. Such a view
has historic justification. Artists have often thought of themselves
as being highly skilled workmen. Most have been trained as appren-
tices under masters, or have been members of schools or guilds. Because
they have made conspicuous use of their bodies, were supported by
patrons, and seemed to function only in order to delight others, they
have long been looked down upon by the leisured and powerful as
having the relatively minor status of superior workmen, workmen
who do their jobs excellently.

The supposition that there is no difference, or at most that there
is only a difference in degree, between craftsman and artist would
have the virtue not only of enabling us to connect the artists of the
past with those of the present, but would make it possible to see the
ordinary man and the artist as pursuing somewhat related tasks with
different degrees of intensity and devotion. And once we accept the
view that artist and craftsman differ at most only in degree, we can
rather neatly combine the Greek and medieval attitude towards the
artist as a superior workman with our current democratic outlook
which holds that men, no matter what they do, never differ in kind.
We will also be able to avoid a romanticism which treats the artist as
though he were a god, apart in inspiration, sensitivity and purpose

from all others, a philistinism which takes him to be a kind of demented child, a snobbism which takes art to be available only to a select few, and a factualism which supposes that art has no relevance or connection with what men do every day. Nevertheless, it would be an error not to distinguish art and craft, and this quite radically.

Art employs techniques to produce something excellent. Its imaginative use of a technique alters the technique's value and role. The artist adventures, risking ugliness and error, exemplifying but never merely following rules, tradition or customary procedures. He is an innovator, a creator, breaking new ground at every venture. He may not achieve much; his achievement may be little more than the introduction of a minor variation or nuance in established forms, but his effort is to make something able to stand by itself, replacing the world beyond. If he fails to make it well, or to work with freshness and independence, he fails as an artist. The craftsman—a fine carpenter or gardener—in contrast, is sensitive in his use of his technique but does not use it imaginatively, creatively, in new territories, forcing himself into the unknown, and making this his own. He uses his technique excellently to make something ennobled, enhanced; he does not use it to make that which is excellent in and of itself. He experiments but does not adventure; he conforms to or embodies rules instead of making them. The craftsman exhausts himself in his craft; the artist uses his craftsmanship to get himself to the stage where he can create.

In speaking of "art" in the above, it was splendid cases of the fine arts of painting, dancing, music and the like which I had in mind. It is in this sense that the term is to be understood throughout this work. "Art," in the nonhonorific sense, is to be viewed as offering an incomplete or partial realization of the excellencies to be encountered in splendid cases of art. There are other uses of the term which are also quite common. "Art" is frequently used to refer to philosophy and history, to teaching and criticism. Colleges often divide themselves into the "arts and sciences," even when they have no courses in painting, dancing, etc. It is quite proper today to speak of the art of fishing, the art of speaking, and so on. In some of these cases what is evidently meant is a craft of some kind. But in other cases the term "art" is used to refer to the pursuit and production of that which is

excellent in the areas of thought, inquiry, and life. What has been said above has considerable pertinence to such pursuits—to the art of scientific inquiry, philosophic speculation, political adjustment, and the like. But these are not "fine" arts. A fine art always has a sensuous embodiment, and contains within it something revelatory of the world and its bearing on man's destiny. It is these features which makes it stand out most conspicuously over against any other type of work and any other pursuit, no matter how excellently done and how worth-while the result.

Art exhibits something of the spontaneity and self-containedness of play, the law-abidingness of games, the control and purposiveness of work, the value of labor, the arduousness of toil, the weariness of drudgery, the technique of the craftsman, and the excellence characteristic of the liberal arts. But it goes beyond all these. It is a full-fledged creative enterprise, making use of material to bring about beauty—excellence given a sensuous body. There is still much more to it than this. A work of art is not only sensuous; it has a rationale; it is not only unified but diversified, many as well as one; there is tension and disequilibrium in it, but also order, proportion and resolution; it is at once at a distance and immediate, opaque and translucent, novel and traditional. In the following exploration of the nature, divisions and problems of art, in general and in specific forms, these and other related matters should become more and more evident. But before moving on to these questions it is desirable to attend, at least for a moment, to the reason why men engage in art and other basic enterprises, which, like it, demand great effort and often yield them little reward.

Were art but a form or extension of play or craftsmanship one could see how, out of exuberance or pride in accomplishment, a man might readily move to it. And it would not be difficult to see that a man might devote himself to the conquest of this newly discovered domain, once he learnt how much more satisfying this was than any other out of which it might have issued. It is true of course that one rarely creates without having first played, and without first having worked with care and skill. But it is possible to engage in art apart from all interest in play or any concern for craftsmanship. Primitive artists

are deadly serious and are untrained. Yet sometimes they can, as the *douanier* Rousseau did, stand alongside acknowledged masters.

And it is questionable whether or not art offers a greater degree of pleasure than other enterprises. It does, to be sure, satisfy an occasional man occasionally, and then primarily when he is in the role of spectator rather than creator. He who produces an art object, who attends to it with sympathy, who appreciates its quality and value, quite often is rewarded with satisfaction not otherwise attainable. But the art is not pursued for or justified by the achievement of such satisfaction. That satisfaction is a kind of surplus value, an added increment, given as it were gratuitously, and then only to those who do not seek it. Art is not primarily an agency of any kind, and surely not an agency for the production of pleasure.

Nor will it do to speak of art as the outcome of some distinctive "aesthetic" impulse. This is but to read back into man the very facts we are trying to understand. Confronted with art as having certain distinctive features, we look for something which will explain it, clarify it, show it in some relation to the other things men do. If we but repeat its features in the guise of some hidden power, we obscure what we first discerned without making any advance in insight or knowledge. Those who speak of men being driven by a need to imitate, to find release in design, to escape from care, not only overlook the fact that there are other ways—often much more effective and certain—for achieving these results, but neglect the truth that art has common roots with other enterprises. An aesthetic impulse can at best be but a common impulse specialized to produce aesthetic results.

Aesthetic results are either aesthetic objects, aesthetic experiences, or works of art. These are not only distinct but somewhat independent of one another. An aesthetic object is produced when, by a shift in intent, we separate an object from its natural or conventional context and focus on whatever new central features are thereby made evident. An indentation in the rocks, for example, is an occurrence in nature. Looking at it as a possible place in which one might live converts it into a conventional object. Neither the indentation nor the envisaged dwelling is a work of art; this demands that material be worked over. Neither is even an aesthetic object. This they can become only when

their characteristic spaces are detached from the rest of space. An indentation is just an opening in nature; a possible dwelling is just an area in which one might remain for a while. Neither has a scale; neither is viewed as having multiple sub-spaces all interplaying and defining one another to constitute a unified whole having nonnumerical relations to man's size, tasks and duties. Only when we see the space between the rocks as a detached scaled space do we see it as an aesthetic object—in this case as an architectural space whose walls and openings were provided by nature but whose volume is constituted by our intent. An architect might make use of that aesthetic object, refining, qualifying, adding to, and subtracting from its space. As a rule though he prefers to ignore the aesthetic object, and even the conventional dwelling place, and instead to create his desired space by working over the natural indentation. He wants his space to be substantial, objective, and self-sufficient. The fixating of his kind of space through an intent gives him little help, particularly since he usually finds the resultant space to be not rich or variegated enough to satisfy his artistic demands.

Like a conventional object, an aesthetic object depends for its being on an intention which separates it off from its natural context. Unlike a conventional object, but like an art object, an aesthetic object has volumes, rhythms and powers other than those discovered through measurement or practical use. It is not yet an art object, for its volumes, rhythms and powers are not objective, substantial, ingredients in it. An aesthetic object lasts only so long as we are interested in it; the art object exists whether or not it be known. Otherwise it would not be true to say of it that it had been ignored, burned or lost. Art is as objective as nature and as public as society; the aesthetic object precariously depends upon man's awareness of it.

Aesthetic experience is immediate, direct; distance between experiencer and experienced object is broken down; in it content is emotionally tinged, possessed and enjoyed, its value heightened and its import changed. Evidently, not all immediate experience is aesthetic experience. Oysters apparently experience without mediation; yet they presumably do not have an aesthetic experience. Mere cutting away of concepts, passive acceptance of the stream of passing impressions

does not yield the kind of immediacy that is experienced when a man is absorbed in the feel of a cloth, the smell of a flower, the taste of an apple. An aesthetic experience is most rewarding when ideas are not denied but are made subordinate to the act of making immediate contact with what is present.

If a spectator does not hold a work of art apart from its setting and enjoy it as having a distinctive kind of space, time or mode of becoming, at least to begin with, he will miss it altogether. He must, therefore, first deal with it as an aesthetic object. If he subsequently makes the work of art the object of an aesthetic experience, he will enjoy its grain, the luminosity of its colors, the purity of its sound. But if he does only this, he will not yet have encountered it as a work of art. To deal with it as a work of art, he must, while aesthetically experiencing it, see it as a substantial reality which reveals something of the world that lies beyond it.

Although one can sometimes have rewarding aesthetic experiences of natural things, such experiences are not prerequisites for the production or enjoyment of art. Some painters find little pleasure in looking at landscapes; some musicians find daily sounds almost intolerable to hear. Art historians find little need to look outside the world of art; often they can satisfactorily enrich their awareness of one work by what they glimpse in others. An aesthetic experience of natural objects may of course stimulate the artist to attempt to recapture its quality in his own way, or (more often) may stimulate him to produce a work that may give someone an even greater good than an aesthetic experience can provide. An awareness of nature's aesthetic values may also make a spectator or historian alert to nuances in a work of art which he might otherwise have overlooked. But whether or not the artist begins with daily or aesthetic experience, and whether or not he converts conventional into aesthetic objects, he must, to have a work of art, make an independent substance, capable of standing, in its own right, over against the rest of the world.

The values of aesthetic experience are worth preserving. Artists are therefore constantly tempted to record or recapture them in their works. Did they do only this they would unnecessarily limit their range, fail to exploit their media, and do less than justice to the

autonomy and freedom of artistic creation. Portraits and romantic poetry rarely attain the stature of arts, because they are too concerned with recapturing an aesthetic experience of natural or conventional objects. El Greco's and Rembrandt's portraits and *Romeo and Juliet*, though, show that portraiture, romance and the like, offer no absolute bar to the production of a work of art. However, it is to be noted that these masterpieces make no effort to preserve the values of an aesthetic experience of a natural or a conventional object. Men who concentrate on preserving such values usually lose the power to engage in the arts fully, while those who devote themselves to the arts usually push aside the aesthetic values with which they began to end with something better—a valuable created substance in which new aesthetic values can be found.

2. ART AND THE FULL LIFE

It is difficult to make that valuable created substance which is the work of art. Mind and will, self and body must be made to act in consonance, at a considerable distance from nature and the world of daily work. Great demands are imposed on the energies and attention. Yet the result does not wholly satisfy. No one can be content merely to make works of art; no one can devote his life simply to their enjoyment. Nature and workaday matters constantly intrude, forcing one to to turn from art and attend instead to them.

Men, too, have a need for virtue and knowledge which can be satisfied only by engaging in enterprises other than art. These needs can be ignored, but only by giving up an opportunity to live a full life. One could even, with Plato, argue that the pursuit of virtue and knowledge deserve more consideration than art. Art might be said to have some value and even to help a man complete himself in a special way, but the demands of virtue and knowledge could always have overriding claims. It has sometimes even been urged that unless art be radically qualified and reduced to a means for the promotion of these, it is not worthy of a man's time or devotion. Apart from its support of and consequent restraint by virtue and knowledge, the argument runs, it should be abandoned. I think this claim is mistaken. Art is an enterprise not inferior to any other.

There are five long-established activities which have often been said to have a status superior to that of art—ethics, politics, religion, philosophy, and science. The first three are held to be indispensable or preferred agencies for enabling men to live as they ought. The second two are favored by those who claim that man's highest interests are best served by concentrating on the promotion, possession and use of speculative and precisely formulatable knowledge. Each of these five activities has something to say for itself; each deserves

some attention. The first four can be dealt with together, since they constitute, at least today, only a minor challenge to art. The last, though actually no more formidable than the others, is the mountain which stands in the way of most men's grasp of the nature, claims, and values of art. A discussion of it is reserved for the next chapter.

From the standpoint of the stern moralist, art should be carefully and severely censored because it so regrettably arouses man's emotions, confuses his mind, and makes him indifferent to absolute standards, particularly those relating to right and wrong. Also, there are evils in the world that ought to be corrected. It is wrong, the moralist says, for a man to allow himself to enjoy even the most exquisite work of art while his fellowman suffers, is in radical danger, or asks for help. It is wrong, fiendishly wrong, to use one's powers as an artist to make that which would corrupt or confound. Who doubts that we ought to stop writing, looking at, or engaging in a play in order to stop a lynching? Art is an enterprise which ought to give way before the demands of ethics. Who would not, the old poser has it, run out of the playhouse to see a hanging? Who would not interrupt a performance to hear the announcement of war or peace?

We need not go all the way with the moralist, but we should admit that ethics does have claims which override those of art—at times. The converse is also true. Neither is sufficient for a whole life. Ethics needs to be supplemented by knowledge and practical wisdom—and needs the insight, refreshment and freedom which art provides. An ethically governed life is overaustere, too restrictive, unable to satisfy a man. His passions and impulses, spontaneities and imagination, his desire to make and enjoy never can and never ought to be entirely frozen by a moralist's sneer. The proper object of an ethics is the promotion of the full life. Artistic creation and appreciation are no less a part of such a life than are the preservation and enhancement of the good, and the fulfillment of one's duties. To save a man from lynching only to prepare him for a life of unremitting drudgery is to do him but little good. Even in the most brutal and uncompromising war, there ought to be some regard for the priceless treasures which art has produced. Sometimes the ethical, sometimes the aesthetic should give way, depending on which will then, and eventually, contribute to a full life.

Ethical goodness and beauty are but two forms of an excellence which man seeks and ought to realize. We should interrupt the play to stop a lynching. It is not altogether clear that we ought to stop it to hear the announcement of war or peace, and it is far from clear that all of us ought to or would leave the playhouse to see a hanging. In any case it is also true that we all need and should have moral holidays, that for the sake of a richer life we should and do at times turn away from the stern demands of duty.

Politics makes a double claim on our attention. It forcefully insists that we subordinate our other interests to it, and it demands, as its right, that we so subordinate them. In part because our families are not sealed off and in part because we are not merely units in them, we, though brought up in families, are also members of a larger world. Our lives often, and our welfare surely depends upon society and state. We are obligated to them, and this obligation demands that we contribute to them, give them time and devotion. But they do not wait for us to recognize what is owing to them. They insist on themselves, unremittingly and endlessly. If we are unwilling to attend to them at all, they will sooner or later intrude on our most intimate affairs.

To ignore politics is to defeat ourselves; it is to allow unleashed what benefits only if controlled. To want to ignore politics is to want to deny our indebtedness to what keeps us secure, promotes our health, holds brute nature at a distance, makes art possible, and preserves our artistic heritage and possessions, sometimes even in the face of violent opposition.

A purely political world is, like an ethical one, too austere to satisfy man. It cannot last long unless it has a Spartan look. And then, as Sparta showed, it will not last for very long. Men hope, believe, speculate, not for want of something to do inside society or state, but because no public life ever can contain enough to occupy the whole spirit of man. A world in which artists are not free to pursue art according to the demands of art is a world in which man's promise is arbitrarily cut short. It is a world bare, stark, cold, overrigid, a half world acting as though it were the whole. We ought to work together in public to make it possible for each to have a rich, satisfying life, part of which is to be privately enjoyed. To spend all or even most

of our time in public is to use a means to preclude the very end which those means are designed to bring about.

The political life has its rights and its deserts. With warrant it subjects the artist to many conditions. The artist lives in the same world that other men occupy; it is there that he receives his sustenance and gets his opportunities. But art also has its rights and deserts; it is wrong for the artist to forget these. This he does when he acts as a propagandist or official spokesman. It is also wrong for society and state to forget the claims of art, but this is what they do when they insist that their demands are to have priority everywhere and all the time.

In comedy and tragedy, in song and dance, in story and print the follies of political life are sometimes tellingly portrayed. They make the world of politics more humane, and are sometimes cherished for the good that they thereby do. Art, though, does not need such justification. It is a good in itself. Indeed we can partly estimate the stature of political systems and leaders in the light of their ability to preserve and promote it. Art is one of the primary loci of their people's hopes, values and meaning. Anyone who would ignore or defy it will eventually be swept away into that soundless night he sought to turn their burly day.

Politics and art both make a contribution to a life richer than either could alone provide. An occasional man can engage in both to considerable extent, but most must be content with stressing one rather than the other. There is little harm in such stressing, if it is not forgotten that the slighted enterprise may have an overriding claim at some time or in some circumstance. A full life demands the great goods made available by both art and politics, functioning separately and together.

From the standpoint of religion, the ethical, political, and artistic life are on a footing. All are worth while so long as they remain in consonance with what the religion dictates or so long as they serve its ends. The religious doctrine of "two swords," which presumably grants autonomy to the political world, should also have been extended to ethics and to art. Extended or not, the doctrine in practice turns out to be one which makes use of three swords, two of which are to

be used by religion. It grants each discipline its own sword to cut through its own problems. But when the interests of that discipline conflict with those of religion, religion thinks of itself as having priority. It in effect demands the right to use a third sword to cut short the activities and end the autonomy of others whenever there is a conflict between it and them.

Religion never grants ethics, politics or art an overriding claim. It gives them the kind of autonomy the mother gives the child when she permits it to ride its tricycle. The mother does not want to ride it herself; she delights in the way in which the child dextrously weaves in and out; she wants it to feel free and independent—but all the while she is and intends to be in possession of a hidden sword which she will use when she feels she must.

Religions speak on behalf of a supreme being or value whose demands may not conform to what men might think right, expedient, wise, or intelligible. Great religious works and men again and again show their indifference to and even defiance of what has been seen and said by ethical and political men. Human sacrifice and slavery have had religious sanction in many lands, and we ourselves accept without qualms, as our definitive religious book, one which tells of God allowing his Adversary to kill and injure innocent men, women and children merely to try the faith of a Job, and in which men are urged to leave father and mother and neglect the unburied dead. If ethics or politics or art make us neglect or even qualify the obedience and love we should give such a sovereign being, they must be condemned by those who believe in him. Augustine regretted his strong interest in rhetoric; Francis of Assisi objected to all book learning; plays have been censored and art's direction redefined again and again on behalf of what has been taken to be religion's primary claim.

It does not follow, however, that an enterprise which has a superior object at the focus of its attention is necessarily a superior enterprise. The glare of such an object could blind those who look directly at it; he who faced it by himself might lose his sense of direction and misconstrue his obligations. This is one of the reasons why that most private and searching of activities, prayer, is performed in public and made to follow routine lines. Religion is too overwhelming in object

and consequence to be allowed to an uninstitutionalized man. And for the same reason it is too dangerous an activity to be unrestrained by ethics, politics and art. Our religions are now a little more responsive than they once were to what we know is right and wrong. In politics today we keep a hidden sword of our own; in the name of a separation of church and state, we ready ourselves to deny place to any religion which advocates what goes counter to what we socially and politically tolerate. And our art, once kept out of the churches and synagogues, or made to serve their ends, now is more and more frequently called in to define for our religions what is valuable, rich and most meaningful.

A religious life which denied a place to art would dismember the human beings it says are images of the divine. One which gave art a place, though, would not necessarily be thereby freed from the typical reactionary insistencies of religion, would not necessarily be tempted to attend with more patience and consideration to the rights of man's deepest passions and emotions, nor necessarily give up its demand that we keep our eyes turned away from the world. A religion sympathetic with art does not yield all one needs in order to make a complete life. The worship of God is only one of the things in which a man can and ought to engage. He must eat as well as pray, think as well as fear and hope. If man is a creature of God he evidently was created to create. In nothing else does man so closely resemble the Creator, in whose image he is supposed to have been made, than in an artistic enterprise, making a world which never was before.

When man creates he worships as surely as he does when he kneels or sings a psalm. Equally important, he reveals himself in his creating to be a man, standing on his own feet, with dignity and self-respect, doing what he can, here and now, to make the excellent, excellently. Religious activity occupies and can occupy only part of his life. If the objective it sets before itself is to be realized, it must look to other enterprises for supplementation and support.

Ethics, politics, religion and art are all valuable. Each rightly comes to the fore at different times and places. Each makes its own contribution to the good life. None has a primary claim. "Hold on there," I imagine someone impatiently exclaiming, "all this is idle

talk. You have won a victory of sorts by dividing the opponents of art into three separate camps and then despatching them one after the other with a generality or two. Face a hard case and deal with it head on. Take something at the centre of all three interests—ethical, political, religious. Suppose a man is starving. Ought one to feed him, or ought one to turn away and continue with the brush or the flute, the chisel or the pen?" Said in a loud enough voice the question could sound overpowering. But I think it need not make one give any ground. Feeding a man is not a simple matter. It could violate an ethical requirement, since the food may not be ours to give. It may go counter to what our society or state will permit, since the man may be a traitor or an enemy. It may violate a religious command, since the available food may be that which he is forbidden to eat, or we to touch. It is not evident, in short, that this or any other imagined situation provides an occasion which is surely sanctioned by all three interests, or that it demands that art always be given only a secondary role.

Food should be provided with a sensitive regard for what a man is and needs, and what it is that all men require and deserve. The artist should feed the starving man if no one else will or can. And then he ought to feed him in such a way that both will be able to engage in those specialized activities which produce goods for all. The existence of the starving man points up the fact that our charities, society, state and civilization are not functioning properly, that they are not as they should be. The artist, no less than the rest, by obeying the law, by paying his taxes, by giving to charities makes his contribution to what he hopes will be the common welfare. He is no more guilty for the failures of his society than he who has devoted his life to making that society function better. Indeed, since he did not take this to be his task, we might well argue that the artist is even less guilty than he who made it his task and did less well than one might conceivably do. We blame the artist not the politician when the artist produces a poor work; we should blame the politician and not the artist when society falters.

A man can usefully spend a life in the perfecting of public agencies. One who did this would be an essentially political man, with characteristic virtues and limitations. He will live a better life if he finds a place

for ethics, religion, and art as well, in his own life and in the lives of others, and recognizes that there will be times and places where art will rightly demand the attention which may now be rightly turned to political, ethical or religious problems.

Ethics, politics, religion and art are all specialized activities and find their ultimate justification in the contribution they make to a life larger than that which any one alone can provide. The practitioners of each should function as representatives of the rest, themselves engaged in representatively acting in different specialized ways. Each should do for all what each would have them do for him—produce great value by engaging in limited specialized work.

He who acts only for himself is either a God or a beast, one who is at a supernatural distance from where men interplay, or one who is a purely natural thing, outside society, to be used as the rest decide. A man is a man only if he does socially useful work. If he engages in a limited job—and this is all he ever can do—he must do it for all. What he does need not be economically valuable. It need not be something socially demanded or approved. But it should be that which is done for and can benefit all.

He who does socially useful work need not think of the rest. He may find it desirable to hold himself apart from and even to oppose the prevailing opinions, tastes and conventions; only in this way might it be possible for him to bring about most effectively a good for all. Should he fail or should he get his result by paying a price higher than need be paid, he is to be judged adversely as one who has not done what he set himself to do. Only success at a limited representative task justifies the neglect of other tasks.

An artist need not go to war nor spend his energies in daily labor or any other specialized activity if these stand in the way of his career as an artist. The other enterprises are no less partial and biased than is his own. But he must, as they must, give up his concentration on his limited task at certain times and places in order to recover his position as one who lives together with political, ethical and religious men. He should never forget that common ground in attitude and promise which he shares with them. He should feel the anguish of the starving man and recognize his desperate need. He must see to it

that the man is fed, if not by him then by some other. But he need not engage in the act of feeding the man except so far as no other does or will. And when he does it, he should do it as the representative of us all, momentarily assuming a political, ethical or religious role.

A decision to deal with a starving man in political, religious or ethically approved ways is no better and no worse than one which favors art. Each answer is partial and biased, producing only part of the total good we need. Each has some wrong in it and some right. To this it may be countered that it is one thing to sympathize while one does something to relieve the suffering of fellowman, and another thing to sympathize while turning one's back on him to attend to an art. But he who raises food, transports it, sells it, or cooks it must also turn his back on the starving man. The fact that he is involved in means preparatory to feeding points up the truth that a public life has long- as well as short-range problems. But the longest-range problem is not feeding men; it is making them mature, enriched, completed. To this, art makes its greatest contribution only if it is allowed to be independent, pursued in its own terms.

But, it will be said, art is so noble, so rewarding that anyone would gladly engage in it and let the rest carry on the dirty and unrewarding work of daily life. Art is joyous but ethics, politics and religion are onerous, to be avoided if only one could. Such a contention supposes that these enterprises do not have their own satisfactions and rewards and that art does not have its hard labors, pains, disappointments and dismal failures. The artist must turn away from helping others not because he is superior to those who engage in this work but because, like them, he brings about goods which can be bought only by a sacrificial concentration on some limited task with a consequent comparative neglect of others. He continues to remain one with them, for his life is inescapably tied to theirs through fellow-feeling, a common human nature, and a common justification in the representative production of values.

Philosophy is a fourth enterprise which has sometimes been said to be superior to art. It is hard to find anyone but philosophers saying this, but perhaps this is because they know better than others what great goods philosophy yields. The Hegelian claims that philosophy

is all-inclusive, having art as well as religion as subordinate moments. Others, most conspicuously Plato, view philosophy as essentially rational, cognitive, the very antithesis of art with its apparent encouragement of the irrational and emotional.

Plato at times held that the sensuous was two removes from the intelligible and therefore twice undesirable. At other times he took a different stand. He treated the sensuous as a function of an irrational, compelling power of vital movement which stands over against and defies, distorts, and infects the intelligible that intrudes upon it. From this perspective, art can be said to appeal to man's basic bad nature; to be interested in it is to be involved in what is not good.

Strictly speaking, Plato found art to be unsatisfactory for two reasons. From the perspective of the Forms it was defective and from that of the state it was distortive. The first inadequacy was to be overcome through knowledge, the second by training. If this could not be done art must be proscribed. (Just as Plato held that art imitated the forms at second remove, he could have held that it did not pervert men directly but only after they had first defected from common public activity and tried to live as private beings. This would have given him a more consistent and sounder position.)

Plato's banishment of the poets is a recognition that they do make something having considerable appeal. He says that the effectiveness of Homer is enhanced by the charm of his verses; without that charm he thought Homer would not have much appeal or much to say. But he failed to see that even if art were not desirable from the standpoint of the state or the Forms, it is not necessarily bad from the standpoint of the individual, the cosmos, or God. His main objection to art perhaps is that it yields a pleasure which is not controlled by the Good, overlooking the fact that the pleasure is controlled by a work produced by a disciplined man.

In the *Republic* Plato granted that there was a place for music in the state. He thought of it not as a source of knowledge or pleasure but as an agency for the training of men, a way of vitalizing the soul inside the state. Having started with the state as a whole he obscured the fact that it too was an artifact in which the various arts could function somewhat as colors and shapes and sounds function in the

arts themselves. Had he recognized the value of the arts in and of themselves, he could have made them into interrelated constituents of a state far richer and more variegated than the barracks he had in mind.

Plotinus gave still another shape to the general thesis that the intelligible was superior to the sensuous and therefore to art. According to him, art offers a sensuous embodiment of the rational, giving it new conditions and subjecting it to exterior and somewhat limitative qualifications. This view does most justice to art, so far as any justice can be done by a view which gives primary status to the intelligible alone. The position it presents could be reversed with benefit: the sensuous can be viewed as the intelligible which subjects the sensuous to new conditions and exterior and somewhat limitative qualifications. More important, the truth that a beginning had been made with either one of these positions would do nothing to show that the other was inferior. The derivation of that other might be only logical, analytic; and if historical or ontological in nature, the result could still be as excellent and even better than that from which it issued, since it might be productive of new values through the operation of new conditions.

The intelligible can also be treated as the only significant category usable by an intelligent, rational man. This is what Descartes, Leibniz and Spinoza claimed. For such thinkers the sensuous is what the intelligible becomes when its nature and outlines are blurred. Their position offers one of the main grounds for the modern preferential stress on science over art, the topic of the next chapter.

If Descartes, Leibniz, Spinoza, Plato and Plotinus are right, philosophy attends to that which is most true or real while art allies itself with what is less than this. In opposition to their insistence that the intelligible alone is real or respectable is that of the empiricists and romanticists. These men argue for the primacy of the sensuous. For them the intelligible, the logical, the rational is a degenerate or qualified manifestation of the sensuous or even its irrational or futile opponent. Hume took the first of these alternatives. "Reason is and ought to be the slave of the passions" ran one of his boyish rebellious claims. Every idea, he held, was but a faint impression, a derivate

from a sensuous encounter. But he also seemed at times to say that the sensuous and the rational were opposed, with the former having a preferential status. The slogan quoted could be interpreted as summarizing this very view. On the first of these interpretations the rational is taken to express the sensuous in a poor way; on the second it is given independent being, but one which deserves to be denied, defied or qualified. When Kierkegaard spoke of a philosophic system as a kind of falsification of the real, he held something like this view.

A stronger defense of the priority of the sensuous is the converse of the view offered by Plotinus. Here the intelligible is treated as the sensuous itself, caught in a new context which qualifies and partly hides its nature. The intelligible now becomes a kind of paraphrase of the sensuous, re-presenting it in another guise, subjecting it to conditions which make possible the communication of its nature.* If philosophy be thought of as essentially rational, it would, on this account, have a status lower than art's, even though it would be due to philosophy that art's superiority to it would be known. But there is some truth in the view that philosophy is overrun with metaphor and sustained by emotion, that its discourse is not purely rational. On such a view, though art might be thought to be subordinate to philosophy so far as this marks out art's territory, art would be at least the equal of philosophy since it makes use of sensuous material in somewhat the way philosophy does. This view, while giving the sensuous a significant role, sees the value in the rational. But it too is inadequate.

The sensuous is not the intelligible, and the intelligible is not the sensuous. Neither can rightly claim to be superior to the other in every respect. The recognition that each has its own nature, career, limitations, values and problems constitutes an advance over the positions presented by the rationalists and by the empiricists. It provides a warrant for the doctrine of art for art's sake, and also for one which urges a mathematics for mathematics' sake, a philosophy for philosophy's sake, and so on. Adhered to firmly, it reveals the rational

* This position is often assumed by masters of an art. Forgetting the fact that rules are part of their own substance, they tend at times to tell others to forget about rules altogether and go back to the original source of content and inspiration in simple experience itself.

and sensuous to be twin prongs of a dualistic system. This allows neither one to have a dignity denied to the other; both are seen to have different natures and correlative roles.

If philosophy is an enterprise which makes this dualism evident, it would have to be on both sides at once and have both a sensuous and a rational nature. The acceptance of this view means that we in effect either have treated philosophy itself as inherently dualistic, demanding some mediation by some other enterprise, or have moved away from a strict dualism to a position which has a single base with two specialized forms. The first of these alternatives but repeats the problems of dualism in the area of philosophy and thus makes no advance except that of maintaining dogmatically that a dualism in philosophy is superior to one elsewhere. The second gives up the original position.

The difficulty with a strict dualism of any sort is that it attempts to speak of two entities as completely sundered one from the other. If we have the one we so far do not have the other; yet we cannot know there are two unless somehow we have both of them together. Dualism says there are two exclusive positions, but in order to say this it must occupy a third position which includes them both. This third position could be said to be essentially intelligible, but capable of manifesting itself not only in intelligible concepts or discourse but in sensuous content as well. One manifestation would be occupied with abstract and repeatable symbols, universal structures, and formulatable implications; the other would be occupied with unique and unduplicable occurrences having immediately apprehendable relations and consequences. Both could be said to be the concern of science and of art. The sensuous, for the former, would be where its formal implications would be dissolved in the shape of concrete movements from antecedent to consequents. The intelligible for the latter would be the repeatable structures and demands which could be abstracted from the sensuous —techniques or lessons of experience, codified and formalized. Both would be at once formal and dynamic, universal and particular, the one stressing the structural, the other the dynamic sides. Underlying both would be philosophy.

Instead of philosophy being treated, with tradition, as offering a

rational base, one might, with the Existentialists, see it as providing a sensuous base. The latter view is more promising for one who seeks to understand art as inescapably concrete and sensuous. Mathematics, logic and science, when approached from such an existentialistic position, turn out to be either effete or, if keyed to the novelty and spontaneities of the world, to make only inductive, probabilistic assertions. According to this view, artists are to be seen as offering specialized ways for dealing with the very real which an existentialistic philosophy reveals. This view is indistinguishable in principle from one which maintains that philosophy is a literary art, underlying all other arts. It does not give priority to philosophy, but to literature. But can one art be justly treated as presupposed by or as superior to others?

Philosophy has its own procedures, tests, objectives and quality. It is not merely rational; it is no deadly array of thin ideas. It is not merely sensuous, metaphorical, interweaving concepts to constitute a reference to something rich and obscure. It is something of both, or better, it is neither. The ground for all subjects and activities, it is concerned with the underlying reality which they all exhibit in diverse ways under limitative conditions. As such it is outside them all, transcending and measuring them and avoiding their characteristic biases. But it pays a price for this transcendent neutrality; it can deal only in abstractions and exhibit only a phase of the real. It, better than other enterprises, can provide a systematic categoreal account of things. But art and other enterprises have virtues of their own. What philosophy can do, art cannot, and what art can do philosophy cannot.*

The real has a being distinct from any of its manifested forms. To know it we must be able to transcend the limits which make those manifestations possible. Philosophy is one way of doing this; it grasps reality as that which is more than sensuous or rational and expresses this in an abstract, categoreal, communicable way. An ethical apprehension of the ideal which men are obligated to realize also gets to reality but in the shape of luring possibilities, or goals which define the purposes and nature of whatever there is. Religious worship also

* In *Modes of Being,* a number of comparisons are made between the two. What is there termed "art," though, might be better termed Rhythmics, an enterprise that underlies both art, as here understood, and history. The change will not I think seriously affect the point now being made.

reaches reality, but in the shape of a final unifying re-evaluating unity. And art gets to it too, but in the shape of man-made creations. Each of these does most justice to one type of being, and lesser justice to the others, themselves more properly dealt with in some other enterprise. Art is most suited to show us the import of existence; not so well suited to let us know the import of actualities, the ideal, or God. Nor does it tell us much about what experience is like when it is quantified or given an historical or political structure.

The concern for art is distinct from the concern for other things, but unless man is only an aggregate of separate insistencies (instead of an organic unity with diverse and specialized channels), his concern for art must have points of juncture with his other concerns. Art specializes a common drive in man. An adequate account of art must therefore make reference to the centre of man's being, to that core from which every other basic drive takes its start. Men speculate, fulfill their obligations, worship, and create all for the same reason—they seek to complete themselves. Such completion demands that the world beyond be mastered. That world defies man. It would defeat him were it not that he can somehow have it on his own terms, thereby possessing for himself that which otherwise would remain outside him, jeopardizing and denying him.

Men in their public roles are for the most part content to adjust themselves to the world. In their everyday lives, as members of social and political groups, as vital members of some particular church, and as units in history, they learn how to carve out a way of living in a universe which is dominated by nonreasoning, relentless forces. The life of the public man is a perpetual struggle to maintain himself in equilibrium with respect to the world outside his public life and institutions. Through action, by means of scientific formulations and predictions, through technology and exploration, in lives of service on behalf of God, state or man, and through their different kinds of work, men go somewhat further, controlling rather than merely adjusting themselves to the world beyond. In these ways they take limited perspectives on a rich and largely subterranean reality, intruding and imposing their own purposes and needs on it to make it follow, at least in part, along grooves they find desirable.

Adjustment to and control of the world is indispensable if man is

to survive and prosper. But neither adjustment nor control suffices to make him complete. Neither can provide an answer to man's basic need to be himself in himself, possessing whatever might be outside and might deny him. Because they have a persistent need to master the world and thereby complete themselves, men seek to know, seek to bring about the good, seek to ally themselves with God or his purposes, and seek to produce works of beauty. They do not engage in these activities with the intent to complete themselves. Their need to complete themselves serves merely to give these activities their impetus. The activities are enjoyed on their own terms. Each yields products having their own structures, problems, values, and demands.

Nothing is beyond the reach of man's mind. By means of it he conquers all there is, subjecting it to his conditioning, grasping the import of things even before this has actually been displayed. The past is gone, closed to all influence and change; but it is open to knowledge. The future is not yet, it is beyond us, outside our grasp—unless we put our minds to it. The vast reaches of space, the interiority of things and man, the nature of God, the course of the cosmos, are there for man to make his own through idea, category, and systematic understanding. Irresistible, omnivorous, limitless in range, topic and intent, knowledge nevertheless fails to deal with the world in its concreteness. To know is to master the world in principle but not in fact; all continues to remain outside, unaffected as before. The mind of man implicates the world in ways otherwise not possible, but all the while that world continues to move along its accustomed paths, at its own pace and in its own way. The strategy of mind is to deal with meanings and thereby achieve universality and comprehensiveness, but the price it pays is that it gets the conquered world in a form that is irreducibly abstract.

The full-fledged ethical man dares more than he who would merely know. He makes an effort to realize the good, to make it concrete, embodied everywhere. He tries to change things so as to give a footing to the good, seeks to conquer what is outside himself and others by penetrating into enemy territory and making this over in the light of the obligating good. But he knows too little, has too little self-control, has too few things he can hold steady enough and know well enough

to be able to make them carry the good they need in the form which would perfect them together with the rest. He cannot possibly complete himself by following the ethical route alone. *and will err in*

The religious man takes a different tack. He seeks to ally himself *The* with a being which is supposed to be complete and which has the power *pro* to, or in fact does, possess the world. By worship, prayer, by sub- *cess* mission and identification, he seeks to share in that perfection and mastery. His goal is to be one with God. For him this is to be as complete as it is possible for man to be. He has faith that he will eventually attain this goal, but he does not really know whether this will be the case or not. Some of us tremble on the verge of saying that we really know that God exists and what it is he wants, does, and will do. With relief at times we readily confess abysmal ignorance—and then as surely we gladly turn from this dogmatic doubt and once again affirm what we think we see to be the very ground of truth. The mature religious man is an uncertain man, restlessly tending towards a blinding, joyous acceptance at one time and a blind, terrifying disbelief at another. Those who have hidden from themselves the doubt that striates the strongest faith, cling firmly not to a religious but to a psychological answer to their needs. They deceive themselves in order to continue to believe. But the genuinely religious man believes in the face of, in the sullen presence of a sickening, despairing, unhappy disbelief. Because, even when most intimate, his God is strangely remote, because he does not know just how divine power is used, or how he can surely make it his own, and most important, because the world seems to be just as obdurate and alien, and he just as weak and incomplete, when he believes as when he doubts, the religious man must supplement his characteristic effort to be complete, by thought, ethics —and art.

In art something is made. This can be done only by dealing with what is other than oneself. Art, unlike thought and religion, demands work; unlike ethics it changes things radically in terms provided by the artist and not merely by some distant, abstract ideal. The artist struggles with the world; he masters his medium, material, brute realities. Did he do this and nothing more, he would conquer but the tiniest fraction of what there is. But he brings his feelings, his emotions, his

very substance into play, thereby turning that which he makes into a world that can stand in place of what threatens and defies. What he makes is a better world in some respects, for it is more excellently made, and more attractive. In his work and through his work he cuts behind the randomness, the irrelevancies, the contingencies which confront him on every side, to get to the very heart of things. He masters existence by conquering a part of it and making this part represent the rest. The glory of art is that it creates a world in which men can live in a better and more satisfying way than they normally do.

Like the thinker, the artist makes a world which encompasses the essence of what lies outside; but unlike him he actually possesses here and now some part of what lies beyond him. Like the ethical man he changes the world, but unlike him he does this as a radically creative being. Like the religious man he seeks a satisfaction which nothing less than the entire cosmos could provide, but unlike him he gets his result here and now. Like all the others, he too fails to master the world in its concreteness and full sweep. But he does produce another world inside which he and we can live for a while.

Man's art, like his thought, ethics and religion, is a strategy, a way of conquering reality by an indirect route—and thereby failing to get what can be had only in a direct encounter. Man's fate is that he must eventually return to that world which his art put aside. It is man's good fortune that he can return along a path which he creates through his art. He then finds that the world which was left behind for the sake of art has, through his immersion in the world of art, been somewhat mastered and become better known.

hands on life – the Body

3. SCIENCE AND ART

THE current climate of opinion is favorable to art. Few think and even fewer say that religion should have a higher status than art; most would allow art to have some rights over against ethics and politics. The main concern of philosophers of art and philosophically tempered critics today is not with these topics but with the challenge they take science to present to art. The great technological advances, the magnificent cosmological theories, the vast regions of space and time with which science deals, its precision, predictive power, international communicatability, clarity, and coherence, its claim to know with surety, and its capacity to elicit agreement from many independent, highly intelligent critical workers have made it stand out for many as man's most signal achievement. They take it to define or present the real world and to demand that everything else be treated as a tissue of confusions, as a distortion of the real, or as a sheer fiction. Art in particular, with its appeal to the emotions, its sensuousness, its nationalistic and cultural roots, its constant change and revolutions, its individualistic practitioners, bitter quarrels, comparative imperviousness to the intellect, neglect of formal clarity and precision, and its lack of clear, fixed, and universally accepted criteria of excellence, offers us, it is thought, no truth, no reality, no belief—nothing more than pleasure or relaxation. One might be able to defend it when it provides a needed interlude; one must condemn it when it intrudes, offering unwanted distractions and thereby making us neglect the more masculine pursuit of knowledge, cold eyed and steady.

This thesis is grounded in misconceptions, not only of art but of science. A proper comparison between science and art is not possible until some of the major claims made on behalf of science, which lie behind these misconceptions, are reassessed. The task requires one to return to a consideration of that common-sense world from which all

our disciplines originate and from which none can ever wholly depart without losing all contact with the concrete, the familiar, and the reasonable.

At every moment we are confronted with the faint and almost clear, the sensuous and the nonsensuous, the commonplace and the surprising. Ours is a world which, pulsating with activity in one place, is almost quiescent in another. It is a mine of difficulties, a tissue of recalcitrant beings and problems. There are no clear finished truths to be found in it, merely awaiting a perceptive reader. It is a world shot through with mystery, and one of the main works of reason is to make it intelligible.

Each being in the universe raises questions by the very fact that it is a being among beings, a reality in time, the locus of a promise partly fulfilled and partly unrealized. Because we are both human and existent, we cannot avoid facing and trying to answer the questions which we ourselves and everything else raise by the very fact of being. Our desire to be at home in our world makes desirable a knowledge of it. This in turn makes it desirable to possess answers to the questions which the world daily and everywhere presents.

The questions raised by nature are specific, and it is essential that we answer them on the level on which they are asked. Our very lives depend sometimes on our ability to know what this particular river is about to do, how this animal will spring, where this blow will fall, what the immediate response of the listener will be to the words we now utter. We cannot avoid specific issues; it is vital to our physical and mental health that we make an intelligent decision as to just how the particular problem we now confront could be resolved most satisfactorily. But we then must deal with it not only as specific, here and now, but as general and universal.

There is no more satisfactory way of meeting the problems of daily existence than by resolving them here and now in such a way as to provide for all similar cases. It is good to know that this river will overflow and that we ought to get out of the way now; it is better to know in addition how any river might behave, and how to build dams so that there will be no further overflows. It is good to know that this animal is about to spring; it would be better if one could know in ad-

dition how other animals might act in similar circumstances, and how to domesticate them so that there would be nothing more to fear. The more practical a man, the more comprehensive his answer and the more is it designed to prevent similar problems from arising in the future.

This much perhaps would be granted by even the most ardent pragmatist and naturalist. They do not desire us to lose ourselves in momentary and local issues. They do not want us to blind ourselves to wider questions, so long as these are pertinent to the lives and well-being of men. They tell us to free ourselves from the particular situation in which we now are and to try to see our present problems as typical or revelatory of what else we might have to confront. But they are quick to remark that there is a point where generalized knowledge will cease to provide an answer to a host of related and specific problems and will instead become irrelevant to any. Just what that point is, they never say. They do not say where it is because they do not know where it is. And they do not know where it is perhaps because there is no such point.

It is merely an article of faith that there is a point at which general truths are irrelevant and useless. Such questions as whether or not there are fixed laws in nature, whether the future is already determined, whether causation is a universal phenomenon, are highly general—indeed, cosmic in reach. Yet they have relevance to what we are to do with the river and the animal. We can get along without such general knowledge for quite a time, but only if we are content to risk facing each problem only when and as it arises. But then we will be far from prudent; we will not be open to the teachings of experience; we will not be very worldly wise.

As common-sense men we must and do deal with items and problems of universal import. The more interested we are in specific items and problems, the more surely must we master the more general topics of which these are but specific cases. To be most just to the concrete, we must be aware of what is abstract. To deal most adequately with the specific we must look to the general. The practice of the wisest men of practice is to encourage and make use of theory, to seek knowledge which can be utilized everywhere and always.

General knowledge is indispensable. If we dismiss such knowledge we dismiss a good deal of science. Scientific knowledge is general knowledge. The scientist is not primarily concerned with describing this fall, that stone, or these trees, but falls in general, the nature of stones, the essence of trees, of which instances are to be found here and there. Most thinkers today would perhaps grant this much. What many would question would be the supposition that any other or more general knowledge than that provided by the sciences was possible or desirable. Were they right, any item of supposed knowledge which was outside the interest or reach of science would have to wait until science was ready for it, or must be denied significance.

A number of reasons have been advanced to justify the disposition to accept only scientific knowledge as worth-while. Scientific assertions have predictive force, enabling all to check their truth; where reliable, those assertions help us to anticipate the future. They are accepted by all competent workers so that agreement and cooperation rather than disagreement or isolation is the order of the day. Scientific truths have great utility, providing principles which enable us to improve our technology and resolve specific problems. It is the sciences which separate the superstitious and illusory elements in common-sense views from those which are objective and real, bringing order and system as a consequence into what we daily know. Scientists frame their assertions in precise and communicable language, thus stating what is definitely true or false and what can be communicated to every normal man. Philosophy, art, history, religion, and the "social" sciences, it is said, do not predict nor provide an opportunity for checking their assertions; their practitioners are evidently at odds with one another as well as with almost everyone else; they offer few truths which have any obvious relevance to living practice, to the world as daily lived; they take common sense too naively or produce schemes too alien to what we know in daily life; and they make use of metaphorical and private languages having reference to no encounterable objects.

Could the contrast be sustained and could it be made to cover the essential parts of science and the humanities, it would be reasonable to maintain that the only general knowledge that was desirable would

be that obtainable by scientific methods, or which was compatible with or reducible to whatever else the sciences affirm. However, were it true that the contrast cannot be sustained there might still be a great difference between the two kinds of inquiries.

Not all sciences predict. Descriptive anatomy and botany do not. On the other hand there have been successful predictions made in economics and politics. Still, scientists usually do seek to clarify what is encountered so as to anticipate what else might be known, whereas philosophers, artists, many historians and some theologians do not anticipate, have no desire to predict. Where the scientist, as a member of a team engaged in an accumulative investigation, turns to nature to determine the value of an hypothesis, these others act as individuals, offering new ways of looking at the world. The different enterprises differ in aim; that is why they differ in methods. But not until one disqualifies the interest or shows the inadequacy of the chosen method to bring about its intended object can one disqualify either enterprise, or show it to be inferior to the other.

It is common to speak of scientists as being in agreement. Any issue of a scientific journal makes immediately evident how mistaken this view is. On the other hand, it is a fact that philosophers agree with one another; artists often do; the members of a religion are pledged to be in harmony. All of them form groups whose members repeat the same shibboleths, accept the same canons, attend to the same works, and ignore much of what is done outside. When members of those groups war with one another, they meet on a common field; they accept common theses most of which are unnoted until after the smoke of battle has cleared away and the result viewed from the perspective of history. Spinoza and Leibniz criticized Descartes, and all three of them stood over against Locke, Berkeley, and Hume. But we see now how closely in agreement all of them were. Plato and Aristotle were often opposed, but that they were Greeks, sharing common views regarding workmen, the state, the glory of philosophy, and the value of knowledge, is evident in all their writings. Hegel was at odds with his fellow-idealists, but it is hard to see much basic difference between his views and theirs unless it is in brilliance and completeness. The classical Dutch painters were individuals, but we see now that

they make up a school. Protestants belong to many sects, sometimes in violent opposition, but they have features in common, marking them off from other Christians. Together with the Roman Catholics they stand over against both the Hebrews and the Muslims. All four of them share features not to be found in any of the Buddhist sects. Russian and American biologists are less in agreement than are Russian and American philosophical idealists, dancers, musicians, or religious men. There are of course differences among the latter, just as there are among the scientists; and there are agreements too among the scientists, just as there are among the others.

There are sciences, finally, which have little or no utility. Descriptive astronomy, particularly when it deals with far off galaxies and the chemistry of rare earths have little bearing on men's lives. That these interest the scientist is testimony that what concerns him are problems, not the possible benefit his inquiries might produce. Art, religion and philosophy on the other hand do make and have made great differences in men's lives. A three-fold contrast between the humanities and science, based on supposed differences in predictability, concord among workers, and utility, cannot be steadily maintained.

Both the sciences and the humanities have worthy procedures and aims. But it might still be urged that those of science are to be preferred, and particularly over against those of art. It has sometimes been said that science alone deals with the real, that it deals with it better, that it alone says what is true, or that it says it better than art or any other enterprise can. Thus, it has been claimed that the sciences help free us from superstition while the other enterprises even encourage men to accept unwarranted and untestable beliefs. If this could be made out, the case for preferring science over all other enterprises would be immeasurably strengthened. But I think this cannot be done.

Although superstitions which torture and distort the minds of many men have been punctured or dismissed by scientists, men still take medicaments which have been shown to have no medicinal value. They firmly believe in demonstratably unworkable schemes for beating games of chance. Some have an unwarranted fear of the number thir-

teen to such an extent that skyscrapers built for balanced, practically minded men have no story numbered thirteen and no room with such a number—and this despite the fact that there is a thirteenth story and a thirteenth room which they happily occupy.

The illustrations are not important, and in any case they are but a sample of those available. Taken literally, such superstitions are tissues of fallacies and falsehoods. But taken metaphorically, or as they function in the lives of men, they often have much to say for themselves. Quite frequently they express profound truths which ought never to be forgotten. It is well known, for example, that some savages erase the names of their enemies, burn them in effigy, or stick spears into their replicas. Some of them—for there are fools and idiots in every society—might thereupon conclude that their enemies had been destroyed. But most of them seem to conclude that they themselves have thereupon become strengthened, or that the enemy, if he hears of the act, is weakened. Their view is sound. If you believe that a certain act will weaken or strengthen you, you are likely, after having performed that act, to have less or more strength than otherwise. The most confident of men soon becomes downcast if told often or forcefully enough that he is looking run down—particularly when these statements are accompanied by some public act testifying that others agree. The superstitious man, of course, is mistaken in thinking—if he really so thinks—that the act in which he is engaged is relevant to the desired result; that it, in fact, produces it. He is not necessarily mistaken in thinking that the act will prove effective, since a superstition believed and acted on will often cease thereby to be a literal error to become instead a vital truth. The belief in the efficacy of an act occasionally makes it possible for the act to be efficacious; the very expression of an attitude sometimes converts an object into one which deserves the treatment that the attitude prescribes. If it were the intent of science to dismiss all superstitions, it would mistakenly try to take activities out of context and would thereby lose the sense in which those superstitions express a truth.

Until we have a scientific account which entirely explains whatever we are trying to understand, we cannot claim to have scientific reasons for supposing that some types of acts are always irrelevant for a

given purpose, and that the performance of them for that purpose is the expression of a superstition. Since every act, every thing, every motion in the universe has some repercussion on others, we have a clear right to term superstitious only those usages which invoke unknown powers when an occurrence could be fully explained without reference to them.

It is not a scientific truth, but a philosophic view acceptable to the sciences, that nature is self-sufficient and that what goes on there is never affected by the decisions or activities of spiritual beings, whether they be human minds, angels, demons or gods. The scientists and the philosophers whose views sanctify science may be—and in the one instance of the will are—mistaken if they assert that there are no spiritual influences. Since it is not the business of science to say whether or not there are spirits, either inside or outside man, and since in its present state science confessedly does not understand how the mind works on the body, science cannot tell us if a belief in the efficacy of spiritual agents is really superstitious. To know that much, we need to encompass the whole scheme of things and then learn to what degree nature is closed to mind and other spiritual forces.

There are facets of the world we cannot adequately observe and others which we cannot grasp in formulae or probe by means of instruments. Some truths are best expressed in metaphor; some realities are best controlled through communal ritual; some sides of the cosmos are most effectively reached through creative or ethical acts, or through speculation or worship. If we say that we will reject or ignore them because they are not knowable by the sciences, we will be bound to reject a good deal of science and a good deal of reliable experience. Electrons and protons, positrons and neutrons, curved space and fields of energy, for example, on which so much of physical science rests, are not observed or even observable. It is true of course that they are intelligible and that a belief in them is justified on the basis of what we can observe. But it is equally true that spiritual powers are also intelligible and that the data of experience leads to them, if not in the sense in which primitive and unreflecting men suppose then in a sense which is a refinement of theirs. Common sense is crude science and crude philosophy; it observes carelessly and reasons loosely. But

still it does observe and does reason and does come somewhere near the facts at which developed inquiry terminates. It is not a question of black and white, of superstition and stable belief, but of more or less, of incorrect assignment and sharpened, corrected judgment.

We are making incantations in the name of science when, in the face of direct experience checkable by every man, we deny that there are "frightening," "threatening," "intriguing," "tempting," "pleasing" things. The dark and unknown are frightening. We are urging a theory and not a fact when we say that they are calm or indifferent and that we, when frightened, project our fright into them. It is arbitrary to claim that all such characterizations express the result of a man's subjective attitude toward that which has no such nature under any circumstances. Not only is the supposed act of projection not observable, but what we confront is confronted as frightening before we have had time to reflect, project, or construct. The dark presumably is not frightening when men are not present. Its character as frightening apparently presupposes a special attitude on their part. Whether this attitude makes the dark actually frightening or whether it merely enables one to know a dark that is frightening in itself is an open question. But in either case the dark would in fact be frightening, in the one case as something known and in the other as something knowable. We have no more right to deny a frightening nature to the dark because it is evident only when men attend to it, than we have a right to deny that a man is listening because he ceases to listen when a speaker stops talking.

If we rid ourselves of what is not sanctioned by science, we limit our horizon unnecessarily. In the last resort we make science itself impossible. In fact the very kind of evidence which supports science, common-sense evidence, is at the root of superstition as well. If we reject this evidence we will have nothing on which to ground our scientific conclusions. The evidence for the existence of positrons and neutrons, for example, is provided not by the senses but by inferences drawn from common-sense observations of photographs, scales, chronometers and the like. If we have no right to accept anything but the refined results of the sciences, say calculations about gamma rays and protons, we will by that very fact have no right to the evidence

which alone warrants the conclusion that there are gamma rays and protons.

We cannot, we ought not, to look to science for the removal of all our "superstitions." A good number of them are grounded in beliefs beyond the province of science to test. Some of those which science might be tempted to puncture or dismiss intend a truth though they literally state an error and should be refined rather than rejected. And the kind of observation on which such superstitions rest must be acknowledged even by scientists to be indispensable, reliable, and worth while.

On the other hand, nonscientific pursuits are in a position to acknowledge fields of data that science ignores. These pursuits need not yield to superstition. They, no less than the sciences, can free the beliefs of common man from a good deal of error. Like the sciences they too can take common sense seriously; they too need not follow it slavishly. But what they assert must, in the end, be in consonance with what common sense affirms.

The observations of common sense are not to be accepted without reservation. Nor are they to be dismissed merely because they do not fit into some favored scheme. They are to be rejected only if they are internally incoherent or can be shown to be out of focus in the light of a substantiated system of all that could be true.

If we are to have stable and reliable knowledge, we must refine the crude knowledge of common sense. Science offers one way of doing this. But we should also make use of other means, particularly if we are to understand spheres of existence beyond the interest or reach of science. It is the task of both scientific and nonscientific inquirers to free us from error, the one doing it in one way, the other in another. Neither suffices by itself. Each needs the protection of the other in order to make sure that some of the things maintained by common sense ought to be eliminated, and some of the things unknown to common sense accepted, because they belong to the whole of what is true and ought to be known. To bring all knowledge into one harmonious whole, we must have recourse to a speculatively achieved view. This relates to what lies behind all special inquiries, and helps prevent any one of these from obscuring the light of the others. The speculatively achieved view looks at all beliefs, common or specialized, from a van-

tage point which requires all of them to be justified, but not necessarily only by the means which the established sciences provide.

Both science and the humanities, then, are opposed to error. Both do much to free us from it. Both accept some common-sense data. Both would deny themselves if they reject the data which warrants the other. A defense of the possibility and worth of science is in part a defense of philosophy and other inquiries as well. And the converse is also true.

But it might be said, "The language of science is precise and is available to all. Other subjects speak in metaphors and then with an emphasis and stress which varies the meaning from man to man." This contention, though, like the previous one, is not altogether justifiable. So far as what it claims is true, it in fact shows that there is something more to be known than could be known by the methods of science. It points, in other words, to a conclusion opposite to that which it was intended to support.

Physics, certainly on its elementary levels, is precise, predictive, and universally knowable. But physics is not the only science. Nor are those disciplines which put their expressions in quantitative terms the only ones which are entitled to the designation "scientific." Chemistry is a science; so are biology, astronomy, geology. Yet none of these is wholly or merely quantitative. The chemist remarks on the colors of his compounds, the botanist and the astronomer classify, the biological unit is the observable cell, the geologist has no hesitancy of speaking of faults in rocks. Each uses notions which have not been quantified completely. No one of them is so precisely expressed that no diversity of understanding is possible.

The language of the sciences is not as precise as it is popularly supposed to be. On the other hand, the terms and grammar of other subjects are not as loose as their critics say they are. It is possible for fellow workers in nonscientific fields to understand one another, to agree and disagree on a given issue, and it is possible for them to teach and communicate what they have discovered. Terms like "the historic past," "beauty," "truth," "prayer" are not in the vocabulary of the accepted sciences. Yet in their appropriate contexts they have an appropriate precision.

Where a topic is complex and has multiple facets presenting a host

of problems, what is needed is not an expression which dissects it and arbitrarily limits the field, but a characterization which roughly marks it off from others and allows for the possibility of conquering it from many angles. If we use only those terms which the sciences have made precise in meaning, reference, and use, we will not be able to locate the common-sense world from which those sciences issued and to which they may refer. If we want to deal with the world as experienced and with every kind of question it might raise, it would be wrong to prohibit the use of the very terms which, though metaphorical and in some respects vague and undefined, point to that world and no other.

The languages of the sciences are more precise than those of other subjects, and particularly of art and philosophy. Scientists can now state more precisely than ever before what they mean by genes, electrons, elements, gravitation, but artists and philosophers seem to be just where they have always been. On questions relating to beauty, creativity, the soul, substance or divinity, men today seem to be at least as incoherent and obscure as they were in the past.

7. Part of the advance in precision on the part of scientists is due to the fact that places where they could not obtain a desired precision were abandoned by them. Also, the sciences abstract from the concrete, the individual, the private, and substantial—and sometimes even from the sensuous and observable—to end with terms which are tissues of universals capable of complete and exhaustive analysis and definition. "Electron" means the same thing for a host of scientists in part because what is intended by the term is not a concrete entity but the universal "electronicity"—the character which all electrons share and perhaps exemplify in diverse ways. Like every abstract universal, "electronicity" is capable of sharp definition; but like every other universal it does not reveal anything about the individual natures and specific differences which distinguish one electron from another.

He who is willing to ignore the individual, indeterminate or substantial nature of beings can make his discourse in other fields as precise as that of the sciences. The classical economist is a case in point. He has few friends, not because he is too vague but because he formulates his principles and conclusions with too great a precision. What was wanted of him was not a knowledge of the way in which an abstract or

The Neglect of Chaos

ideal "economic man" might behave, but a knowledge of the character of a concrete economic process which could not be obtained by manipulating the economist's abstractions. Descriptions of the exact course of individual events in the world, like sensuous portrayals of the real, require the use of elements which are more flexible, more comprehensive, and more emotionally palatable than those which the sciences employ. Those who are interested in such descriptions acquire knowledge despite an inability to express themselves except in metaphor or by reference to qualities or impressions.

Science, it is also sometimes claimed, alone is coherent and intelligible. It alone is supposed to be disinterested, disowning the flavor of words and concentrating on the pure, nuclear, distilled meaning of terms. Its counters are said to be duplicable and fixed, well-defined elements which keep their meanings in context after context. Primarily concerned with concepts and not with feelings, enjoyments, qualities or impressions, it is said to ignore the emotional aspects, the music, the psychological associations, the ineffable tonality characteristic of other modes of communication. Putting aside the fact that psychological associations, emotions, and tonality intrude into the most austere and abstract discourse, and the fact that artists communicate quite well with others in quite distant places and with large groups of spectators, there is some truth in this contrast. But it shows merely that science follows a different method from the others; it does not show that it either gets more or less of the truth than they. An artist reads into his product the alterations which must be made in order to have his work relate to the world beyond. The alterations which a scientific discourse requires are not mentioned in it; they are provided by the instruments that are used when scientific formulae and hypotheses are made pertinent to something experienced.

A related point is made in the contention that science by making use of true universals, the only items that can be properly dealt with by the intellect, alone can hope to be universally understood. Only it, it is said, can provide knowledge free from the limitations and emphasis that the senses and emotions inevitably impose on observed material. Only such knowledge can be communicated; only this can be grasped by a multitude. The supposition is doubly questionable. First,

though the same universals can be known in the same way by many intellects, each intellect is rooted in an individual body and grasps things in a different way. The same content has a different meaning for each. Second, the senses and the emotions offer us content which is one with the content others confront. Both points require some elaboration.

All men may be able to understand the definitions and usages which the sciences give to their basic terms. But that knowledge alone will not suffice to make them scientists. The knowledge must be supported by common habits of response and work. The reason why scientific truths are universally intelligible is not simply because they make use of universals but because individual scientists, despite the different weights which these truths have for them, are habituated to respond to them in common ways. In the same sense, the language of carpenters is also universal; even though they have no commonly accepted names or definitions, they view wood and their tools in similar ways at similar times.

A truly universal language presupposes either a set of habits in the respondents which enable all of them to isolate a common meaning in diverse contents, or the use of terms in such a way that they prompt individuals to so respond to different meanings that the outcome is the same for each. Science follows the former procedure. Other subjects follow the latter; they use a universal language in that they say different things to different men with a corresponding difference of appeal, thereby enabling the different men to know a common truth.

There is of course a difference between the languages of the sciences and other subjects. The sciences use a comparatively cold language, a language about the nature of things as they might be when all human interests, preferences and insights are suppressed; the language of the others is warmer, more subjective, humanized. It is not enough, however, to be concerned only with those truths which can be universally acknowledged. Since the language of science expresses the least common denominator of knowledge, the aspect of things which anyone could affirm at any time, it can provide only a minimum of content. But then, since some men are capable of noting things which others cannot, what the sciences report cannot be all that there is to know. If we try to deal only with that aspect of things which every man can

affirm, we run the risk of denying the truths that men of genius and sudden insight can reach. Artists present truths in a guise which most men fail to see. That does not mean the artists are mistaken; on the contrary, those who take account of what the artists portray learn truths they never knew or otherwise could have known.

There is a sense in which all men could be said to have a knowledge of things not expressed or expressable in the sciences. The senses and emotions provide them with content which, though differing from individual to individual in specific nature, is as common and constant as it is vague and general. Though Tom may see red where John sees blue, both see a color and not a set of vibrations. If we ignore such content, we leave out the most reliable data we have about the nature of the real so far as this can be gleaned through perception.

The sciences are not as precise as they are supposed to be; nor strictly speaking are their languages necessarily or exclusively suited for universal communication. The sciences are precise to some degree; inside the frame of special habits and customs they speak a universal language. But a comparable precision and universality is evident in other disciplines as well. So far as a science neglects or rejects what cannot be made to conform to its ideal of a precise and communicable expression, other subjects must be brought to play on the facts so that full justice can be done to them. Supplementing what is open to dispassionate thought, the quantifiable and duplicable, is the concrete, the unique, the qualitative, what is open to men of insight. The truth is all together, only fragmentarily grasped in any inquiry whose reach is less than the whole of things.

Science and other disciplines are then closer in nature, topic, objective, method, value and truth than is currently supposed. All take their start with what is experienced. Science, unlike the others, tries to find intelligible links between the various parts; the others try to get to first principles or to create what none can adequately cognize. No less than the others, science turns away from obtrusive reality to construct a world that never was encountered, but unlike them it does this in order to forge fruitful ways for interrelating phenomena, thereby making it possible to explain and control them.

A sharp contrast can be made between science and art if one at-

tends to the way they reach their truths. Scientists tend to make distinctions, refine divisions, use sharp and steady definitions, whereas the artists are inclined to encompass, unify, merge, bridge, combine. But if truth means, as it does, the conveying of the intent of an entire situation, of its general import or meaning as well as of the structure and interrelation of its parts, then art must be said to convey truth as surely as science does. A work of art is a unified, substantial whole representing a world beyond. Its various parts interpenetrate to function in it in ways quite different from the ways they function in ordinary life. An interpenetration of terms, though, is not altogether alien to science as a whole. The assertions, experiments, and contributions of individual scientists are so many words in a single, organic, creative discourse engaged in by all the scientists together. Their total work constitutes a single whole, having a value somewhat analogous to that which is provided by a single artistic work.

Science, taken as one enterprise, is a cooperative discipline involving the employment of many independent workers. These provide the focussed terms, phrases, and occasional lines which make up the final single "poetic" discourse of science. The artist, on the other hand, though he does attend to the tonality of his items, does not build up his unity in terms of these alone. While taking some account of the meaning of his words, the natural affiliations of shapes, positions, textures, colors and sounds, he uses them in new ways to create a new syntax, thereby making it possible to tell a story which cannot be heard if one keeps too close to the relations that its terms have with that odd miscellany which makes up this world of ours. He alone is able to convey the sensuous nature of the basic reality which common-sense obscures and from which science abstracts.

Scientific workers are constantly helping one another. This is a signal fact about them, setting them over against the students of the humanities and particularly artists. Artists are strikingly individualistic, not very cooperative—though without genuine cooperation there would of course be no theatre, no opera, and little architecture, music, or dance. Artists may pool hints and suggestions, but they rarely add to one another's knowledge or production. Even inside a school artists function more like a colony of concurrent workers than

as an integrated body of men, mutually supportive. Their works do not form a systematic whole. Scientists, in contrast, add vital units to one another to build bigger than they know.

Close cooperation and a common outlook are desirable in science but not necessarily in art. Since art is not trying to do what science is doing, it would be foolish for art to accept the conditions for work which are essential to science. The converse is also true. Nor does it follow that if art does not conform to the conditions to which science submits, it cannot lay hold of reality or that it cannot convey a truth. This would be the case if reality is only what science can convey and if truth can be had only in a scientific way—the very questions at issue.

In both science and art there are innovations in techniques. These relate primarily to the craft aspects of these enterprises. The current doctrine tends to exaggerate the place such innovations have in art and minimize their importance for science. The making of microscopes for the first time, the use of new surgical instruments, the grafting of plants, differ only in locus and purpose from the innovations of artists in the use of new materials and media, in the way to make and preserve paint, and so on. Artists tend to make their innovations integral to the production of their works; the scientists take them to be essentially preliminary, more like the finger exercises of the musician or the practicing at the barre of the dancer than they are like the usages of the full-fledged performing artist. Nevertheless science is interested in great innovators, perhaps because their achievements so signally affect the instruments, habits, experiments, outlooks, and lives of great numbers in a rather short time. Since the artist allows less of a break to occur between preparation and achievement, between what he takes to be instrumental to his art and the art work itself,* than the scientist does, he is more ready than the scientist to make the great innovations an incidental part of the entire work.

It is perhaps primarily experimentation that is at the focus of the attention of those who insist on making a radical distinction be-

* The innovations of doctors are closer to the innovations of artists than they are to those of scientists. The improvisations of a dancer are like the practice of the doctor; they are part of the work itself. The practicing dancer does not of course perform in public; the doctor unfortunately doctors while he practices.

tween art and science. Science alone, it is thought, experiments; it alone therefore can learn what is and is not the case. But art makes no experiments; it merely weaves idle fancies together, making no claim to be true of anything at all. This contrast is forced and largely mistaken. Not all scientists experiment. Theoretical physicists do not; astronomers and many botanists do not—unless by experiment one means a constant process of exploration, modification, reorganization, a trial and error use of means and procedures in the attempt to get to some desired result. But such experimentation is also to be found in the arts. The tentative tacking back and forth in an effort to resolve a difficulty or problem is characteristic of all probing men, scientists and politicians, artists and philosophers. For every color applied to canvas, for every form cut in metal, for every incident marked out in a story, another must be altered or replaced. That modification might require a return to the beginning, which must be changed in the light of what had just been done. Art is as much re-making as making, retreat as advance, more trial and error than clear purpose made evident.

The scientist tends to allow the world to set the conditions for the type of result which is to be achieved. His experiment is primarily a way of enabling nature to answer his questions. The material with which the artist deals has its own nature and rationale; no less than the material which occupies the scientist, it is brute, objective, to be molded but never entirely mastered. But the artist insists on being in control; he experiments with the very material which is to provide him with his product. Indeed, it would not be amiss to say that the artist is even more of an experimenter, even more empirical, than the scientist. For it is the artist, not the scientist, who loses himself in the activity of manipulating material then and there available. Experimentation for the artist is a way of finding out the promise of the material, his own capacities, and the kind of transformation his intentions must undergo in being realized. What he elicits from his material is incorporated in the object he produces. The scientist instead tends to experiment just for the sake of getting clues to what lies hidden.

Each work of art is an experiment in that the desired result is in good measure achieved by trial and error. It is not, however, an experiment in the scientific sense of a designed set of traps and sluices

through which nature may be led and thereby made to yield results not otherwise knowable. Scientific experimentation is concerned with means for the effective evidencing of nature's ways; artistic experimentation is concerned with means for the effective production of an artistic whole. This is an important difference between the two disciplines. Another is that the scientific experimenter usually has a definitive question to put to nature. The artist in contrast has a not clearly-defined outcome which he desires.

The scientist, though concerned with what he experiences, looks beyond this for the laws and forces which serve to bind the phenomenal world into a cohesive, intelligible realm. The artist, though primarily concerned with grasping the subterranean aspects of reality, confines himself to his material. He adumbrates what lies below by reorganizing what lies above. The attempt of the scientist is to cut through incidental particularity to the laws and principles which the particulars illustrate, and to the presumed elements in terms of which phenomena can at least in theory be transformed into one another. As we saw, it is not necessary that he express his principles or elements in quantitative or mathematical terms. These are but agencies making possible easier deductions and more precise expressions of what is to be expected if such and such modifications are imposed on such and such phenomena. But in the end the scientist would like to express himself in precise terms, and if possible in formulae having a mathematical form. He is more speculative than the artist, more ready to leave the phenomenal world behind in order to express laws and isolate the elements which provide phenomena with their explanation and ground.

He who attended to science alone would know what is real, but he would not make contact with it in its concreteness; he who attended to art alone would grasp the real, but he would not know how to make this evident to an inquiring mind. From the standpoint of science, art exhibits an over-sensuous world, outside science's interest and beyond the reach of its methods. Art from its side sees science as presenting reality in an over-formalized guise. When it is said that art is just a tissue of fictions or that science is empty and futile, it is usually because one has mistakenly taken science or art alone to possess the truth.

The most accurate way of relating art and science is to view them

outlines

as supplements, not as correlatives. Arts conform to the laws science seeks to discover. Science rests on the foundations art discerns. Art is more philosophical than science, science more valuable for practice. How science goes about its task, what its hypotheses are like, what kind of results it can produce are matters best seen when its work and objectives are contrasted with those of others. Only when this is done can we attend with some surety to what art is, says, and does. To these matters we must therefore now attend.

4. EXPERIENCE, SUBSTANCES & REALITY

PHILOSOPHIES of art are rarely written by artists. Usually they are the works of philosophers who have not spent much time producing works of art. But many philosophers of art have given a good deal of time and attention to the productions. Consequently, their studies tend to deal with art from the position of a spectator rather than from that of a creator. And quite soon they turn away from the very objects they were intending to study to discourse about the nature of judgment, the principles of evaluation, the use of aesthetic terms, and similar matters. Since theories of judgment, knowledge, and discourse have for the most part been developed in order to do justice either to the claims of common sense or science, it is almost inevitable that they will fail to provide the categories and distinctions needed for an understanding of art. Most students of art who have made an effort to deal with art from the standpoint of its creators or at the very least in terms which are primarily appropriate to art, have therefore had to ignore the philosophic studies, with their bias towards common sense and science. Unfortunately, students of art have usually accepted the philosophical claim that science and common sense alone yield unvarnished truth. Consequently these students have, with the philosophers, spoken of art as being incapable of providing knowledge and as offering instead only pleasant illusions or agreeable expressions of feelings or emotions. Even ardent defenders of the arts have spoken of them as loci of paradoxes, as tissues of symbols and forms, and as exercises in self-deception. Though they speak well of these paradoxes and illusions, such defenders of art actually ignore an essential truth about art—its capacity to convey, better than anything else can, the import that existence has for men. To see this we must turn away from the traditional discourses, not only of philosophers but of students of the arts, and make an effort to

see just what the analytic components of a common-sense object are, what these components portray, how they together can constitute realities, and how the existence lying behind and permeating those realities is grasped through art.

The borders, content, and even the salient features of the common-sense world vary from place to place, and from time to time. Shifts in interest, habit, the pressure of tradition, language and technological needs, new discoveries, and prevailing myths all contribute to the changes which that world undergoes. What we now take to be the common-sense world is not altogether identifiable with what Aristotle, for example, accepted. It is hard for us to look at the stars without seeing them as having tremendous magnitudes and as being at great distances in space and in time; it is hard for us to see the ethereal, regularly moving, not too distant perfections which Aristotle acknowledged. To know what is true in his or our common-sense view, it is necessary for us to know the essential components of common-sense objects. This will enable us not only to free those objects from the assumptions and conditions read into them in a given historic period, but will at the same time enable us to free ourselves from the temptation to confound familiar common-sense objects with the abstractions derivable from them, or with the beings which reflection constructs or art produces.

The common-sense occupants of the familiar world of which we unreflectively take account are somewhat inchoate. But we can distinguish and isolate four dimensions or *strands* in them. A common-sense object is a *perceptual*, actual entity, something at once sensed and judged; a timeless, *scientific* entity, exhibiting mathematical and other formalities whose acknowledgment makes clear the causes and effects of whatever exists in space-time; an existential, *eventful* occurrence, a stretch of vital movement in which beginning and ending are, though separate, inescapably interlocked; and an ideal *important* value, reflecting both our sense of excellence and the presence of an objective standard outside us and unaffected by our interests. On some occasions one of these facets may be to the fore; on other occasions it may be so recessive that its presence is overlooked. But all are present in every common-sense object, merging one into the other. To

focus on any of them one must dissect and abstract from the common-sense object, thereby purging the strand of irrelevancies and enabling one to carry out an inquiry concerned with it alone. A unity produced by conceptually uniting the various purified strands refers to a being which is more real than any of those strands or the common-sense object from which they were abstracted. But it is no more real than the being which the artist creates.

Not only common-sense objects, but the counterparts of the beings constructed through the conceptual unification of abstracted strands as well as the beings which artists produce are *substances*. All are unified entities capable of action or motion, or of opposing, resisting or rejecting such action or motion. (This I think is the common core of both the ordinary and philosophic use of the term "substance.") An encountered man, cow or tree is a common-sense substance; a rationally understood man, cow or tree, as that which is at once perceptual, scientific, eventful and important, is the substantial counterpart of a construction; a painted or sculptured man, cow or tree is a created substance. All of them yield all four strands.

Perceptual Objects

The problem of empirical knowledge is not the problem of how a man, living in radical privacy, can go out into or be reached from an outside, independent world; it is the problem of how he and common-sense objects, each involved with one another across space and time, can become better focussed, better organized. The common-sense object is unfocussed, unclear, insufficiently organized because it is the counterpart of men who are themselves unfocussed, unclear, insufficiently organized. When the common-sense object is shorn of all features except those evidenced through the use of sense organs the resultant abstraction is a sense datum. A perceptual object is such sense data when these are oriented in a substance which has been grasped as their locus and ground. Such a perceptual object is simple or complex, depending on whether it is encountered through the use of one or more sense organs. Some simple perceptual objects contain a number of distinguishable elements—a sound may vary in tone over a stretch, a seen shape is also colored. A flash of light, a sound, a

taste are simple perceptual objects; a seen pencil in the hand, a drink of water are complex perceptual objects.

One simple perceptual object has affiliations with other simple perceptual objects of the same type, and no affiliations with those of a different type. The simple colored shaped object here has definite relations to that colored shaped object there, but no relation to the taste of herring. A complex perceptual object embraces a plurality of simples of different types.

Perceptual objects have a distinctive time, quite distinct from that which is characteristic of the common-sense object, and from what is characteristic of other strands. To isolate the perceptual object is to displace, distort, qualify the common-sense object and its characteristic time, space and movement. It is to place the common-sense object in a time which issues out of the past, terminates in the present, and points toward the future, and thus to make it that which is available only to one who uses memory, habits and experienced associations. I don't see a sense datum, a mere brown shape over there; I see a perceptual object, a dog so far as it is visible. Nor do I see it as just a lump in space; I see it as that which might run toward me, which might bark, and so on. But I would not so see it were it not that I face it in a present which issues out of a past where similar adventures had been undergone. Had I once had a traumatic experience with a dog I would encounter this one in the light of that experience. Evidently what I would see in the present would be the past prolonged. But a traumatic experience is just an ordinary experience, high lighted, accented and upsetting. If it is operative in a present perceptual experience, other past experiences will be operative there too, though not so conspicuously.

What is perceptually known is in a time scheme overrun by the past. We do not move back in time when we perceive; we do not enter into the antecedents of the common-sense object. In the act of perception we utilize experiences from different regions of the past. By means of these we produce a perceptual object in which we, who are remembering beings, and the present encountered content are brought together. That object is what it is because what has been experienced in the past is effective in the object now. By transmuting the inchoate common-

sense object which we inchoately confront into sense impressions and by affecting these impressions with the experiences we have had, we make it possible to isolate a present perceptual object which is resonant with what has occurred in the past. An effective past is then and there made to be. It is not one in which light rays move or one which can be stretched backwards with a minus dating; it is an operative experienced past existing only in the context of present perception. That past tells us what to expect and thereby defines the incipient future which is relevant to the perception.

A perceptual object not only has a distinctive time; it occupies a peculiar type of space. The space of vision is distinct from and unrelated to the space of touch. They are, however, interconnected in the space of a complex perceptual object. The space of the object is distinct from the lived-in space of the common-sense world, from the geometrical space of scientific objects, and from the tensed sensuous spaces of architecture, sculpture and painting. The items in it are related to other items not primarily as distant or near, but as contrastive, oppositional and supportive. In the space of perceptual objects, no effective action, no production is possible. Since each perceptual object constitutes a region of perceptual space, a change in the nature of the perceptual object entails a change in the space, and conversely.

The perceptual object also has its own characteristic dynamics, its own way of becoming, of changing. Alterations in color differ in tempo, nature, and rationale from alterations in sound, taste, or touch. Each occurrence is purely phenomenal, leaving over no residue. Because a complex perceptual object encompasses a plurality of simple perceptual objects, it exhibits a plurality of rhythms. A complex perceptual object is an irregularly pulsating thing, vibrating here and quiescent there, altering radically in one dimension while remaining comparatively unaltered in others. Like a simple perceptual object, its being is exhausted in its career. It does not act, it does not persist; its existence is spent in coming to be and passing away.

The perceptual object, thus, is a dynamic, sensed object in a space of contrasts and complements, embracing a past which has been given

a present role by vital habits and memory. It is not a substance. But also, it is not a fiction. It is a strand, an object, or what is the same thing, it is a real substance qualified in certain limitative ways. Each of these ways is on a footing with the others. Rails perceptually converge; seen oars in water are broken. To see the oar as broken is, as Merleau-Ponty observed, to see it in water. The fact that for certain purposes seen parallel rails and felt unbroken oars are to be treated as normative, and convergent rails and broken oars treated as illusory, in no way affects the truth that they are perceptually on a par. The distinction between the normative and the illusory is in fact one which requires a reference to something other than perception—to some other strand and its demands, or to the substantial object which underlies all strands. If we want to measure, or if we want to row, we assess the different perceptual objects according to their capacity to make evident whether and how we are to act on the common-sense guise which the substantial object assumes in daily life.

Scientific Objects

Scientific objects are of two basic types: mathematical and nonmathematical. "Natural" or "descriptive" sciences, such as botany, geology, astronomy, anthropology, economics, and sociology (all of which have mathematical branches) attend primarily to the nonmathematical type; the "predictive" or "formal" sciences, such as physics and chemistry (which also have a descriptive side), attend primarily to the mathematical type. The nonmathematical sciences alone occupy themselves with single occurrences. The origin of a variety of species, the growth of a mountain, the explosion of a nova, the distribution of wealth in a slave society of feudal origin, and the like are appropriate topics of reputable though nonmathematical sciences. However, the two kinds of science have quite similar objectives. Both are concerned with isolating and precisely characterizing repeatable patterns to constitute scientific strands. The nonmathematical sciences, however, tend to orient the patterns and strands in the common-sense world, whereas the mathematical sciences make an effort to hold the patterns and strands apart from that world.

The nonmathematical sciences unobtrusively relate their patterns

and strands to the common-sense world by attitude and interest. Technology performs the same task for the mathematical sciences. In both ways the scientific patterns and strands are radically altered in meaning and role. They are not, though, thereby changed into perceptual objects, common-sense objects, or real substances. The patterns and strands remain abstractions, but abstractions which are oriented in and carried by substances.

Alternatively, one can say that scientific objects (mathematically defined or not), like perceptual objects, are real substances subjected to special qualifications. These substances are initially encountered in the somewhat inchoate form of common-sense objects. We come to know scientific objects by subjecting those common-sense objects to the conditions for precise, objective, formal, communicable, intelligible knowledge and discourse. The result, though not as concrete as the common-sense object, is a genuine element of the substances which the common-sense objects exhibited in an unfocussed, impure way.

If we want to deal with the cup before us scientifically, it is best to try to do this in formal terms, expressing the cup as a complex of variables and mathematical functions. We will then neglect the perceptual and other strands to concern ourselves with an alternative abstraction, an item in a scientific strand. It is wrong to suppose that the result is an illusion and wrong to suppose that the result is the real. It is an abstraction which results when the common-sense object is dislocated, redefined, given a new context, role and meaning. The common-sense object is thereby purged of impurities and vagueness, but it is also deprived of its concreteness. To retain the purity and recover the concreteness it is necessary to weld together the abstract, pure scientific strand with other types of strands. The result will be a construction representing that concrete substance which we daily encounter, not as it is in itself but in the guise of a common-sense object.

The scientifically known world has its own characteristic time. That time is unlimited backwards and forwards. It has an endless past and an endless future. It is a time, however, which is merely formal, a sheer structure of before and after without any earlier or later within it, a sequence of numbers with plus and minus signs. We say sometimes

that we look up into the sky and see a star which existed millions of years ago. Now it is evident that we cannot look back into an actual past; this has passed away. And if it did remain, we would have to look back into it instantaneously and thus traverse millions of light-years in the blink of an eye. The star we are looking at is evidently not the substantial star existing at some remote time. Yet we must not suppose that the star we see is inside our minds, or that it is something we projected outwards under the stimulus of some physical object which had its origin in the star. Such suppositions would force us to give up all recourse to scientific evidence. Scientific evidence is objective, public evidence; it is not inside minds or projected outwards from them. It would also be incorrect to say, as I once did, that the star I see is a real star in the present. This would require one to identify the perceptual with the substantial star and to hold that the substantial star does not have a scientifically knowable aspect. The real star is a substance having a space, time, and dynamics unlike that of any strand, perceptual or scientific. The space, time, and dynamics of the common-sense object is the space, time, and dynamics of such a real substance, but blurred, marred by irrelevancies, distorted, and obscured by conventions, traditions, and practical needs.

The time of common-sense objects is the origin of the times of various strands; it is also the blurred form of the time of the substances which those strands diversely but concordantly articulate. If the common-sense star is now, that now is distinct from the present of perception, the zero moment of time of a scientific formula, or the real now of the substantial star. To locate the substantial star one must synthesize the present of perception and the zero of the formula (overlooking, for the moment, for simplicity's sake, the present of the strand of events and the present of the strand of importance) to constitute the concept of a substantial now—or, what is the same thing, one must purge the now of the common-sense star of its cultural accretions. The real substantial star will then be found to be neither millions of light years away (for that is possible only to an abstracted scientifically formulated star located in a sequence of numbers), nor in our perceptual present (for that is possible only to an abstracted perceptual star located in the "psychological" present), nor in the

now of daily action (for that is possible only to the common-sense star of fishermen and sailors, located at the terminus of an anxious practical interest), but in a now which encompasses us as well as the star.

Both we and the stars exist now. That now is not the present of perception, science or common sense; these are abstractions from that now, telling us, under special conditions, just what that now is. We have no accepted vocabulary, clocks or units of measure for this fact, having reserved our words, instruments, and measures for common-sense objects and their derivative strands. But this does not mean that we cannot "know" the substantial star. When we look at the star or express it mathematically we at the same time face it as other than ourselves. We are, after all, real substantial beings who but partially express ourselves when we perceive, reflect, or act as common-sense men. So far as we are aware that we are such substantial beings we are aware of *other* realities which are as substantial as ourselves, and are partially evident in the shape of common-sense, perceptual, and scientific objects.

The past of the perceptual star is in an experienced past. The past of the scientifically known star is not experienced, not remembered. It is a past in which nothing ever happened, because it is in fact nothing more than a past date to which I assign the star in the attempt to provide a law-abiding account of the operation of causes having the star as focus. What is now in existence must be credited with a great magnitude and a remote date in the past if it is to be properly expressed in mathematical terms. Its effects must also be given remote dates in the future if we are to understand what its law-abiding effects can be. Even this cup now in my hand must be assigned a past date if I am to deal with it scientifically. I must treat it as a teeming set of submicrosocopic entities whose turmoil is to be dated as earlier than the date I ascribe to my vision and touch. For science an object has a position in a series of dates which never happened and never will happen, but which can be called past and future by virtue of their positions as before and after what is dated as the present.

The space of a scientific object is also peculiar to it. It is not a space which things occupy. It is merely a geometry with positions and vectors, but no roominess, no extensionality, no place for move-

ment or change. The perceptual star is over the chimney we say; the scientific star is millions of miles distant. But the "nearness" of the perceptual star is not of the same type as the "distance" of the scientific star. Both are correct ways of speaking, but neither tells us where the substantial star is. That star is neither perceptually nor scientifically defined and is therefore neither in the space of the one or of the other. These spaces are derivations, abstractions from a real space which has properties quite distinct from theirs. The substantial star, to be sure, has a magnitude, but this magnitude is distinct from that characteristic of the scientifically characterized star. The magnitude of the latter is a matter of numbers, not of extension; it is a magnitude that takes up no room, fills out no space; but a substantial star is spread out, pushing aside other things, filling up a real space.

The scientific object also has a distinctive dynamics. There is no change which it allows, no coming to be or passing away which it encompasses. It is merely a set of logical transitions exhibiting laws which relate causes and effects. This fact is overlooked or distorted when we turn without reflection from the theoretical achievement of science to the engineering and technological usages to which it has been put. Those usages take us outside the realm of the scientific objects to substances where scientific, perceptual and other strands are intertwined. It is only such substances which are capable of being moved, used, worked over; only these have power, potentiality, the capacity to ground a plurality of changes, to remain self-same as they change in place, to persist through time, and to act. What exists all on the surface, or what is exhausted in formulae or derivations from these, has nothing left over which can persist, resist, act, move. In order to find what is able to do these things we must enter the world of substances, either through the powers of our own substance or by means of those substances which are resident in or made available by tools, instruments and similar objects.

Events

An *event* is distinct both from a perceptual and a scientific object. It has its own time, wholly present. Existing only in the present, the event occurs in an extended moment. Past and future are not relevant

to it; they exert no pressure on it. If an event is now affected by what has been, this is because some exterior power is bringing that past to bear on it; if it is now being influenced by the prospects before it, this is because powers in control of the event compel it to conform to them. The event is like a scientific object that has been compressed within a tiny span; it is like a perceptual object, something to be encountered only by abandoning a stress on formulae, necessities and structure; and it is unlike either, having a distinctive time of its own, a time which encompasses the whole of the event's pace and its single adventure of becoming, a time which perishes as it comes to be.

The space of an event is also peculiar to it. It is a space of interlocked vectors which knot together and untie to make the career of an event a set of tensional configurations differing from moment to moment. The vectors of the event reach beyond its boundaries to terminate in other spatial events, thereby constituting with them an intervening environing space for all. Each event is an extended tensed region inside a larger spatial whole, an island in a sea it has helped constitute.

Each event also has a characteristic way of taking place. A locus of sheer activity, an ongoing, a happening, a process of causation freed from causes and effects, there is no accounting for it, no rules or controls, no compulsions to which it is subject, no directions it must follow. It has a dynamics of its own. Whatever laws and necessities there be are submerged in it, subjugated by it, made to conform to the event's career. An event is mere process, exhausting itself in its becoming, incapable of acting or being acted on. The paradox of process philosophies such as Bergson's or Whitehead's is that they do not allow for any possibility of action, creation or movement, for these demand the existence of substances, expressly denied by those philosophies. Such philosophies therefore have no room for ethics, politics, engineering, art or anything else which demands that there be something that can act, move or make.

An action embraces a series of events. That series is no more and no less real than the events which compose it. It is an abstraction just as they are. Scientific and perceptual objects can at times show us where changes in an action's pace and direction occur. They cannot

tell us what the action's space, time and rhythm are like. A space ship will be aimed at some planet through the help of mathematics. It will, as its camera will make evident, face a series of perceptual objects, at one extreme of which is the perceptual object seen from here, and at the other extreme of which is the perceptual object to be seen when the ship arrives. But the ship will move in a space and over a time which is encompassed by neither the mathematical nor the perceptual strands. One cannot travel to a scientific or perceptual object, for these are not to be found in the dimension where traveling takes place. When we travel in accord with what we learn from science and perception we are moving towards a substance and as substances. Our traveling is an event, but one which is sustained and produced by something other than itself. If we isolate the traveling, we will separate out a strand of mere action, of events, which is no less but also no more real than the strands isolated by science and perception.

Importance

A fourth strand is the strand of *importance*. Here there is also a distinctive time, space, and dynamics coordinate with those characteristic of the perceptual, scientific, and eventful objects. Its time is essentially future, the present and the past being for it items which are temporal and significant only in the light of the standard which the future imposes. Here time seems to run backwards, transforming dead material into pointers for it. It is this time which is stressed in those philosophies of history that look at all history in the light of the day of last judgment. In a less striking way it is the time employed by every historian in the course of his re-presentation of the past. In such a time the past is made, produced by the future, out of material which would otherwise be merely data without order or temporal meaning. It is a time which is the reciprocal of that which we encounter in a perceptual strand.

The space of the important is one of affiliations, of help and opposition, intensification and frustration, adoption and rejection. It is a space which, like that of science, reaches far beyond the powers of perception, but which, like perception's space, has a qualitative, intensive character. It is a space which, like that of an event, encom-

passes an area inside of which a vital occurrence is to be found, but which, unlike the space of an event, makes connection with all there is.

The dynamics of the important is one of mastery and subjugation, of assertiveness over against and submissiveness to others. Here we have a shifting of alliances and disassociation which force items into a valuational hierarchy. Here an ideal conquers content. No genuine passing away and no real coming to be is to be found in this strand, but only realignment perpetually. Here teleology operates; what is possible governs what is. Cosmically, the dynamics is of some final perpetually dominating value; in a more limited guise it is the dynamics of our reassessments of our accomplishments.

Each of the four strands, perceptual, scientific, eventful, and important, can be made the objects of a judgment. They are then analyzed into a component making evident where or how an item is to be located, another making evident its meaning or nature, and a third expressive of the unity of the two. The third element is rooted in the strand itself and merges imperceptibly into a background in which something more substantial can be faintly discerned. All the strands are thus knowable, and all of them can be recognized to be aspects of something more concrete than they.

Each of the four strands has a tonality, an aesthetic quality which can be immediately encountered, apart from all judgment. This quality is the terminus of an aesthetic experience, of an unconceptualizing mode of acknowledgment. The quality has often been thought to be the primary concern of art or at least of an artistic sensitivity, in part because it has been taken to be part of an encountered substance. Actually an aesthetic quality is only an abstraction from an abstraction, not to be identified either with a strand or with a substance from which strands are derived. Sensitivity is needed if we are to properly be alert to the immediate nature of any strand, and such sensitivity is not to be despised. But the artist and the spectator of art have a much more penetrating concern. They have an ontological interest in themselves and other things.

That the various strands belong together seems quite clear. The real is more than what is revealed in perception, science, action, or evaluation. But we have no way of showing what the nature of that

real is except by making use of the strands with which we are acquainted. We usually take it for granted that a strand is the real. We recognize it to be an abstraction only when we become aware of other strands no less and no more real than it, that no strand has potentialities, and that none has sufficient complexity or the capacity to stand over against us. We are substantial active beings with an interiority; we subtend any strands one might abstract from us; what cannot oppose us in the very terms with which we insist on ourselves must be an abstraction from something as real as ourselves.

We combine our acceptance of a given strand as real with the recognition that it and others are abstractions by treating it as the ground in which the other strands can be located. Sometimes we take the perceptual object, sometimes the scientific object, sometimes the event, and sometimes the important object to be basic, depending on whether we are functioning primarily as bodies, minds, emotions, or wills. By means of emotions, for example, we bring to bear something of our substance on the event we confront to make it the locus of the perceptual, formal, and important strands. The result is the acknowledgment of a substantial occurrence which is primarily but superficially exhibited in an event, and which is expressed in the guise of perceptual, formal, or important objects. In a similar way we use the perceptual object to make possible an acknowledgment of individual natural substances, use scientific objects to make possible an acknowledgment of substantial technological instruments, and use important objects to make possible an acknowledgment of substantial sacramental objects.

Each one of us is a substance who can know four different types of substance. In each of these substances three abstract strands are intertwined and rooted in a fourth. These substances have something like the space, time, and dynamics of that fourth strand, but precisely because they are loci of other strands as well, each with its own type of space, time, and dynamics, the substances have a space, time, and dynamics not identical with what is to be found in any of its four strands. That is why we cannot know what their space, time, and dynamics are by studying any or all of those strands. We can know the space, time, and dynamics of substances only in an encounter

which occurs beneath the strands and beneath ourselves as dealing with these strands. Known substances are the common-sense objects of daily life, reconstructed, purified, reorganized, answering to the firm correlatives that stand over against us. No one of these substances is ultimately real. The ultimately real encompasses all types. To know it we must combine all types, use one of them to represent all, or have recourse to a form of apprehension other than cognition.

A combination of different types of known substance is difficult to achieve. When we retreat into our privacies, when we fully obligate ourselves, when we pray, and when we act with radical spontaneity, we do sometimes bring about such combinations for fleeting moments, and thereby come to have quick glimpses of ultimate reality. We then are in immediate relationship to some mode of being and see it to have properties other than those possessed by any substance. But we also lose the distance and the release which are so necesary for a leisurely apprehension. A surer, steadier grasp of reality results if we use one type of substance to represent the rest in the guise of a symbol pointing to what is distinct from all of them. Such a symbol does not enable us to feel the texture, to live with that ultimate reality. To get the feel of reality we must create substances. This is what we do when we engage in art.

The space of a painting, the time of a poem, the dynamics of a dance, precisely because they are not parts of abstracted strands, portray a space, time, and dynamics either more or less real than any to be found in a strand. If they portray what is less real, every work of art must be viewed as a kind of beguiling error, falsifying what in fact is the case. If, on the other hand, they tell us more than any strand can, they must reveal something beyond the reach of the wisest common sense, the most acute perception, the most developed science, the most effective action, or the most accurate evaluation.

Since created substances are partly constituted by our emotions, they can tell us not what reality is in and of itself, but what it is as emotionally charged, as having relevance to us. Works of art are emotionally sustained works exhibiting the texture of existence. But existence is at a distance and quite distinct from a work of art. How then could the work have the texture of existence in it? How could

the work represent existence in any other way than by functioning as
a distant symbol of it? I know no better way of answering this question
than by taking advantage of an insight of Thomas Aquinas relating
to a somewhat different question. There are, he saw, two types of
meanings, forms or ideas—those which portray essences or structures
in and of themselves, and those which portray such essences or struc-
tures as having residence in something other than themselves. A sphere
(my illustration) is a mathematically defined object. The idea of a
sphere gives us the entire essence, nature, meaning of the sphere.
There is no claim here that the sphere exists in the world or that it
has any function or role in some other context. A balloon is a sphere
made of nylon or some such material. If I have an idea of a balloon I
have an idea of a material sphere, of a sphere in material. I do not
have the material inside my mind, but I do have in my mind something
more than the idea of a mere sphere and something other than the idea
of the essence or structure of nylon. The idea I have of the balloon is
iconic * of a sphere as possessing the texture of the material. If there
is no balloon in fact the texture I have in mind is that of some material
or other. If I merely had an idea of material I would have another idea
alongside that of the sphere ; I have texture in mind only by having the
conceived material function as a residence for the conceived sphere.
That texture is made integral to the sphere only so far as that sphere
is thereby made richer in meaning than it was before. I conceive of a
balloon only so far as I conceive of a sphere which is capable of exist-
ing, of being resident in the material. If I invent the idea of balloon I
not only know what a sphere is like but grasp the fact that it is em-
bedded in material. The texture of that material distinguishes the bal-
loon from the sphere ; the mental grasp of the texture distinguishes
the idea of the balloon from the idea of the sphere.

The texture I have in mind is but a faint copy of the texture I

* I use this term in a sense related to that given by Peirce: "An *Icon* is a sign
which refers to the Object that it denotes merely by virtue of characters of its
own, and which it possesses, just the same, whether any such Object actually
Exists or not. It is true that unless there really is such an Object, the Icon does
not act as a sign; but this has nothing to do with its character as a sign. Anything
whatever, be it quality, existent individual, or law, is an Icon of anything, in so far
as it is like that thing and used as a sign of it." (*Collected Papers of Charles
Sanders Peirce*, 2.247.)

experience. But when I *make* something I use material and thereby get an experience of the texture. If that material is made integral to a meaning expressive of existence, its texture will, if appropriate to that meaning, convey to us the texture of the existence in which that meaning is resident. This is what happens when we treat a work of art as self-sufficient. We then make the work not only represent existence but thereby convey something of existence's meaning and being.

Not every work of an artist can be treated as self-sufficient. It may be too incomplete, too chaotic, too frustrating, too tight, or too loose. If it is self-sufficient, then we must be able to remain with it. We must not only push aside everything else to enjoy the work but must find that by doing so we are confronted with something final, ultimate.

The cheap, the tawdry, the sentimental are at most minimal works of art and are only faintly revelatory of reality. Their being does not require a full emotional involvement either to constitute them or to enable them to stand apart from other substances. Instead of being deliberately held over against the rest of the world, the rest of the world is in part carelessly ignored for the moment and in part allowed to intrude. And what is made of the work or read into it is some idea or feeling which the work fails to entrap because it lacks the appropriate texture. The sentimental work is one with which a man might be content. But it is neither substantial enough nor capable of utilizing his emotions. Those who remain with such a work do not often know of its poverty. But others, who see that such a work does not do justice to the joys or tragedies of men, or who have had experience with other works of art, can judge it with considerable objectivity and accuracy.

"But what reason," it might at this juncture properly be asked, "do we have for assuming that the texture of even a substantial, emotionally effective, and self-sufficient work of art reproduces the texture of a reality beyond it? Perhaps there is no such reality? If the only evidence we have of it is provided by art, obviously we cannot say that there is anything outside art which answers to art." The point is most acute. No one, so far as he is immersed only in art, clearly knows whether or not there is a reality beyond it. However, apart from the hints which creativity, myth and the artist's dissatisfaction with his work provide, we can get at least three assurances that there is

such a reality; each independently tells us something of that reality and thereby provides us with checks on what art portrays.

We live in a common-sense world whose substances are caught in a dynamic field. Those substances interact and move into the future concordantly. In the region between the various substances we know, we are aware of a power embracing and affecting them all. That power is the power of existence. Secondly, we come to learn through speculation something of the categoreal nature of being, the features it has at every time and in every place; we know through speculation something of every mode of being in itself and in relation to others, though only of course so far as these can be caught in abstract concepts. One of these modes of being is existence. Finally, we ourselves are substances who know, who interact with, and who live together with other types of substance. This we can do only because we enter into a domain which is inclusive of us both. We are always acting inside a reality less specialized and limited than ourselves or other substances. What art portrays thus can be checked by what is independently discovered through an ideal common-sense experience, an actual philosophic inquiry, or a sympathetic action.

Art offers an illuminating, a most concrete way of grasping existence as pertinent to man. It is a means for making existence man's own (and incidentally grasping something of the nature of other modes of being). It is not then the immediacy of the artist's experience or the rendition of such immediate experience with accuracy or insight that distinguishes his work from that of other men. He might not be interested in immediate experience; he might be more concerned with ordinary common-sense objects in their conventional settings. Or he might be interested in substances. In any case it will be his task to deal with space, time and becoming in independence of the manner in which they function in daily life or in known substances. Only by exploring them in their own terms, apart from the limitations to which common-sense experience or different substances subject them, can he grasp what existence is in fact. If he portrays familiar things in his works it is only to enable him and others to locate themselves better in that deeper, more ominous, challenging world which man has a need to master. He cannot adequately deal with it so long as he tries to act

on it directly or to study it in the shape in which it appears in daily encounters.

A work of art is actually unique, ideally complete, and existentially insistent. But most evidently, it is self-sufficient, final, and worthy of man's most passionate devotion. It is this because it presents him with the nature and texture of what is in fact self-sufficient, final, and worthy of man's most passionate devotion. This it can do because it is produced by holding real existence at a distance in the course of an emotional creation of a new space, a new time, or a new becoming.

5. ARTISTIC CREATION

THERE is no act which is entirely devoid of an element of creativity. If there were such an act one would be able to repeat it endlessly. But a mere mechanical repetition is only a fancy, achieved by ignoring the particularities which distinguish an outcome at one moment and in one situation from that of another. Nor is there an act which is entirely devoid of organization. One without any structure would be completely chaotic; its components would stand in the way of one another's expression, thereby precluding the occurrence of any activity at all. A supposed totally unorganized act is just one whose structure is unexpected, undesired or unnoted.

Both when we reason and when we make we exhibit structure and creativity. If we ignore the structure we will be unable to predict or see the necessity for the outcome of our acts. The structure is a relation connecting our beginning with the kind of terminus with which we, in creating along the lines of the structure, must in fact end. By itself the structure enables us to predict what is to be, not in its concreteness, as it will in fact appear at some place and time, but abstractly as a merely formal, necessitated consequence. If, on the other hand, we ignore the process of creativity and the difference this makes to the structure, we will fail to understand how the result could be what it concretely is. The result is made to be what it concretely is, only by being achieved at the end of a creative process which adds to and realizes the structure and its necessitated outcome.

Every outcome, in its full concreteness, is both unpredictable and avoidable from the standpoint either of the structure or of the creative process by which it is achieved. But every outcome is deducible, even inevitable, given the structure and the creative process. In the realm of thought, though, it is usual to emphasize rules more

than processes. There is a tendency to ignore the particular, un-duplicable course of inference in which the rules of reasoning are exhibited. Inference is a mystery for logicians. In the realm of action, there is instead a tendency to stress process rather than structure, and to suppose therefore that the outcome must be inexplicable, basically irrational. Reason is a mystery for productive men. There are of course radically creative thinkers who pay little or no at-tention to any rules; there are artists who belong to schools and use similar techniques to produce designs which almost hide the creative element in their work. These exceptions but show how wrong it would be to deny there is creativity in thought or rules in art.

Logicians use rules which have been worked out in the past, thereby minimizing the novelty of the particular outcomes to which men in fact infer. If reasoning is primarily concerned with avoiding the derivation of falsehoods from given truths such a stress is desirable. An analogous use of rules can be made in art. This is done when one attempts to understand or to produce works of art according to a formula, such as the golden section, the serpentine line, the ellipse, major and minor chords, modules, paradox, and the like. It is good to emphasize and follow such rules so far as one is concerned with avoiding ugliness in the course of an effort to produce the ex-cellent. Reasoning and production at their best, though, are ad-venturous, beyond the control of any preestablished rules. They risk error and ugliness to get to fresh truths and beauties.

Inference is a creative act. As Brouwer so long ago saw, this is unmistakably the case in a field where many think creativity to be absent—mathematics. It is a rare productive mathematician who attends to logicians. He, too, wants to obtain nothing but truths, but he gets them by carving them out of an indeterminate realm, proceeding by little steps to avoid signal error. The artist takes greater risks, adventures in a thicker medium, so that he fails more often—but also makes more signal advances when in fact he does succeed.

The reasoner tends to focus on some particular item and tries to derive from that starting point another similarly demarcated item, to be characterized as acceptable for a certain purpose. Artists do

not start with such well-defined items, and they proceed not by inference, by moving from one item to the other, but by filling out, by making present, vivid, and concrete a vaguely apprehended prospect. We know when we reason well because we already have an accepted truth which defines what kind of result is acceptable. We know when we have produced well when what we in fact create embodies a vaguely apprehended prospect.

Though every activity has some degree of creativity, the term is peculiarly appropriate to the activity of the artist. His creativity differs from that of others both in degree and in kind. His combines in a better way a greater degree of spontaneity, inventiveness, urgency, persistence, and emotionality than other activities do. Other activities may exhibit a greater degree of any one of these than the artist's does, but none has them all together in such a heightened, desirable form. More important, perhaps, is the fact that the artist's creativity is directed towards the production of excellence in a sensuous form. This is not the concern of any other activity.

An action is spontaneous when it arises from within in independence of any external cause or pressure and without acknowledgment of or control by any known rule. It is most evident in play, where energy is expended without regard to circumstances and without regard to established conventions. The artist's spontaneity is less than the child's in part because his habits are more intrenched, because he is constrained by his knowledge, because he gives a place to other aspects of the creative act, and because he realizes a desirable prospect. His is a spontaneity controlled and directed.

The artist's creativity is inventive. It makes use of contrivances, chance occurrences, available material in ingenious ways, trying to take advantage of every opportunity in order to bring about a more desirable result. But the craftsman may at times be more inventive than the artist, precisely because he is so immersed in the means, and does not restrain himself in the light of the need to make a self-sufficient, revelatory substance.

The artistic act is an urgent insistent one. Like lust and avarice it is deep rooted and hard to gainsay. Artists create not so much

because they wish as because they must. One might conceivably feel a greater urgency to love or hate than to make, but this urgency is partly triggered from without and inadequately constrained by a control of the material which the act will transform. The artist urgently acts, but not without a sensitive regard for the capacities of his materials and the demands of his prospect.

The artist stands out, with other masters of disciplines, as one who persists in working at his task until an excellent outcome is achieved. There are men who are more persistent; they have single, fixed ideas to which everything else is made to give way, or who work more constantly at some given task. The persistence of the artist is a consequence of an insistence that the excellent be achieved. Much of his time may be spent in preliminary work, in preparation and training. The fact that a work is produced quickly and without apparent effort shows not that it is an idle, easy outcome of forces, unknown and undirected, but rather that the actual production of a work may be but a climax of an activity part of which took place some time before and perhaps subconsciously.

Most important, the artist puts his emotions to work. He is emotionally stimulated, emotionally guided, and emotionally satisfied. Because his emotions are so involved in his portrayal of what is real, it is best to reserve a detailed consideration of the emotions until the next chapter. But it is important now to note that the emotions can be expressed more vividly and effectively outside art than in it. The artist's emotions, though, are purer, being purged and controlled by what he in fact is producing through their agency.

Spontaneity, inventiveness, urgency, persistence, and emotionality yield no art, even when intertwined in the best possible way, unless they are caught within the effort to produce excellence in a sensuous form. (This important fact receives extensive treatment in Chapter VIII.) The artist is one who seeks something which cannot be found in daily life. As other men do, he of course begins with common-sense objects. But he soon finds that these do not do justice to the promise of the qualities thought to reside in those objects, or to his own need to complete himself by mastering what lies beyond him. Since sensed qualities exist only when and as they are sensed,

it would seem that qualities cannot reside in unperceived objects, unless those objects are able to perceive those qualities too. But no stone or tree, no cat or cloud senses the qualities which are commonly said to characterize them. Berkeley thought that such qualities could be objective, have a being apart from a perceiver, only if they were resident in or sustained by some external mind, such as that possessed by God. This conclusion is not warranted. Qualities can be freed from their dependence on sensing to become objective qualities in mindless substances which occupy space, exist in time, and come to be and pass away. But first they must be purged of the impurities they have when sensed and be interlocked with structures, on-goings and values also resident in the substances. Naive perception is faced with the impure and dulled; scientific formulae are conceptual products; mere activity is dictated in part by accident and by compulsions alien to a substance's needs or rhythms; what is unreflectingly taken to be important is largely a matter of prejudgment and preconditioning. To know what qualities, events, structures or values are like in substances, we must dislocate them from their common-sense settings, purge them of their accrued irrelevancies, and locate them in known, reconstructed beings.

An object in an abstract strand is distinct in nature and function from itself as part of a common-sense object or a known reconstructed substance. To understand it, we must free it from the accretions imposed on it by common-sense experience and know what happens to it when it is integrated with and affected by objects from other strands which, with it, constitute a known substance. We produce a known substance when, after we purify the abstractions which resulted from a conditioning of common-sense objects by the senses, by scientific attitudes, by an immersion in mere activity, or by an evaluation, we solidify all into a single being. Berkeley overlooked the fact that the senses, instead of confronting what is concrete, terminate in abstractions which have to be reassessed and integrated with other abstractions before we can refer to beings having an objective status.

The counterparts of the substances we know through construction are but common-sense objects purified and given focus; they are no less real, external to us, perceptible, intelligible, dynamic, and

valuable than those common-sense objects. An artist is not primarily interested in such substances. He does not purify strands in order to understand what focussed and purged common-sense objects are like. Instead he seeks to make a new type of substance, one which is self-sufficient and therefore truly satisfying. Even when, in architecture, music, sculpture, theatre and dance, he uses the very same items which are embedded in common-sense objects, he subjects them to the special conditions of an act of creation. A street sound in a musical piece is a tone which has been torn away from common experience and allowed to exhibit new relations to other tones inside a substance which is then and there being produced.

The artist, then, makes strands into elements, not of reconstructed common-sense objects, but of substances which have new natures and careers. To do this he does not attend to purified strands or to the objects in them, but to altered versions of both. He does not use perceived qualities; he uses sensuous content. He does not use the formal mesh which science isolates, but modifications of this in the shape of helpful rules. He does not attend to pure events; he infects events with his emotions to produce a new spatial, temporal or dynamic content. And instead of acknowledging the conventionally important, he is occupied with making a substance which will have overwhelming importance. This last consideration overrides all the others. To see this we must first see how the artist fits inside the cosmos.

An artist is an actual, substantial being. Taken merely as a being, in abstraction from his individuality, his membership in a society, or his status as a man, he is, together with all other actualities, directed towards a single Ideal, part of which he and they, in the course of their careers, will make concrete and determinate. That Ideal is an irreducible, cosmic mode of being which the artist, qua man, faces in the guise of an obligating Good. The artist is, of course, more than a mere man; he is also a member of a culture or society. As such he, together with all other members, faces the Good, not as a single and unitary objective, but as creased, subdivided in ways which reflect the basic concerns of the culture. As a distinct individual with ideas of his own, finally, the artist deals with a specific delimited form of one or more of these divisions of the Good.

Such a delimited form is a prospect or pertinent possibility to which the artist initially attends by means of his ideas.

The relations which an artist's ideas have to possible prospects are humanized forms of a natural purposiveness, to be found throughout the organic kingdom, relating need to what is needed. In the higher organisms this natural purposiveness is expressed as an expectation relating desire to desired. In the artist, it has the form of a tension relating idea and prospect.

The idea that the artist has merges imperceptibly into himself as social man, and the prospect which he faces is consequently faced as the surface of a basic subdivision of the Good. If the individual idea be stressed, the prospect which the artist will realize will usually have the look of a more or less familiar thing, for the artist's ideas are, like most men's, directed towards prospects which are germane to the objects they daily know. If the social root of the idea be stressed, the prospect which the artist will realize will convey something of the meaning of an important division of the Good. Society as a whole refers to such a subdivision by means of a myth. The artist is directed towards a more or less socially acknowledged prospect because his ideas are more or less rooted in his personal adoption of the myth.

A myth is society's "idea"; every individual personalizes this and roots his own individual ideas in it. The artist makes a tighter union of his own idea and society's than other men do; the prospects which he faces are always seen from the perspective of the prevailing myth. Only when he overintellectualizes his tasks does he follow the guidance of his own ideas, ignoring or rejecting part of his own being when and as he rejects the myth. This is not to say that the artist works as a merely social man; he is in fact overindividualistic in temper, but his individualism is one which involves a utilization of the current myth as a ground for his ideas.

Myths are of three types. The subdivisions of the Good to which they refer express the meaning of a beginning, a turning point, or a terminus.* Each of these, when realized, will reveal a crucial aspect

* Comparative studies of myths have been made to find those common points around which all people pivot, but the lists that are offered agree hardly at all. The

of existence in its bearing on man. Theft of fire, the creation of the universe, birth, make specific a reference to an origin. Those which relate to magic, chance, dedication, and adoption, make specific a reference to turning point. Death, resurrection, the eternal return, make specific a reference to a terminus. These specific references can be presented in the form of a mythological story or even in the form of some limited event, assigned a date and spread out in daily time. The Fourth of July and Washington's Birthday are for us turning points; Columbus Day and New Year's are days of origin; Memorial Day and Lincoln's Birthday, termini. Though we recognize four seasons, only three have mythological value for us. Spring is origin, Fall turning point, and Winter terminus. Summer we merely live through.

Common education, background, experience, and practice make a people one. And the people, in their common work, celebrations, worship, and crises, forge myths enabling them to make vivid the nature of the future they face together. Those myths are participated in emotionally and only by those who are part of the culture. Even when those myths purport to record some signal past event, they refer to values to be realized in that culture.

An artist's idea, even of the most commonplace thing, has a mythological base. The course of his creativity is guided by his mythologized idea. The beginning, turning point, or end which he mythically discerns becomes in his work the meaning which existence has for him. The mythologized idea, having made him aware of the meaning of a prospect, enables him to reveal the import that ex-

Spring, 1959, issue of *Daedalus,* the Journal of the American Academy of Arts and Sciences, was devoted to the problem of the nature of myth and myth-making. One list had fire-theft, deluge, land of the dead, virgin birth, and resurrected hero; another had father-seekers and slayers, mother murder, the eternal return. Yet Clyde Kluckholm could there say, "the following themes appear always and everywhere 1. were-animals . . . 2. the notion that illness . . . and eventual death can result from . . . magical means; 3. a connection between incest and witchcraft." The discrepancies between one list and another were in good part undoubtedly due to the fact that the term was understood in quite different senses. Some of the difficulty could also be traced to the fact that different investigators made different kinds of analyses of the same material. A good deal of the trouble, though, seems to have arisen because basic values in a vivid form have been confused with the topics of drama and poetry, which embody those myths in their own ways.

istence has for man. His idea of a flower is one which relates him to the meaning of beginning in existence; he takes the breaking of a glass to signalize and existential crisis or turning point; the idea of a departure makes him alert to existence's endings.

The material of creativity is a dislocated sensuous content; its form is a structural whole; its power is given by the emotions, but it is the meaning of the prospect which guides and controls. The artist desires to embody the prospect through the agency of his power. In the act of creation he expresses himself and at the same time achieves a corresponding control over his emotions. To begin with his emotions are excessive, not altogether appropriate to a prospect he faced in experience. His expression of his emotions is his way of adjusting himself to both the material and the new prospect he now confronts. As he progresses in the activity of providing an embodiment for the prospect in the material, he purifies his emotions more and more. At the same time he affects his material by his interests and feelings, thereby making the prospect one which is congenially felt in the material.

Dewey observed that the individual makes himself when and as he molds his material. Using the energies which he would normally employ in daily life he brings himself, material, and prospect together. This is difficult, tiring "work." The result has its own rationale and values. But the work of art is not the end which the artist seeks to achieve; it is but the residuum of a process involving a self-purging, a purifying of experienced content, and a transformation of confronted prospects. The heart of the artist's life is in the process of making, not in possessing the outcome of that making. The outcome, the work of art, serves sometimes to remind or to provoke, but it can be used to make it possible for the spectator to have something like the artist's experience and to achieve a somewhat similar grasp of ultimate reality.

The prospect which guides creativity is a possibility. How is it chosen? How does it operate? Poincaré thought that the sublimal self, in the dark recesses of its being, tried out all possibilities. Otherwise, thought he, there would be only a small chance of finding a good result. Putting aside the fact that a small chance is not equal

to no chance at all, it is the case that, even if one starts with some collection of possibilities, one would still face the question of why it is that the sublimal self selected a good possibility or combination of possibilities, and how what had been selected came to consciousness.

Poincaré would find considerable support today for a belief in a sublimal self. But there seems to be no warrant for his supposition that it confronts a multitude of distinct possibilities, that it combines these in all possible ways, that it isolates the good ones, and that it then allows these to come to the surface—all in a rather short stretch of time. Creativity is more than combination. Possibilities before realization are not distinct one from another. And we are often conscious when we create.

Strictly speaking, an artist need do nothing more than attend to an unspecialized possible beginning, turning point, or ending. Being finite and occupied with a finite task in limited material, he gives one of these the more limited form of a prospect referred to by an idea. The prospect which an artist faces is personalized and specialized by him, largely under the pressure of experience and tradition. Although it need not be interesting, it must guide the very work which makes it be here and now. The good result is one which the artist in his work has *made* good. Sometimes he overlimits the prospect, and thereby produces a work having an unduly narrow compass; sometimes he does not limit it enough and thereby produces a work having only a vaguely apprehended meaning. Concepts of the monumental and epic are most appropriate, for they report the nature of significant beginnings, turning points or endings more adequately than more limited prospects do.

The realization of a prospect takes time. It is an adventure in which what is achieved at one moment is inherited in the next. Later stages are affected by the earlier and press on to consequences that could not be envisaged from the standpoint of the earlier. Yet an artist such as Mozart will occasionally claim that he envisaged a whole work, even a long one, almost complete and finished, and that he did not even consider the parts successively. Mozart thought that the creative work had all been done before he wrote a note. But

that means he supposed that the writing down involved no genuine creativity. Living through the process of writing, making the parts fit one with the other, are vital parts of the creative act of a musical composition. The working through time either in writing or hearing is a way of making material and the prospect determinate, thereby producing a world with a new kind of meaning, one which is involved in human activity, interest, and emotions, and which realizes a transformation of the prospect originally confronted. The unconscious component in creativity is in good part an unnoted willingness on the part of the artist to follow the route of a medium in such a way as to realize what he envisaged. When too reflective he is apt to intrude concepts, to impose set plans, to become self-conscious; that is why it is often better for him to work right after awakening from sleep, and why it is that he is sometimes helped by drugs.

The artist does not have a perfect control over his activities or material, or have a clear prospect in view. Nor does he usually attain what he set out to produce. There are surprises at almost every moment; direction and aim constantly change. There can even be a courting of accidents. The accidents reveal the power and variety of nature, free one from common conventions, and make one aware of new and otherwise neglected combinations and features. But it must not be forgotten that the utilization of accidents is itself part of a deliberate and controlled action. When a Pollock or a Cage allows chance to set him going or to define the work itself, he but frees himself from accepting the conventional world's steady features or patterns; he does not free himself from a restrained use of what he encounters.

From the beginning to the end of a creative activity, the artist is dominated by a sense that his prospect should govern every part of his work. At the beginning he operates aware of a need for parts through which the prospect can be articulated; at the end the prospect has been articulated through parts which his efforts produced. At the beginning he is aware that the prospect needs content; at the end he confronts it in the guise of a plurality of items governed by the meaning of the whole they constitute. The prospect is

for him nothing more or less than a division of the Good in the role of a guiding principle and an achievement. As the first it demands that the parts be worked on so as to give it a role inside them; as the second it demands that the different parts interplay so as to make an organic whole.

The accompanying diagram summarizes a good deal of what has now been said and points to what must still be discussed. It may serve as an easy reminder and guide.

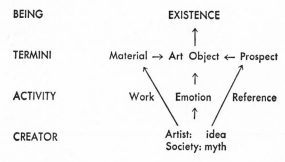

Acknowledgment of the fact of creativity inevitably requires one to admit that man is free. Were man not free there would be no genuine creativity. The examination of the nature of freedom, with an indication of how freedom can exist in a causal world, would unfortunately take us somewhat away from the central problems of the philosophy of art.*

Creativity is an adventure of relating, combining, altering, making, destroying material in an effort to articulate a prospect which is to be made sensuously evident through the emotional use of transformed material. Just how this is to be done is partly a matter of trial and error. Techniques mastered in the past should be employed, but if there is to be a fresh achievement, these must be subjugated to the prospect functioning as a governing principle. The

* The interested reader will, however, find the matter discussed in my *Nature and Man,* and *Man's Freedom.* The former makes evident the limitations of a determinism and shows how freedom is an integral part of nature, not dependent on man's existence. The latter deals with the form that freedom takes in man, with particular reference to his ethical life. It will not be difficult I think to make what is said about freedom in those books relevant to art.

parts must be constantly manipulated in new ways in the effort to achieve the most adequate organization. Extreme usages may result in signal successes, but they do involve great risks. The wise artist is one who knows just what kind of risk he can take in the light of his present insight and techniques.

6. THE EMOTIONS & THEIR EXPRESSION

A CREATED work is objective and public. But the act of creation is a highly personal one. Not only is it an individual who creates, but the creation is inseparable from an expression of his emotions. Such expression is no mere externalization of something inward; it is a transformation of the emotions under the guidance of a prospect and subject to the restraints imposed by material. The work of art is no public device for communicating what one privately feels; what one feels is at once discovered and altered in the act of producing the work of art.

Each one of us knows he is an individual, independent and separate, solitary, private, all alone, even when he is immersed in a common history or subject to common physical and social conditions. But it is a hard thing to fixate the nature of ourselves as just below the arena of identifiable features. I know that beneath the public face I show others; beneath even the mind, intent, and character which that public face partly exhibits and partly betrays, there lies a more constant, a more secret self. I have a partly subterranean being, not entirely under control. Some of it exists below the area where rules, concepts, and ideas are to be found. I am two-ply, with a self divided, one part manifest, another hidden. In crises, in sleep, sometimes through inadvertence, I stumble on that dark secret which is at the core of my every act and thought. Terrified by what I see I keep it covered, ashamed of what I am in root and what I might allow others to see. If I am not to put my daily life wholly in jeopardy, if I am to be a part of the world with others, if I am to be at peace with myself, I must control and use this which now defies and endangers what I publicly am and do.

I keep myself repressed as much as I can; I put barriers in its

way. But it continues to make itself manifest. I sometimes expose myself; occasionally deliberately and often accidentally I allow others to glimpse something of my inmost nature. Publicly qualified and redirected, I nevertheless somehow express myself. What I show in public is thus my secret self, but a secret self half disguised. Like a drunkard and perhaps with something of his cunning I let my mask slip halfway down, exposing a telltale eye and a betraying smile. But usually I have a better grip on myself. For the most part I hold myself in quite rigidly, mainly by the way in which I use, redirect and control my body and its activities, thereby publicly expressing my self along lines which that self neither defines nor controls.

In modern times we have learned much from Freud and his followers on how to master our selves. Oddly enough it is an old way but presented in a new guise. Freud's answer is knowledge. "Know thyself," said Socrates; Freud agreed but went on to tell us how. He noted that our activities are interspersed with oddities of various sorts. Man's life is a strange mélange of lapses and repetitions, mistakes and errors which have no apparent reason or excuse. Freud devoted a good deal of his life trying to understand this fact. He recognized the aberrant behavior to be an outcropping of a part of the self which escapes direct apprehension. He found himself driven to speculate, to forge hypotheses, to frame new concepts, not only because the self was hidden, but because the conceptions and assertions appropriate to the public world preclude a clear and sure grasp of that self.

One might differ with Freud, as his disciples sooner or later almost unanimously did, as to just what the primary divisions and motives of the self are. Considerable progress has recently been made with group therapies and conversational techniques which Freud did not envisage. But the main work today is still along the lines he laid down. All who have felt his influence seem to hold that the new understanding of the nature of the self which he made possible does not of itself yield a proper or satisfactory control of the self. Knowledge of the self can help only to show one how to free, restructure, or confine oneself. In the end the Freudian is back with the answer men have always given to the question of how they are to

overcome unwanted limitations—they must subject themselves to self-discipline, reorganization, redirection. To be the master of yourself all you must do, says he, is—well, master yourself.

In some cases our errors, odd behavior, and difficulties take up a large share of our attention and time. Sometimes they screw us towards maladjustment and misery, making it imperative that the causes of the aberrations be known, and their occasions or effects avoided. Men have always known that punishment, education, and work, when properly limited and judiciously pursued, are effective agencies in this area. But Freud discovered other, overlooked ways that could be used to avoid expressions of the self which are felt to be undesirable. Unfortunately, he did not pay enough attention to the question as to just what must be done not merely to avoid the undesirable but to achieve the good. This is why perhaps he failed to recognize that art offers a splendid means for perfecting the self.

To say that art offers a splendid means for perfecting the self is quite a different thing from saying that art has a therapeutic value. This it has. But art has this value mainly for those who do not look to it for that purpose. Only they allow art to touch their depths and there elicit the expression of basic emotions. Only they make it possible for those emotions to be freed from excess and diffusion. Art has maximum therapeutic value only for men who deal with it as art, thereby allowing art to work on them as men who need not help but improvement.

Art restructures and purifies the emotions. Those emotions initially are raw and unfocussed, being provoked by what is itself roughhewn and vague. Vaguely aware that the world might injure or destroy me, I am moved to terror. Looking towards what might be the instrument of these disasters, I become afraid. Aware that others are also jeopardized, I feel desperately alone if they have no need of me, or I pity them if they do. These are undesirable emotions, as are their counterparts, the feelings of smugness, overconfidence, self-alienation, and sentimentality. Only if we can hold the world at a proper distance can we subdue the terror and fear, the loneliness and pity which tinge our thoughts and lurk behind every

move we make, and yet avoid the counterfaults of excessive smugness, overconfidence, self-alienation, and sentimentality.

Were we to deal separately with each threatening item, and then only when it confronts us, we would soon be swamped by an unconquerable sea of tasks. We must, if we are to make any headway, deal with most problems before they can arise. One way of doing this is to take advantage of the lessons society teaches. Society can help us avoid both the extremes of terror and smugness, fear and overconfidence, of pity and sentimentality, of loneliness and self-alienation. Quietly and persistently it edges all of us towards the mid-point of these extremes.* Education, knowledge, training, technology, and the established conventions, traditions and taboos help reduce our terrors and fears. Criticism by work and practice, and the failure that comes to men because they live in a world not altogether in their control, cut down the tendency to smugness and sentimentality. Pity and loneliness are restructured through love and charity, and law and social criticism keep our overconfidence and self-alienation from being expressed in lust and prejudicial favoritism. But society never touches the roots of things. It has found no way of preventing excess except by the inculcation of habit, the removal of opportunity, and the development of a fearsome respect for its power. When these fail to control men, society punishes. But it then always acts too late and is rarely effective in preventing reoccurrences. Men are never wholly or properly remade by society. Society also acts to inhibit our expressions, not knowing how to utilize them for maximum good. It regulates the expression of love and enthusiasm, the one through the conventions of courtship and marriage, the other through ritual and creed.

If we can make our emotions conform to the contours, time, structures and consequences of things, we will be able to express them with

* There are many other emotions besides those here focussed on. Some of them at times come insistently to the fore, crowding out all the rest. But they can be understood in terms of the others. Hope is directed towards what prevents fear; hate towards what promotes it. Shame is directed at oneself, condemnation at others, for not reaching the midpoint. Despair is persistent shame without, while remorse is persistent shame with, hope. Pride is self-approval for having made the mean; admiration is approval of others for having done so. Envy is shamed admiration; contempt is proud condemnation.

appropriate strength in proper ways and places. We do this when we plan our acts, engage in disciplined activity, or work at a craft. Were we suddenly to see a stabbing, done or suffered by us or another, we would be shocked. Were we able to free ourselves from the social conventions which even then make us keep our distances, we would be flooded by fear and hate, rocked to our foundations. Were the stabbing planned by us, however, we would, so long as the situation was within our control, express ourselves coldly, spelling out our feelings along the lines of our designed act. In the different cases our emotions would have distinctive rhythms, routes and outcomes.

The emotion expressed by a spectator of an acted stabbing is quite different from any of the foregoing. It is an emotion elicited and directed by an ordered, isolated work. This gives the emotion a distinctive structure, role and clarity. The result is a sobered emotion, expressed more neatly and more appropriately than that which an actual occurrence, observed or designed, might elicit. There are times, to be sure, when the awkwardness, inchoateness, the dark density of unordered emotions do not matter and might even be desirable. No emotion is properly geared to a birth or a death. But these emotions, though not appropriate to the event, are appropriate to the occasion, to the situation as involving oneself and others. They offer a good index of the degree of one's concern or involvement and of one's need to make contact with another. Emotions expressed in the creation or appreciation of a work of art, in contrast, are worked out and through until they become appropriate to the work and to the creator or spectator. Such emotions tell us less than raw emotions sometimes do about the character, interests and needs of a man. But they do testify to the fact that a sensitive man and a work of art are in accord. The love of men and women, because sustained by half-suspected secrets, deep-rooted anxieties and tensions, individual tempers, and semipersonal needs and appetites, has a single integrated rhythm only rarely, and then for but short spans. The enjoyment of art is less intense than love, but it is also better controlled, longer lasting, more unifying.

Most of the so-called harmony between humans is but an absence of signal discord. In art the harmony, while more positive and per-

sistent, is also more one-sided and expendable. The emotion appropriate to art is different in quality from that accompanying the acknowledgment of any matter of fact. As Hindemith observed,

> If we experience a real feeling of grief—that is, grief not caused or released by music—it is not possible to replace it, at a moment's notice and without plausible cause, with a feeling of wild gaiety; gaiety, in turn, cannot be replaced by complacency after a fraction of a second. Real feelings need a certain interval of time to develop, reach their climax, and fade again; reactions to music, however, may change as fast as musical phrases do; they may spring up in full intensity at any given moment and disappear entirely when the musical pattern that provoked them ends or changes. Thus these reactions may, within a few instants, skip from the most profound grief to utter hilarity and on to complacency, without causing any discomfort to the mind experiencing them, as would be the case with a rapid succession of real feelings. In fact, if it happened with real feelings, we could be sure that it could be only in the event of slight insanity.

Unfortunately, since Hindemith takes the feelings provoked by nonmusical events alone to be genuine feelings, he concludes that "The reactions music evokes are not feelings; they are the images, the memories of feelings." But these supposed "memories of feelings" are not memories at all. They are genuine feelings, then and there experienced as fresh occurrences. Like all other feelings they have resemblances and affiliations with feelings undergone in the past. The fact that they have a different occasion, use, tone, and pace than that characteristic of the feelings provoked by objects outside the world of art, provides no warrant for the belief that they are residua of something more real, ultimate or genuine. The grief "caused or released by music" is a grief which cuts and bites and upsets; since it is confined within the musical situation, it is unable to disturb much beyond the time that the score allows. Sometimes a man in ordinary life will pass quickly from grief to joy—on hearing for example that a dear son, supposedly dead, was actually alive. This sudden passage from one extreme of feeling to the other does

not compromise the reality of the feelings. Why then suppose that it must compromise it in the world of art?

An artist begins by separating off the raw material on which he is to work from the affairs of daily experience. He cuts it away from irrelevancies, holding it apart from its context, freeing it from the jostling of the indifferent companions it has in the workaday world. The emotions he had when he initially encountered that material are now excessive. The material which the artist isolated is not complex or meaningful enough to be a proper object of the emotions which the material, in its original context, had provoked. His act of separating off his work from the world, because it involves the detachment of the emotions from the world, results in a disturbance of his innermost being. Like a man bereaved or in love, he is somewhat in disequilibrium, filled with energy and tendencies he does not know how to use.

If futility and frustration are to be avoided, the detached emotions must be expressed, and this in a double way. They must be made to terminate in an appropriate object. Substantial objects, natural or created, alone are worthy of the emotions. Substances provide limits to and a rest for their expression. To allow emotions to terminate in anything else is to allow them, at least in part, to explode without purpose and with little use or value. The emotions must also be spent appropriately. They are disturbances in attitudes, affecting the functioning of both the body and the mind. In and of themselves they are unorganized. Consequently, he who lives emotionally lives partly frustrated and partly misdirected, without a clear object in view. Only when the emotions are geared to an activity of creation do they find an appropriate form of expression. In the making of a work of art, the emotions are structured by the structure that is produced through their aid, thereby becoming better expressed, more in consonance with the objects at which they are directed. They are then refined, redirected, made to yield a result better than themselves or their usual expressions.

A work which makes full use of the emotions not only terminates and helps structure them, but is experienced as completing us, as a self-sufficient universe which answers to our deepest needs. A work

of art satisfies the emotions because it is enjoyed as self-sufficient, iconizing a reality which exists outside it and outside other substances. In being satisfied those emotions are purged, as Aristotle long ago observed.

Following Aristotle's lead it has been customary to speak of the purging of the emotions as relating only to the emotions of pity and terror and as being undergone only in the course of an acted tragedy. But there is a purging in comedy as well, and there is a purging in painting and dancing, in poetry and architecture—in fact in all the arts. Every art provides disoriented, unorganized emotions with a more controlled but also fresher, sobered, and more adequate expression than they otherwise would have. The need to do justice to the emotions is the subjective side of the need to master a world which at once threatens and defies. No art, though, is to be pursued merely in order to do justice to the emotions or to help us master the world beyond. If it were, it would be indistinguishable from a work of craftmanship serving the ends of pleasure or control.

The common objects of daily life, which a work of art may picture, are themselves avenues through which existence is manifested. The emotions usually expressed with respect to these objects have relevance to art bcause art exhibits this existence even when apparently portraying only ordinary things. Only existence can quiet such a great emotion as terror and such small emotions as fear—the latter being but the former made pivotal, finite and familiar. Since art is concerned primarily with existence and not with finite transitory expressions of it, a work of art need not occupy itself with a representation of familiar things. But a work of art must provide clues to familiar things if we are to grasp the nature of existence as expressed through those things.

Since the familiar things focussed on by the artist are emotionally acknowledged, they are viewed by him not as they are in themselves but as having pertinence to him. His work is no mere exteriorization of himself as an individual. When he creates, he objectifies and transforms his emotions, imbedding them in the work itself, thereby expressing what familiar things mean not for him as a unique being but as a man. The existence which is in himself and which he ex-

presses emotionally in his creative act, iconizes the existence outside him, as affecting his destiny. The existence which is discerned through the veil of familiar things is consequently grasped as having pertinence to man.

Collingwood, the most original English philosopher of modern times whom his compatriots unfortunately neglect, remarked that "Until a man has expressed his emotion, he does not yet know what emotion it is. The act of expressing it is therefore an exploration of his own emotions." The observation can be accepted without adding, as Collingwood did, that the man "is trying to find out what these emotions are." One does not express the emotions to explore them, or even to purify them. One does not even express them to learn about oneself as a human being or as a representative man. The emotions are insistent and a burden. One must rid oneself of them. The explosion of them in the ordinary course of events is rarely desirable; discharging them in a controlled way permits of their maximum, beneficial use. But this result is obtained only by those who attend not to the emotions but to the task of making a work of art. All art offers a continuation of oneself inside a new domain; the new domain, the world of art, as occupied by the products of one's emotionally sustained creations, supplements one's being, giving a man that which he needs in order to be more complete.

A work of art is emotionally produced and encountered. By means of our emotions we hold ourselves away from the world; by means of them we impose new relations on that part of the world we are now working over; and by means of them we look at the result and grasp that reality which lies behind all we see, are, and do. As a consequence we are able to participate more and more in life and in the world.

"If you want to express the terror which something causes," said Collingwood, "you must not give it an epithet like 'dreadful.' For that describes the emotion instead of expressing it, and your language becomes frigid, that is inexpressive, at once. A genuine poet, in his moments of genuine poetry, never mentions by name the emotions he is expressing." A poet may of course mention the name of the emotion he is expressing; but Collingwood's point is nevertheless well-taken. The task of the artist is to express, not to classify the emotion which

is being expressed. But the expression of the emotion is only part of his achievement. It is not his primary objective. In the light of an attractive prospect, he emotionally works over material to make a work of art. His product, though individual and unduplicable, has features in common with what he has made before and what others make in that and other areas of art.

7. COMMON FEATURES OF THE ARTS

ALL works of art involve the emotions; all are the outcome of genuine creative efforts to produce excellence in a sensuous form. In addition, all have a number of significant features in common. That is why it is legitimate to deal with them philosophically, in terms of rather broad categories. That is why it makes sense to look for standards and criteria for them all. To be sure, the different arts have distinctive problems, work in different materials, and produce different types of outcome. That fact will enable us, in the sequel, to classify the arts. The present effort to isolate the features shared by all the arts will, like the effort to classify the arts, run grave risks. Not the least of these will be that the author and the reader will almost inevitably tend to treat the accounts as prescriptive and complete. Again and again in the history of aesthetics similar efforts, even when accurate and illuminating, have led men to ignore those works of art which did not ostensibly fit within the given rubrics.

Again and again men have therefore tried to get along without any characterizations or classifications of the arts. Only in this way, it was thought, would it be possible to deal with works of art with independence, sympathy and freshness and be ready to welcome developments not yet known to the generalizers and classifiers. But if one did not know what the essential characteristics of an art were, how could one know that a new product was a work of art at all? If one had no classification of the arts, how could one know whether or not a new development was but a variation on some older art or a distinctive, not yet envisaged one? It is suicidal to refuse to make use of criteria for determining whether or not something is a work of art. It would be uncritical of the philosopher of art—indeed it would be unphilosophical of him—to remark (as he does and must) on signal features of the arts and to employ criteria for determin-

ing what a work of art is in itself and in relation to other works, and yet not make explicit what these criteria are.

This chapter offers a set of criteria, not canons and not descriptions. Canons are generalizations of practices followed in certain schools, conformity to which shows that one is competent to be a member of the school. Criteria are not descriptions. They do not report what is in fact to be found in actual works. They characterize ideal cases, defining paradigms, models, perfect works which actual ones partially and not altogether clearly illustrate. They are neither mere generalizations of what has been done nor a priori rules to which practitioners must attend. Initially abstracted and generalized from actual cases, they are freed from irrelevance, critically examined, corrected in the light of one another, until they meet the specifications of categories which also illuminate and order other activities and realities.

Through a control of generalizations by what is learnt from an examination of many different works of art and by what one knows of basic principles which are exemplified in everything whatsoever— art and science, the living and the dead, the good and the bad—one reaches universals which are pertinent to, and can therefore serve as preliminary guides in understanding the arts severally and together. Results initially achieved can be corrected by a reapplication of the same method until one arrives at a critically tested set of characterizations and a helpful classification. We avoid the folly and dangers attendant on attempts at common characterizations by checking what is said regarding one work with what is said with respect to other works in the same art, and what is said regarding works in one art with what is said regarding those in another. And we avoid the folly and dangers attendant on the acknowledgment of general principles, by correcting any disposition to apply these principles dogmatically through a confrontation of them by what we learn from the works of art themselves. What is defective in the results can be known if they are made public, and other men as a consequence make an effort to find out if there is anything wrong with them in fact or in principle.

Throughout one faces the difficulty of finding terms which can be

understood by the practitioners and students of the different arts. The meaning of terms in one art are usually conveyed by different terms in other arts. Yet if terms are taken from common speech, from some other enterprise, or are newly forged for just this occasion, it is more likely than not that their import will not be readily evident. It is not wise, I think, to use either method exclusively. Sometimes there is less danger in borrowing a term from some one art (and perhaps extending it or qualifying it somewhat) and sometimes less danger in making use of common terms (though with some effort at making their usage more precise). There is no way, except that of trial and error, of finding out which works better in a given case.

The essential features to be found in all the arts can be conveniently collected under three headings: *themes*, referring to the type of thread one can follow in the course of enjoying a work of art; *structure*, referring to the way the various parts of the work are related; and *outcome*, referring to the product as encompassing the interrelated parts.

Themes

"Theme" is primarily a musical term relating to a melodic sentence developed throughout a work. In literature it refers to one large controlling idea. Used here, as having reference to every art, it relates to those pivotal points which are repeated with or without modification throughout a work. It is thus closer to what is sometimes called a motif or phrase in music than it is to what some musicians call themes. They take the musical theme to embrace a plurality of phrases, and thus a number of recurrences of a motif. But "theme" I think is a better term to use; even musicians sometimes use it alternatively with motif. In any case, as here used it refers to a unit part, of any magnitude or complexity. A theme can be conveyed by a single focal item—or by a number of these as constituting a single unit—reproduced with modifications throughout the work.

Definiteness: Themes are identifiable, definite, focal points. But they are not sharply demarcated; if they were, the organic quality of the work would be destroyed. But if they are not at all distin-

guishable the work is blurred. The architectural module, the painter's design, the sculptor's curve, the poetic metaphor or paradox, the incident or character in a play, and the gesture or movement in a dance, are so many definite and fairly simple themes.

Luminosity: A color is said by painters to be luminous if it is bright, clear, shining, vivid. Extending the term to apply to a theme in any art, it refers to the intrinsic value of the theme, to the fact that it is focal not because of some extrinsic interest or association but by virtue of what it itself exhibits. Without any luminous themes a work is dull, flatted, muddled, brown. With too many luminous themes a work becomes overcharged, overinsistent, disruptive.

Luminosity is not a constant. A theme may be luminous in one place and not in another, either because it has been dimmed or because its neighbors take away some of its force. A theme may have to be dimmed in order that the whole may be unified. It is possible in fact to have a vital work produced through the use of themes of low luminosity. But if nothing luminous is provided by the artist the spectator will either be unable to find his way in it, or will introduce alien stresses into it. The artist is most in control of his work when, without losing its organic quality and internal rationale, he provides isolatable luminous themes in it.

Grain relates to the quality of the material in which a theme is imbedded. A work of art always gives some grain to a theme. Theme and grain together make a unity of form and matter. Or, more dynamically, the theme in abstraction from its grain is part of a strategy, of a mere structure, and its grain is part of a tactics, one of the ways in which the strategy is carried out; the two together, the grained theme, are in turn part of a tactics in the production of a sensuously textured, thematically developed whole.

Without grain there would be only a formal order, an abstract form without location. But if there is just a minimal grain the work will be too slick, too smooth, without sufficient challenge to the effort to stay with the thematic development. If there is too much grain, if the grain intrudes on the theme, it obscures the theme's nature. The work as a result will be roughhewn. Too much grain dims the luminosity of the theme, just as too much luminosity may

hide the presence of the grain. Luminosity, though an effect produced by the material which provides the grain, is actually part of the theme. It is possible therefore to have high luminosity with little grain and low luminosity with conspicuous grain. A rough-grained green may be as bright as a smooth-grained one; a soft voice can be as clear as a hard one.

Grain resists, forcing one to move from part to part inside the work of art. It should vary in quality over the whole to constitute a single texture. If it does not vary, the texture will be too external to the developing theme. If the grain varies too much there will be no ascertainable resistance offered. If it varies proportionately with the theme, the work will be wooden, rigid, rule-determined. If it varies in complete independence of the theme it will be distractive. Variations in grain should be independent of variations in theme but still in some felt consonance with it, to yield a nuanced texture.

Structure

This term is perhaps used in all arts in somewhat the same way as referring to a single tissue of thematic occurrences, mutually supportive.

Modulation, as usually employed, relates to the process of shifting keys in music. It is also used in painting to refer to a transition from color to color. As here used it embraces that meaning as well as what is usually designated by "plasticity." The latter relates to a transition from shape to shape in sculpture. Generalized so as to be applicable to all the arts, modulation relates to any graduated transition from one thematic focal point to another. The difference between two points may be imperceptible or they can be sharp and shocking; modulation is possible in either case. There are to be sure sudden breaks in every art. But were there no modulation from what is on one side of the break to what is on the other, the work would be broken in two.

Every feature of a work of art achieves maximum value only when produced in the face of a risk of signal failure. To move between points which do not differ much from one another is to carry out an easy mode of modulation. The work will then lack vigor. It will be

pretty, gentle, lulling, not capable of arresting attention or involving one deeply. There is little of interest in a tone continuously altered in intensity in one direction or in a color gradually changing in intensity over an area. If a number of other transitions, say of words or pitch in the one case or shapes in the other, were also produced the interest would be heightened. It would be a little more interesting to see a painting in which less and less vivid reds occurred together with smaller and smaller or larger and larger circles, for example, than to make use of only one color or shape. But it would be better still to have, say, the transition from shape to shape sharper than that characteristic of the transition from color to color. It would be even better to have the transition change in tempo many times in the one case, while remaining constant in the other. Should both change in tempo, and in independence of one another, chaos and dispersion would result. Modulations of different types of entity inside the same work must have some affiliation; they must not all be continuous, and they cannot all be sudden. If there are sudden transitions in one dimension which defy or almost defy a prolongation of the attitude germane to one point into another, there ought to be gradual transitions in another dimension so as to enable the work to hold together.

Bleeding, a term having primary application in dyeing and bookbinding, relates to the manner in which one item cuts into another. Modulation is a bleeding which the work forces the spectator to produce; bleeding is a modulation produced by the introduction of one quality into the area of another. Assonance and alliteration help one carry sounds over into disparate words and meanings; different instruments at different pitches can be made to bleed into one another through the use of the same phrase.

The pointillism of Monet and Seurat has sometimes been described as though it demanded a rejection of bleeding. But the pointillist, though he proceeds by producing a set of dots on a white background and leaves it to the spectator to merge these when looking at them from a certain distance and position, can as a matter of fact produce his effects only because the colors do bleed from some of the dots to others. Where there is no bleeding there are only dis-

crete items, a mere plurality of focal points having nothing to do with one another. Bleeding makes the work continuous.

Molding in sculpture (its meaning in architecture is quite different) refers to the fact that a work has been organically produced by making part responsive to part. A building can be molded, and so can a poem, a dance, a symphony, and so on through the arts. In each case the molding is the result of producing parts of a work in answer to the demands made by other parts. Every part is incomplete within the context of the whole; it demands something else which will supplement and contrast with it. Strictly speaking it is the whole work which is molded and not the separate parts. The parts are produced from within the work, constituting it by their interplay. Where there is no such molding there is only a mixture, a medley, a potpourri. The items then do not constitute a work; they are merely together, in a place. A collage, though its items are merely glued together or tacked on a canvas, is to be considered as a molded work so long as those items constitute a single artistic unity. A mouth can be painted on a head with the same paints and in the same manner as are used elsewhere in the painting. The color and shape of the mouth may bleed into the rest; there may be a gradual modulation from the intensity of the mouth to the rest of the head. Nevertheless the mouth may be not an organic part of the picture, but merely something put there from the outside.

Spacing is a term which is not the special property of any art. It relates primarily to the "negative" elements in a work, the silences in music, the rests in poetry, the recesses in architecture, the negative space of painting, the syncategorematic terms of the story, the periods of waiting in a drama, and so on. This spacing is not to be slid over; it is to be taken as positive, as having its own demands, with limits at the thematic focal points. We can remain quiet only for a certain time. The quiet has its own measure, insisting that it be closed after a while, that it be silenced by sound. To neglect it is to miss half the work, for it is to see the work only as relating the usually focussed parts to one another over an indifferent distance, rather than as one in which there is also a relating of the unfocussed parts by the focussed ones.

"Spacing" also relates to the work of the "positive" elements on behalf of the negative. Themes function both as relations and terms; empty space is a theme as well as a relation. The "positive space" of a painting spaces the "negative space" as surely as the negative spaces the positive. Tones space the rests, foreground spaces the background, as well as conversely. Every part of a work, silence as well as sound, shadow as well as light, recesses as well as protuberances, background as well as foreground, has a role to play in it.

A work can have spacing even though it has no absolute silences, rests, emptiness in it. What is needed is something which spaces the parts of the work, be they focussed or unfocussed. A crowded work has not enough spacing. A divided work has too much spacing. Where the negative space is uninteresting there is poor composition; a good composition demands that every part, negative as well as positive, have value. A good work has a foreground because some parts function as background. Since the background must be capable of being foreground, the normally accepted foreground of a work of art, despite its intensity and familiarity, must be capable of functioning as mere background, offer a spacing for what before was background.

Development: A good structure is achieved when a theme is developed throughout a work. The theme must vary not only in emphasis, extent, luminosity, but must be stressed, qualified, contracted, expanded, dimmed, and intensified in different ways throughout. Its direction, pattern, order should be altered again and again in an attempt to exhibit its full power and promise. A work in which the theme is changed at every point is restless; a work in which it is not changed at all has a monotonous structure. The best work has intervals between the different occurrences of a given theme, and has no fixed or predictable manner of presenting the theme in a new place, being able to repeat as well as to invert, to qualify as well as to intensify.

Climax: In the theatre the climax is the highest point of the work, the place at which all the problems are clustered and resolved. Usually it refers to the highest point in a progression of terms, incidents, or adventures. Since plays do not usually end at a climax, or do not have the climax centered in one momentary incident or

occurrence, a climax is also a turning point. Extended to apply to all the arts, the term "climax" is to be understood to refer to an unusually stressed turning point, one towards which a development is progressing and from which another takes its start. He who merely develops a theme ends with a decoration. Decorations are lax; they produce no involvement and cannot help to refine or redefine emotions or meanings. The theme must either itself function in some place as a climax or must yield before such a climax, thereby giving the work a change of pace and focus.

A climax can be unprepared for, come too suddenly, in which case it is artificial, dividing one from the work. It ought to be prepared for in a series of minor climaxes, by a number of less intense and less radical turning points. Too many of these will result in a shocking or irritating work. One must arrive at the climax through a series of separated minor climaxes; between them there should be tensions, drawing one towards the climax to come. Each subordinate climax is thus at once a problem resolved and a problem presented; only in the major climax do we have final answers.

In every art all the problems are essentially problems of aroused expectation and what must be done to satisfy it. Each subordinate climax at once quiets and arouses expectation, changing its direction and its import. The difference between the major climax and the subordinate ones may not be very great. A shift in perspective may in fact make what is subordinate into a major climax. But a single work demands that there be only one major climax from one perspective.

Anticlimax is produced by focussing on themes of a lower order after the main, summational work has been done. In acting, it is to be found in the unnecessary gesture and the refusal to occupy the proper place; it is dislocation and emphasis beyond what is needed. In dancing, it is exhibited in the return to prosaic movement, the falling back into the commonplace, after an effort at maximum achievement. The danger in dancing is greater perhaps than in any other art, for every dance movement comes to rest in the prosaic; there is a strong tendency to close all dances too soon. The final rest must be encompassed within the dance itself.

Scale is a term borrowed from architecture. (In music it has a

quite different import.) As here used it has affiliations with beats, cadences, and pace, units which enable us to get into a work and live with it. Every work of art has its own scale, and every work exhibits this in a way which can be known only by one who allows himself to be slowed and quickened, raised and lowered, redirected and blocked in accordance with the stresses, emphases, and interrelationships of the work. A scale has a reference to the nature or attitudes of a possible spectator. A theme can be taken to offer a scale, but it will then be seen to function in a new way. Empty spaces provide scales too. In any case, themes are followed through, whereas scales are used. By using the scale instead of following a theme one tends to make the meaning of a work, as pertinent to man, more evident.

Complexity: A developed theme yields a structure. An integrated development of a plurality of themes yields a complex structure. A work may have more than a single type of theme. If it does, those themes should fit together. If they do not, the work becomes fragmented; if they fit too easily the work is obvious. A subtle work has a plurality of climactic points, but only one major climax. The themes, when functioning as climactic points, should contribute to the major climax, or either be or contribute to minor ones.

Without structures a work would be unorganized, chaotic. Had it only one it would be thin, inane, superficial. A mere plurality of structures would yield only a plurality of works in a single area. A complex structure gives it body, solidity, interest. What is needed is difference in prominence; some developed themes should be prominent and others recessive, though what is recessive from one position may be prominent from another, forcing what had been prominent to then be recessive. A work in which every theme can achieve prominence from some position or other, or by a stress on some elements in the work, is universal; one in which only some themes can have this prominence is programmatic. The former is characteristic of the monumental works of art to which mankind has returned again and again for inspiration and enjoyment—Homer, Shakespeare, Michelangelo, Da Vinci, Bach and Beethoven. It is evident in the great cathedrals and that one single cathedral, New York, whose buttresses are skyscrapers.

Harmony is a musical term relating to the simultaneous occurrence of sounds or to sequences of sounds of various pitches. An harmonic work combines a number of melodies, each of which is a structure of sounds. Generalized to have application to all the arts, harmony relates to the way in which a plurality of structures contrast and cohere. It demands that recessive structures support, supplement, not minimize the dominant structure. If the presence of secondary structures involved some loss to the primary structure the work would be blurred; if the secondary structures conflicted with the manifestation of the primary, cutting into it perhaps or forcing one to turn away from it, the work would be dissonant. The more distinctive the themes making up a complex structure the richer the harmony. Still, each increase in difference risks loss of a unity in which, from some position or other, every theme can be dominant with the others recessive. It is necessary to increase the distance between themes up to the limit of possible incoherence. They should have different tempos, types of spacing, modulation, bleeding and the rest, so far as this is consistent with their constituting a single unitary work.

Outcome

A work of art is rarely produced with the preceding considerations in mind. Nor is it usual to enjoy a work by attending to them. Their acknowledgment makes possible the better mastering of techniques and the sharpening of sensitivities. They are good therefore for teachers and students to know. But it is the outcome of the creative act which is of primary interest to all, except perhaps to the artist himself. He is more concerned with the production than with the product, though he of course recognizes that the production merges into and is tested by that product. He reaches his outcome through the practice of two rarely acknowledged acts—omission and closure —which make the product as excellent as he can make it. The result is a single work having four dimensions—design, meaning, rhythm and unity. When these are present the work can be said both to represent and to be beautiful.

Every artist knows that there is a place where he ought to stop. He knows that, like everyone else, he tends to hide, to fake

a little, to allow his cleverness to take him over hard spots. There is a great temptation to put a special finish on his work which it actually does not merit. Every artist knows that he lacks the insight, the ability, the interest, the techniques to be able to do more with a work at a given stage than spoil what he has so far achieved. Each must decide for himself in each case whether or not he can do more. The decision is no intellectual exercise, no act of the separated will; it is a reaction to his awareness of the fact that his character, the nature of the work, and the process of creation are about to lose an intimate relation one with the other.

Every artist must practice closure. It would be ideal if he could achieve a psychological closure, bring about a whole which defined his work as being at an end. But he rarely has such an opportunity; he must decide before psychological closure is reached that he has come to the end not of the work but of his own working. Too late a closure brings the work towards the tawdry, the contrived, a matter of tricks and slickness. Too early a closure results in a partial work, a sketch, or a schema for a later, more adequate effort. And since different parts of a work demand different abilities and restraints, it is possible to have too late or too soon a closure with respect to this or that part rather than with respect to the whole. Such closure is not to be identified with omission. Omissions are demanded by the work itself and serve to improve it. Closure is required of the artist and prevents him from marring his work.

Since every artist is imperfect, even his successful works will exhibit a closure in the parts or the whole. The result, though falling short of being a psychological or artistically perfect work, will be honest. The honest work shows us the artist at his best; only at moments does he, at his best, make the best possible work of art.

Design: The use of themes, the interrelating of parts to make structures, the practice of omission and closure with respect to the work as a whole, yield a single work of art. The actual observable nature of that work as a whole is exhibited in its overall design. No matter how complex or how achieved, there is an overall pattern to it. This is of major interest to the masters of the style of a given artist, to those who think that formal criteria can be provided for

the determination of the excellence of a work, and to those who think that a work of art is a completely self-enclosed form to which the sensuous content is, strictly speaking, irrelevant. Without an overall design there would be chaos; too explicit a design makes art give way to ornament. Design must be present, but together with other pervasive features.

Meaning: The work of art makes evident the meaning of an ideal beginning, turning point, or end. This need not be done by explicitly or conspicuously pointing up one or the other of these. A play may begin with a climactic event, as *Medea* does, and decelerate as it goes on; it may have its climactic event somewhere near the middle, as *Caligula* does; or it may, as in *Anthony and Cleopatra*, have it come quite close to the end. But the meaning of spiritual or physical death could be said to pervade them all. Without meaning, there is nothing to be communicated; if the meaning is overwhelming, no work is sensuously enjoyed. The meaning of a work is not primarily an object of an intellectual process but of a man exercising his emotions, and thus his mind and body as intertwined.

Rhythm: Every work of art has a rhythm. The various parts are paced and bunched in different ways to yield an overall dynamics. The master poet and composer flattens an occasional note or delays the recurrence of a beat to produce not only an extra stress upon some desired feature but to make for a more adequate whole. The entire work must have a rhythm which is a reflection not only of its capacity to present the nature of existence to us, but of the way in which that existence has been brought into consonance with the existence in ourselves. Simple rhythms are tiresome; overcomplex ones are tiring; the one shows a failure to do justice to the comparative complexity of existence beyond us; the other shows a failure to do justice to the comparative simplicity of the existence in us.

Unity: A work of art is self-contained, significant, and structured; it has unity, a texture and rationale, and it makes possible both the enjoyment of the quality of existence and an awareness of existence's import for man. No work of art answers to this description perfectly; all answer to it more or less completely, for all offer more or less perfect instances of works at once beautiful and revelatory.

A work of art results from the interplay of a textured structure with a prospect. A work of art is a whole in which both structure and prospect are important. So far as the texture of the whole is enjoyed the work is opaque; if the whole is also enjoyed as self-sufficient, it is treated as iconic of an existence beyond it and to that extent is translucent. The work of art is both. It is a created object in which textured structure is married with prospect to yield an opaque self-sufficient iconic unity.

Aristotle has been interpreted as saying that a work of art—or more specifically a play—must have a unity of space, time and action. The texts are hard to discover. In any case, the claim is difficult to understand. What is a unity of place? No dramatic action occurs at a point. What maximum magnitude can a region have before it loses unity? Or must the region be continuous? If so, when a messenger enters, does he disrupt or preserve the unity of place? In a play, allusions to other places bring in the exterior world through words and intent, and change the nature, direction and import of the action. Does this disturb or promote the unity of place? The idea of unity of place seems most unclear.

The unity of time too seems unclear. Is there any necessity for holding that a single day is more a single time than a week or an hour? Do references to other times disrupt or promote the unity of time? Action in a play is dramatic, heightened, concentrated. No one takes as long to write a letter on the stage as he would in daily life. Strictly speaking, the two times are not even comparable. How can the time in a play be compared with any other time? Must we not stay inside the play and decide that it has a unitary time if it is a unified play? Theatrical time is quite different from time elsewhere. It is not the time of clocks or history, of common sense or theology; but it is a real time nevertheless. Its unity is defined by the way in which what comes later closes the development begun earlier. Thornton Wilder's *The Skin of our Teeth* covers aeons; *Rashomon* deals with a rather brief event and does it again and again. Both are unified plays.

Nor does it make much sense to speak of the unity of an action. Every action is a unity. The entire work, if a unity, has a plot which

comprises one action. That action encompasses a plurality of subordinate actions each one of which has a unity of its own. A unitary work dictates what is to be understood by a unitary space, time and action, not conversely.

The three traditional unities have value if taken as warnings of the areas where irrelevancies tend to creep in. Arbitrary jumps in distance, condition and aim, the introduction, without preparation or purpose, of new rhythms and themes, sudden radical changes in direction, are risky. The unity of a work of art is the result of an act of creative unification.

A unitary work of art has a self-determined closure. Its beginning and development dictate when, where and how the closure is to take place. Since all works are closed sooner than they ideally should be, all have an imposed unity while remaining actually somewhat open. One can of course acknowledge whatever ending there be and take this to redefine the beginning and development as having that ending as the closure. If this is done, then every work will have an objective unity which will nevertheless permit it to be incomplete, not as excellent a whole as it should and could be.

Closure relates to the parts of the work in interrelationship, emphasizing the points taken as beginning and ending. Cutting across closure is a unity dictated by the prospect exemplified in the work. Too great a stress on the prospect will make the work programmatic. But the failure of the prospect to permeate the work will allow the nature of the medium to have too great a counteracting role. In that case, the work will point in two directions: to the prospect which was to be realized and to the material which was to be mastered by that prospect.

That a work is beautiful is a truth about it, but this truth is not to be found within the work itself. The beauty of it is an overall characteristic, making a reference to all the features of it, and particularly of the fact that a prospective meaning has there been given a proper textured structure. Sentimentality results when the meaning is not mediated by an idea which is pertinent to the nature of the material. The meaning then seems to have taken up lodgement inside the work, when as a matter of fact it is entirely outside it and is

brought in only at the moment by the sentiment. Many stories take advantage of the readiness of men to laugh or cry, to sympathize or hate. Instead of eliciting and molding these expressions, they merely provoke them. Plays about national victories, heroes or disasters, happy beggars, blind children, prisoners of war, innocents on trial for their lives, and the like, rarely succeed in being anything more than box-office successes. Prettiness results from the use of an idea in separation from the prospective to which it refers; the work then becomes a vehicle for some doctrine or finite truth and misses excellence. Meanness results from the use of ideas which distort or misrepresent the prospect; formalism results when one attempts to express the prospect instead of making it permeate the work. Only when an ideal prospect permeates the entire creation do we have an excellent object, a work of beauty.

That a work of art is revelatory is also a truth about it. It is also a truth not to be found in the work. That truth exists only so far as the created product is related to something outside it. We imply this fact when we speak of a work of art as a comedy or a tragedy or as joyous or sad. The comic or tragic elements in the work would be only peaks and valleys in a design were it not that they are caught within the texture of existence, thereby enabling us to grasp the root of the promise or threat which the universe has for us. It does this, not in its parts, not by virtue of what it may convey at some particular juncture, but by virtue of the relation which it, as a whole, has to the whole of existence.

Evidently, the nature and occurrence of beauty and the capacity of a work to reveal something beyond itself are recondite, difficult matters. Each deserves to be looked at more closely. This is done in the next two chapters.

8. BEAUTY

An excellent work of art is a beautiful work of art. The beauty must be encountered to be enjoyed, and it varies in content from case to case. This fact would seem to put beauty beyond the reach of conceptualization, communication and understanding. The difficulty is not avoided but increased when one turns from the works of art to examine their effects on men.

The view that a work of art is excellent because it satisfies deals with a work of art in terms of its effects. This is perhaps the most dominant view of our time. Just what its defenders wish to maintain is, however, difficult to determine. Is it the satisfaction of any individual that is intended? Since what one man finds satisfactory another does not, we will then have a plurality of somewhat incompatible measures of excellence. Should all satisfactions be equated? This would put those who are sincere and sensitive on a footing with those who are prejudiced against art, with those who are unfamiliar with what is intended, and with those who look at it in the light of some perverse or extraneous interest. Or is it to be supposed that the excellent is that which satisfies most completely? Yet sentimental works, works cushioned inside a patriotic context, and works which express current fads satisfy the average person more than those which demand a greater attention and a greater concern for art. Or is the best work of art one which satisfies the largest number of people for the longest time? This would require one to believe that if we know that a work of art is highly satisfying we know something about the nature of that work. But all we would in fact know is that it is then the object of a common sensitivity.

The judgments of ordinary men are often robust, ready, and sure-footed. Unacquainted with current fads, established canons, and the market, they are not affected by such factors. There is an irreducible

ultimacy about most of their judgments which it would be foolish to gainsay. Ordinary men have a rough-hewn honesty to them and have a grasp of basic realities about which all speculations ought to pivot. Nevertheless, ordinary men do not attend enough, do not know enough, do not have interest enough to make it possible for them to see all that experts can. What satisfies most men over the course of time is not necessarily the best of works.

Is an excellent work then one which satisfies experts? They have spent time and energy in study, are as honest as the rest, and are often more flexible. Still, they disagree with one another and occasionally disagree with themselves. They have prejudices, and they make mistakes. No one of them ought to be slavishly followed, for like the rest of us the expert is only a finite man who sometimes fails to see what is there to be seen. His satisfactions offer no final tests of the presence of excellence in works of art.

Ordinary men sometimes differ from the experts. This does not mean that the two are on a footing. The experts might be right and the others wrong. The reverse might also be the case. We do know that experts sometimes make mistakes. They even tell us that they do, and they make unmistakably clear that it is characteristic of most of their colleagues present and past to err grievously. But if experts make mistakes, their judgments cannot be accepted as beyond all questioning. Because we know that even experts may be in error, we know that we cannot hold that a work of art is excellent merely when and so far as it satisfies them.

Every man in the end must trust his own feelings, but it is wise for him to begin by accepting as excellent what satisfies most men, particularly when this also satisfies most experts. Such a consensus of satisfactions offers a good, rough, practical index of the presence of excellence. It would be foolish though to put much reliance on it. Since experts and the common man affect one another, they cannot offer truly independent testimony. It is also notoriously difficult to know what really satisfies either. Eventually we must turn attention away from satisfaction, our own or that of others, if we wish to know whether or not a work of art is excellent.

For over two thousand years men have again and again sought for

some formula which determines or defines the excellence of a work of art. Such a formula at its best, it was thought, would have a mathematical form. Mathematics, after all, is precise and clear; its formulae are fixed and pure. Some of the most unlikely topics have already been clarified and mastered by being dealt with through its agency. He who uses mathematics as his guide through the labyrinth of art should, it is thought, be able to bring light and reason where before was only darkness and emotion. Architects are strongly tempted to use a module throughout their works, getting variety by simple multiplications and divisions of the initial unit. Painting has again and again been analyzed in terms of the golden section, the ellipse and spiral lines, or has been treated in the light of the teachings of a mathematical optics. Sculptures have been measured, weighed, and their curves and magnitudes checked by some formula. There is no reason why poetry, story, the theatre, or the dance should be exempt from such a treatment. Pythagoras long ago showed that what was thought to be the most sensuous, formless and nonrational of arts, music, could be profitably analyzed in mathematical terms. If music is amenable to such treatment, why not other, more palpable arts?

The position raises a number of vexatious questions. If mathematics offers a test of the excellence of a work of art, why is it that mathematicians sometimes use aesthetic criteria to measure the excellence of mathematical work? How does one select, out of the many formulae available, that one which deserves to be exemplified in works of art? How does one know which of the many possible ways of exemplifying a formula is the best one? May not a formula be used in an unimaginative way? May not the material which carries the formula be somewhat dispersed and thus fail to make a single work of art? Are not the formulae which are offered as measures, definitions or determinants of the excellence of works of art but distillates obtained from works of a certain kind? Will there not be different distillates in every generation? There is no reason to believe that, even if every great work in the past exemplified a certain formula, every great work in the future must do so.

Mathematics deals with ideal forms in terms of which everything

else can be judged as distorted, nonrational, unorganized or impre-
cise to some degree. Everything in the world can be judged in the light
of mathematics. But mathematics does not control the material which
it evaluates or in which it might be embodied. Control is in fact ex-
ercised in the reverse direction. Mathematical formulae are altered in
nature, implication and value when they are made into the struc-
ture of things. Because the excellence of a work of art controls it,
that excellence can be expressed only by something which, unlike a
methematical formula, can permeate every part of the work. Formulae
could be used with considerable effect to suggest limits and con-
ditions, to indicate where one might experiment, to mark off places
which had been effectively mastered in the past. Danger lies in
their use as prescriptions, for then they turn out to be devices for
constraining the future by what had been achieved in the past.

Coherence offers a criterion of excellence which is superior to
that provided by such subjective, variable incommensurables as
tastes and satisfactions, or by such external measures as mathe-
matical formulae. It is more than a lack of discord, of course, for
lack of discord can be obtained by an endless repetition of sound,
color or gesture and has no controlling meaning. It is a unity achieved
and maintained in the face of obstacles, dispersions, tensions and
negations and can be found only in unified works where every part
is in active accord with every other.

Coherence is a one in a many, opposition altered or overcome but
not destroyed. Since a one in a many is where the many is, chang-
ing in nature as that many changes, coherence necessarily differs in
nature from work to work. There are different kinds of unities in the
different arts, in different works of a single art, and often in different
parts of a single work. Coherence is therefore too concrete and vari-
able in nature to be identifiable with the excellence of a work of art,
or to measure such excellence. The excellence of a work of art has
the concreteness and variability characteristic of coherence, but it
also has a being and a nature transcending the particular case. Only
because it is concrete and variable can such an excellence be the
excellence of an actual concrete work; only because it has a distinct

being and nature can it measure the achievement of any and every work.

The Good is a better measure than coherence because it is an ideal of which coherence is but a special case. At once exterior to and ingredient in all actual cases of excellence, the Good can therefore offer a measure for artistic excellence and be exhibited in the shape of concrete instances of it. In itself, it is an ideal prospect, which as Plato put it, "imparts truth to the known and the power of knowing to the knower," "the author of knowledge to all things known and of their being and essence." It can be applied to art no less than to life, to play as well as to work. It ought to be realized everywhere. And it has a different content in different realizations. Still, it does not offer a proper measure of the excellence of a work of art, nor is it identifiable with the excellence of such a work. What is needed is a measure which is less general and less alien to the being of a created, sensuous product than the Good can be. Not an excellence in general, nor a type of excellence similar to that found elsewhere is what is sought, but an excellence which is peculiarly pertinent to art. And this the Good is not.

To know that a work is good is not yet to know that it is a good work of art. A bad work of art might express the best of intentions, the noblest of sentiments, and produce great satisfactions and desirable results. It could be badly executed, incomplete; it could be effective only because men were ready to accept it. And a beautiful work of art could provoke undesirable impulses. On ethical grounds, it might be condemned as wanting. Like a Socrates among the Athenians, its merits might be those which most arouse distaste. The excellence which is characteristic of a work of art is evidently not that which is characteristic of an ethical act or outcome.

Gilbert Murray, however, has argued that there is no real difference between the demands of art and ethics. He accepted the ideal of *Kalogathia*, a union of the "fair and the good," of beauty and virtue, as the best of all measures and excellencies. On this view to do a helpful thing, or to do something because it is right, is to do what is at once good and beautiful. He who does wrong does what is ugly;

he who produces the ugly does what is wrong. The ethical good, for Murray, is identical with the aesthetic good. His equation depends, I think, on a failure to distinguish the prospects which concern the artist, the ideal good which lies beyond these, and the beauty which the artist produces.

An ethical act is a desirable act governed by an awareness that one is obligated to enhance existent things, thereby in part at least fulfilling them. The ethical act thus seeks to enhance what is. So far as it succeeds, it incidentally benefits the Good, since it thereby gives it concreteness and effectiveness. But the primary benefit accrues to the beings on which one acts.

The artist differs from the ethical man in at least three respects: he has a somewhat different prospect before him; he acts for a different motive; and he achieves a different type of excellence.

The artist attends to a prospective beginning, turning point or end through the help of ideas and under the guidance of the prevailing myth. These prospects are subdivisions of a single ideal, the Good of which Plato spoke. The ethical man, in contrast, attends to the ideal in its singularity, as germane to whatever there be in this world. And he often does this without the intermediation of an idea and sometimes in defiance of the prevailing myths. The artist may be out of gear with his fellows, but this is because of what he does with what he discerns, not because he rejects the prevailing myths and that at which they point. The ethicist, when out of gear with his fellows, defies and denies the myths, and yet does what all might be willing to endorse.

The artist, unlike the craftsman, has some sense of obligation to the Good. But, unlike the ethical man, he does not seek to enhance some being in this world. The materials he uses might have been put to better use; his work may depress or disturb. His work, though, benefits the Good itself. Through the agency of his ideas he makes a prospective pivotal meaning effectively control the functions, stresses, and interrelationship of every part of the work. The work with which he ends is excellent, not because his materials have thereby been helped to fulfill their promise, but because the Good has thereby been made most real. His work is beautiful because he has made the

Good possess a work and not merely be expressed in or through it.

The artist acts to bring a desirable prospect into the world, to make it control, dominate, affect whatever there be; the ethical man acts to fulfill the promise of things, to make the Good more determinate, to realize it by filling it with the content of fulfilled realities. Few men deliberately seek to realize the ethical good; few are definitely ethical men. But all act occasionally so as to realize it, and all, at least occasionally, are therefore good. And few men give a part of the Good an appropriate sensuous body; few are artists. But all sometimes seek to do this; all, at least in intent, are therefore artistically inclined.

The artist, finally, provides part of the Good with a sensuous field of expression, thereby making it the excellence of an actual work of art. The ethical man instead changes things so that they can provide an appropriate filling for the Good as an ideal. The ethical good is aimed at, and things are acted on to help them provide an instance of it. There is no ideal beauty to aim at; beauty is the result of the way in which a subdivision of the Good is enriched by having sensuous material come under its sway. Ethical men make things do justice to the standards of a worldly relevant Good; artists make sensuous material give lodgement and thereby particularize a basic subdivision of the Good.

Beauty is a special case of the Good. It is that Good when it has been subdivided and then subjected to the limitation that it have a particularized sensuous being. The artist makes the division of the Good permeate, be effective in every part of his work, by working over his material more thoroughly than the ethical man does or needs to. While working he can be said to take a moral holiday in the sense that he does not then concern himself with the fulfillment of the promise of the objects on which he works and does not try to make anything measure up to the external standard of the ethical good.

When we judge a work of art to be a forgery we judge it in ethical terms; we see that it denies warranted expectations in men and thereby injures them. The work could still be beautiful, do full justice to its prospect in the medium. When we say that an ethical

act is graceless we judge it in nonethical terms. We could never properly call an ethical act beautiful, for at its best it is only graceful, i.e., has a desirable aesthetic quality. The ideal of *Kalogathia* is realized if we both enhance a being and make its sensuous side be permeated by the meaning of beginning, turning point, or end. This ideal is sometimes approached in the work of college coaches when they change the bodies of their charges under the guidance of liberal ideals.

The ugly reports the defeat of the beautiful. It usurps its place, showing where a prospect was prevented from permeating an object. Since permeation is a matter of degree one can say that anything less than perfect permeation is so far ugly. Or, conversely, we can say that anything in which there is some permeation exhibits some degree of beauty. The latter way of speaking is more in consonance with common usage. Also it avoids the embarrassment of having to say that most ethical acts and results are ugly, for most such acts and results involve little or no permeation by a prospect.

The ugly is repugnant, offensive. It would seem to be evil. To say this is to come quite close to sharing Bosanquet's ethical characterization of the ugly. He took the ugly to be a contradiction disguised by fraud and confusion—the sentimental presented as touching, the effeminate as tender, the feeble as delicate, the tawdry as brilliant, and so on. But, as Bosanquet himself observed, such an account makes it impossible for ugliness to be in nature, for nature does not disguise contradictions by frauds or confusions. More important, the ugly need not be evil, or the evil ugly. National monuments are the one, not the other; excellent work of art may corrupt. To be sure, if the Good is not present in an ugly work, the work will be evil as well as ugly. But the work will then exhibit two failures, not one: the evil will be the result of a failure to give a foothold to the Good; the ugliness will be the result of a failure to exhibit some prospect throughout.

Beauty and ugliness, like good and evil, are experienced pervasive characters, terminating acts of judgment. This claim has been challenged in many ways, the most constant of which perhaps is that they are not objects of judgment at all but merely termini of special

ethical or aesthetic senses. Just as it is the eye that is used in vision, the tongue that is used in taste, so ethical and aesthetic senses, it is said, serve to apprehend the appropriate ethical and aesthetic realities. Rarely in the history of the world has such an obviously a priori doctrine been allowed to pass itself off as "empirical." The supposition that the beautiful or the ugly is known by the exercise of some special sense is a consequence of the adoption of an atomistic faculty psychology in which the senses are treated as so many distinct powers, each with a particular function that it infallibly performs.

The theory supposes that the eye, nose, tongue, ear, and flesh could know or even note something on their own. But by themselves the senses cannot act at all. The entire organism is needed if the eye, nose, tongue, ear, and flesh are to function. Because it is the individual who perceives and not the senses themselves, we, when we perceive, are able to take advantage of our past experience, can be tensed to act, can be aroused, and can make a number of senses converge on the same object. The senses cannot judge or know; they may help one fasten on data but that is all, for each is only an avenue through which the organism focusses its attention and channels its energies. Had we a sense of beauty, which was like our other senses, we would have to confess then that we would not be able to know by means of it, and that we could not be able to perceive beauty by means of it alone. The theory that there is an aesthetic sense is not only unwarranted; it is futile, unable to do the very work for which it was invented.

It is the self, making use of mind, will, emotions, and bodily tendencies, which alone knows. And it knows most fully when it judges. Beauty and ugliness, like good and evil, are well-known by it.

All judgments relating to experienced objects have three components analyzed out of those objects and reported in distinctive ideas and terms. All have an indexical component making evident the location of the object in relation to the knower. We express the index in English by means of such denotative terms as "here," "it," "Bach." This is supplemented by a contemplative component, the cognizable meaning of the object. We refer to this by such common nouns

as "horse," "square," "red." Most of us have been taught in our grammars that the contemplative component (or its counterpart in discourse or mind) is predicated of the other. But this surely is an error. A mere "here" does not and cannot have a color; if we predicate "red" of it we wrongly endow a colorless entity with a color. The "here" and the "red" are correlative, analytic components enabling us to articulate the object. That object continues to confront us, and we, when isolating the indexical and contemplative components, adumbrate it, deal with it as a third component, unitary, distant and confronted. This third, adumbrative aspect of the object is referred to through the agency of the copula "is" and such relations as "eats," or "walks." When we judge an experienced object, we analyze out and then unite its indexical and contemplative components to make a single judgment, connected by means of the copula or its affiliates, to the third, adumbrative component.

When we judge "this is large" we unite a "this" with an independently definable and locatable "large" by means of the copula, and then use the copula again to connect the result to the adumbrated aspect. This second use of the copula is hardly ever noticed, and our grammars tend to ignore it. That is one reason why they say that a judgment does nothing more than attribute a predicate to a subject. It is better to follow Bradley and say that a judgment is a hypothetical with a categorical base.

The fact that there is a sensuous, adumbrative, terminal element in judgments of beauty and ugliness makes them quite different from those which can be made of scientific objects. It is inevitable then that those who forge their theories of knowledge in terms of science will not be able to accommodate judgments of beauty. A judgment of beauty is different from an ordinary judgment of perception, which also has an adumbrative component, by virtue of the fact that "beauty" is a distinctive type of term—somewhat on a par with "exists," "good," "unity," "divine." Scholastics called some of these terms "transcendentals"; many moderns speak of some of them as "nonnatural" to point up the fact that they are not to be identified with any limited feature, function or aspect of a thing. All these terms exercise two roles at the same time. They at once connote

and orient. Thus, like any other term which conveys information, "beautiful" is connotative, a genuine predicate. But unlike such a predicate as "large" it remarks not on some feature of the object existing alongside other features but on the nature of the object as a single whole. Beauty as a predicate tells us that the object as a whole can be expected to answer to a sensitive, critical taste, to illuminate the nature of existence, and to be enjoyed as a self-sufficient substance. The predicate "beauty" is not to be identified with or even measured by these occurrences; they are consequences which the judgment of beauty entails.

The predicate "beauty" directly reports that a work is excellent, that it is as good as a created work can be. The term also reports the nature of what is adumbrated by the copula. Because it combines the two roles in one, "beauty" is a term which not only offers us something to contemplate but directs us to something to be experienced. It tells us about the object in which it, as contemplated, is to be found. If, with logicians, we forget that "beauty" has the role of an orienting copula, we make it into a nonexperienced, purely ideational element. If, with aestheticians, we forget that it is contemplatable, we neglect its intellectual content, and therefore can use it only to mark off places where we must sensitively attend.

The beautiful attracts. The utilitarian thinks it is attractive because it serves some need or desire, say relaxation or pleasure. Putting aside the lower case goal he thinks beauty serves, the fact remains that there must be something in the object by virtue of which it can so function. Augustine and Aquinas were well aware of this. They held that the beautiful attracts because of the nature it has. But they then went on to say that the beautiful had to have certain proportions, which satisfied the senses' need for something ordered. Such a view takes the senses to have needs, supposes that beauty speaks only or primarily to them, and that it is essentially something ordered, and never to be found in the presence of disequilibrium and tension, the baroque, the disturbing. With Augustine and Aquinas we surely ought to look for something in the work which makes it attractive. But we ought also to recognize that beauty can be present in a work lacking the classical proportions; that it is attractive to

men as single individuals, and that it need not be attractive to their senses. Art is too complex, subtle and tensional to be dealt with simply as that which contents the senses; it could be sensuously disturbing and still be beautiful and attractive. This fact has often been remarked by students of poetry, music, and the theatre.

The beautiful is testimony to the successful penetration of a prospect throughout a portion of mastered existence. We are attracted by the beautiful because that which it characterizes is thereby shown to be a completed object which can help complete us. No work of art, however, fully satisfies our appetite either for existence or for a prospect, not only because each delimits the other in the work, but because they both continue to remain outside the work as realities and as powers. No work of art, no matter how beautiful, can therefore ever entirely content us. Indeed, it will move us to move away from it.

Plato thought that the beautiful aroused a desire to reproduce and possess. This it does at times, and ought to do. But it also arouses us to leave it behind so that we can attend in new ways to the object it characterizes and to other realities as well. Because the beautiful object does not do full justice to the existence or to the prospect which it partly exhibits, we cannot remain with it for long.

As a rule the beautiful serves to give us joy, to change our attitudes, to quicken us, and to tap previously unsuspected sources of energy. How that energy is to be used we do not know with surety. Beauty opens us up in ourselves and to the universe beyond. It can enable us to act with more freedom and self-assurance than we had shown before. We may then do what we regret. Fortunately, as a consequence of our contact with it, we are more often improved. We become better organized, more ready to engage in more valuable work. Because of beauty's power to relate us to the universe without, we become more alert than ever before to the tragedy and comedy, the glory and folly, the purity and stupidity, and the brutality and vitality of the beings with which we live.

Like every other character, beauty can be explicated in terms of four conditions expressing demands imposed by four basic modes of being. The demands, ideal purity, existential unification, actual

fulfillment, and transcendent encompassment, are not to be confused with the four strands which are abstractable from common-sense and other substances. Strands are real objects transformed; the demands imposed by the four basic modes, in contrast, are standards, criteria, measures, dependent for their being on the reality of irreducible beings outside the work of art.

A *pure* work of art is a single work of art. It does not drive one off in different directions. It does not demand that one shift attention or force one to find some category, not present in the work, in terms of which the work can be treated as one. Such purity is not easy to achieve. The simplest sound has overtones, and is heard in a world where other sounds impinge. A simple color, as Barney Newman * makes evident, develops internal tensions as it moves over space. It becomes internally complex, demanding a boundary at which the tension is brought to an end. And when one turns to complex works, it is hard to keep the parts from infecting and spoiling the purity of the unity in which they are to be contained.

Purity characterizes a work which is primarily a unity. *Unification* characterizes the way in which parts of a work are interrelated. It is present when a plurality of diverse elements support one another. If there be simple things there are cases of purity without unification, for they are unities having no multiplicity within them. Most mosaics are unified but lack purity; they are unities overwhelmed by the pluralities they embrace. Better than either is a complex work in which a pure unity is filled out by means of diverse, interlocked parts.

Fulfillment is the outcome of the realization of the promise, the capacity of the work. It is double pronged, referring to the parts on the one hand and to the unity on the other. Ideally each part of a work ought to be fulfilled in a unity which expresses all that can be expressed through the agency of those parts. It is possible, though, to satisfy the parts and not the unity. Where every actor is to the fore there is neither foreground nor background. A world where each man pursues his own desires, a museum of excellent works of art, a work in which a number of styles are excellently employed,

* Newman paints large canvasses of single colors which are punctuated by one or two simple lines at the point of maximum tension.

yield a fulfillment for the parts but usually not one for the unity of the whole. It is also possible to satisfy the unity and not the parts. As Plato observed, though purple was thought to be the best of colors, one would not want to paint an entire statue in purple; the several parts ought not to be colored as well as they severally could be. A satisfaction of the parts here would result in a failure to satisfy the unity.

There is fulfillment and unification but no purity where the parts are excellent but united in a minimal way, as in a mosaic. We have fulfillment and purity but no unification where simple entities stand alone, making manifest the excellence that is theirs. There is fulfillment without either unification or purity when the demands of the unity and the parts are both satisfied, though a superior excellence would require that one or the other be quieted. A beautiful house may have beautiful paintings in it, but the paintings and the house may not be suited to one another.

Purity, unification and fulfillment are like integrity, proportion and clarity, the notes of beauty which Thomas Aquinas dwelt upon. But to them must be added another, which he apparently overlooked: *encompassment*. This has two dimensions, an extensive and an intensive. Extensive encompassment has to do with the importance of the prospect which is being exhibited in the work; intensive encompassment has to do with the degree to which a prospect penetrates the work itself.

There are small prospects and great ones. There are those which have little bearing on man's major concerns and others which make one alert to the dignity of man and the magnitude of the world. The greatest prospect is that of a beginning, turning point or end which every excellent thing will illustrate; the smallest prospect relates to that which has been personalized to be at once simple and final, having no subordinate items. But no matter how small a prospect may be it can be made integral to some matter in such a way as to produce a beautiful result, provided that the matter which it penetrates has little magnitude and little resistance. Imposed on a large or inflexible area a small prospect may produce something pretty but never something beautiful. Conversely, a major prospect

can be made integral to the material in a minor way. The result may tell us something about the prospect but it will not be a work of art, and cannot therefore be beautiful.

Intensive encompassment, unlike extensive encompassment, is inseparable from purity, unification and fulfillment. A major prospect may be effectively resisted by the material and thus yield a work relatively impure. The parts of a work may not cohere very well with the unity, so that there is only a minimal unification. And neither the unity nor the parts may be adequately fulfilled. Where such failures are avoided there is also an intensive encompassment; prospect then permeates the work.

The best work of art is one in which there is a maximum intensive and extensive encompassment. This means that a prospect must permeate material having an appropriate magnitude and resistance. Since all the works men produce are finite, no one of them in fact has material which is actually adequate to an absolutely major prospect. Such a prospect is all-encompassing; the most appropriate material for it must have a stupendous magnitude and be infinitely plastic. It can be brought into a work only representatively, through the agency of a delimited version of a prospect which has been given its appropriate material. A sonnet on spring may be beautiful if the meaning of spring permeates it. The sonnet can become a great work if the meaning of spring is treated as representative of some such basic meaning as origin, beginning, birth, referred to in the prevailing myth. Everything has a beginning of some kind and spring is only one form in which such a beginning may occur. If one tried to express the nature of mere beginning in abstraction from spring or other particular ways of beginning, he would have a nonsensuous abstract idea. Were he content to stay just with the idea of spring he would not be able to produce a major work. Without losing the concrete, sensuous character of spring, and without departing from the activity of making the meaning of spring permeate the poem, the poet must deal with it as a special case of a more extensive, encompassing prospect. And this he can do if, while writing and enjoying the poem in which the meaning of spring is imbedded, he sees it to be a special case of the meaning of beginning.

Beauty is not exclusively a product of a human act of creation. It can be found not only in works of art but in nature as well. The beauties there are rarely as subtle or as exciting as those made by men. Nor are they the outcome of a creative emotionally sustained act. They do, though, exhibit a union of meaningful prospect with existence. When nature sustains a long-ranged prospect, it is sublime. When it allows the power of the whole of existence to be sensed, nature is awesome. It is beautiful only in those cases where a portion of existence is harmonized with a delimited prospect.

The sublime results when some crucial, long-ranged prospect permeates either existence itself or something taken to be representative of it. The Rockies, Death Valley, and Grand Canyon, the starry heavens and the ocean are sublime; each is taken to represent the whole of existence and to offer a lodgement to some grand possibility. We can also say that the great cathedrals are sublime; Kant thought we should speak of the Psalms in these terms; Hegel thought we could call the Decalogue sublime. But then they too must be taken to represent all existence and to give embodiment to an ideal prospect.

The presence of a prospect in a representative of existence makes that representative appear to have the power to withstand the ravages of time. The sublime is said to be everlasting because the possibilities it exhibits do not have their meaning exhausted in any manageable period. No object is of course everlasting. This only existence itself can be. But an object can be accepted as everlasting just so far as it is treated as a representative of existence in which an apparently inexhaustible meaning has taken up residence.

When existence itself uses some actuality to represent it, the actuality is awesome. The awesome is the all-powerful making its presence felt. We look upon the mountains and heavens with awe when we glimpse in them the power of the whole of existing nature. Since the sublime is the result of man's making some part of existence represent the whole of it, the sublime is in part the outcome of man's imitation of the awesome power of nature. The sublime therefore not only tells us about some magnificent, long-lasting prospect but something of men's own power to make finite objects epitomize existence's formidable majesty. Man is never so great as when he

awesomely attends to what is sublime, when he senses that the whole of existence is there being expressed through some finite thing.

When meanings restrain and are restrained by existence we get natural beauty. The daisies pell-mell in the open field, the Rhine, the Hudson, a leopard, a snow storm have natural beauty. The prospects which are so evident in the sublime here permeate, but only by being quieted. The objects are not seen as everlasting, but only as possessed of a dignity which transcends their actual performance or finite forms. At the same time existence, so evident in the awesome, is subdued, schematically presented, making the object not into a representative of all existence but only into an instance of it, a demarcated illustration of existence's power. In natural beauty a meaning achieves concreteness, but only in an actuality which does not represent all existence and only when a part of existence's power, not all of it, is operative there.

This characterization of the sublime, the awesome, and the naturally beautiful is not grounded on radically different principles from those in terms of which man-made beauty has here been understood. It has been almost traditional, however, to insist on a radical distinction between the beauties of nature and those made by man. It was long thought that nature was just a vast machine and that there was a great difference therefore between what it and men could produce. Suppose, Kant asked, we had heard a nightingale's song and then found out that it was in fact being sung by a man. Would we not, he asks, think it tedious? I think we would. But this would not be because, as Kant supposed, we would then see that there was no beauty in the song. We would be dismayed to discover that a man was doing nothing more than imitating a nightingale. When a man imitates natural beauties—an imitation which is a kind of work or craftsmanship rather than art—we are disappointed. We want men to use nature as a stimulus or occasion, as a theme or a model, not as the locus of beauties to be duplicated. We would find the song more satisfactory if we had learned that a man had created it. But we would still expect a man to be more than one who sings only that song. We demand of him that he manifest a creative power in the song, revealing him to be the maker of the song in a different way from that possible to a nightingale.

The nightingale and its imitator both exhibit a cosmic power through the localized form of a nightingale's song. The imitation is of course as beautiful as the original song, but it is so only because the man had brought himself down to the level of a nightingale, a low-grade organism through which nature makes beauty be. Did a man want to exhibit natural beauty on a human level, he would have to exhibit the cosmic power through some characteristic human expression. If he had a good voice he might spontaneously break into song. That song, if beautiful, would be superior to the nightingale's, since it could express the very power that manifested itself through the nightingale in a superior and therefore more appropriate vehicle. Such a man would still be doing less than a man could. An artist is superior to the man who imitates nightingales or to one who spontaneously sings, for *he*, unlike them, makes beauty be. He is on a footing not with one of nature's local forms, but with nature herself, a source of power which is able to sustain a meaningful prospect.

Since the beautiful outcomes of both art and nature are unities in which a prospect permeates the parts, the products of both can be readily confused. We might find what seems to be a piece of driftwood and later discover that it had been made by a man. We would not have been wrong to have called it beautiful before, but we would have been wrong had we said that it had not been made beautiful by a man. We like it more when we come to know that it was made by a man, because we then see it as providing evidence of the creative powers of man and no longer have to take it to be just an example of the sinuous, insistent powers of nature. Contrariwise, were something beautiful to be thought the work of man and later be discovered to be the product of a machine or of the interplay of natural, blindly operating forces, we would have to say that we were wrong to think that a man had worked over it, directly acting on every part. We would not be wrong to say that it was beautiful then and now.

There are times when men create in a frenzy, when the powers they use are only manifestations of nature, not wholly within their control. We do not always know when this is the case. We are never altogether sure just when and to what extent men create as

individuals or by acting as channels for the expression of nature. Discoveries that something we thought to be a work of man is in fact a work of nature are analogous to discoveries that something we thought to be a work deliberately designed was one produced without express intent. We are not necessarily mistaken in our evaluation of its excellence but only in our determination of the responsibility for the result.

When we find nature making something as excellent as man can produce we can take either nature's or man's work as a paradigm. If the first we will then be able to assert that the art of man is an expression of nature, more sharply focussed and more steadily exhibited in art than in other places. But if we say this, we will in effect be denying that we have a knowledge of created beauties, made by man deliberately, and thus denying that there is a genuine world of art. Or we can suppose that nature molds a special species of man, the artist or perhaps the genius, who then, having an unusual reservoir of natural powers, is able to do what no other man can. If we say this we will go counter to the truth that men are all equally men, possessing the same potentialities in root, though expressed in diverse manners and degrees. It would be better to take the artist as our model. Then, when nature produces a work as excellent as his, we can say that nature itself is an artist for the moment or that she is being used by some creative intelligence which does with her what men do with the shards of color, sound, movement, stone, and words out of which they create beauty. Since nature does not seem to be intelligent, to have control, to make anything deliberately, only the second alternative is plausible. If we are to understand her beauties in the light of man-made ones, we must take her to be an instrument manipulated every once in a while by some power beyond her who knows, acts, and is concerned with the excellent. But there is no need to take either nature or artist to provide a measure for the other. Natural beauties can be the result of accident. After all even a good deal of the excellent work men do is a product of accident, and is often, at least in part, the result of unexpected occurrences of which the artist knows how to make good use.

If there are no distinct subspecies of men endowed with abilities

denied to others, there are, strictly speaking, no geniuses, and it will be possible for any man, in principle, to do what any other does. There is no doubt of course that there are men with absolute pitch, 20-20 vision, flexible arches, pleasant voices. This means that all men cannot, in the same circumstances, expect to have the same degree of success in a given field of art. A man's early habits, his bodily structure, the relation of his temperament to that of the prevailing spirit, his opportunities for training and production may all preclude his doing much of consequence in some art. Creativity, too, is a contingent matter, with its sharp peaks and valleys and sometimes sudden divides. But it is never wholly absent. Through determination and concentration, a man can make himself be more creative than he usually is, though not necessarily as creative as he need be if he is to produce a great work. He may be initially disadvantaged and thus may have to work harder than another to reach the same level. But once he attains that level he need not be disadvantaged any longer. And in any case, since all he ever need do is to make use of his own powers with respect to material which he in fact can control, he can achieve beauty in some area. He can be successful in an entirely new art, or in a new direction in an old one.

A similar observation can be made with respect to religion, philosophy and mathematics. They are open to all men. The point seems obvious in connection with religion, less obvious in connection with philosophy, and mistaken in connection with mathematics. But there have been "amateur," untrained philosophers—Plato, Spinoza, Hume, for example—who make evident how diverse, fresh and new philosophic work can be, and still be excellent. And mathematics, now that it is becoming more and more to be recognized as not entirely subject to the demands of formal logic, should become more and more open to the creative explorations of any man, though an antecedent training and knowledge is of course presupposed by anyone who would like to make contributions to the field. Each one of these disciplines will answer at the start to one man's temperament more than to another's; but each is basic and inclusive enough to accommodate all, if only men are willing to make up by self-discipline, interest, and

persistence for whatever initial handicap and bias they had when they first confronted it. If a man is to achieve a maximum result he must not only use his ordinary powers of attention, honesty and persistence to a degree not called for every day, but he must also make use of powers which all men have but only a few ever exercise. He must be more modest, more flexible, more disciplined, more imaginative, more courageous, and more perceptive than any man otherwise need be.

There are phases, parts, areas in religion, philosophy, and mathematics congenial to each man. And there is some art appropriate to each too. Each can make a signal success in some art if he be willing to make a persistent use of his powers and opportunities and proceed with unusual courage, passion, concern and objectivity. His particularly appropriate art is not necessarily one of those now exploited. To suppose that all men can or must work inside the established arts or their recognized forms is to suppose that it is art and not man who is master.

Like the devout, the philosopher and the mathematician, the artist sets himself apart as one who is ready to act as a representative of the best in all men. Should he produce a poor piece of work he stands condemned as a botcher, as one who wrongly turned away from the rest in order to engage in creative work. He would be one who in a sense had not worked to benefit mankind for whom he was supposedly acting representatively. But if he is successful he will say in his own way and in his own appropriate medium what all the others say in theirs.

Men do not fall into distinct subspecies. Still there is some value in distinguishing among those who exhibit aptitude, talent, power, gifts, and "genius." *Aptitude* is the capacity to participate in a discipline, to be ready to operate along the lines of its rationale. Since men differ in their physiology, psychology and sociology they will have different initial aptitudes which can be altered for better or worse by training, practice, and self-criticism. If a man is not very apt in a given enterprise he will need more time than another to master it, and thus will not be as ready as that other to exhibit his abilities. But in principle he should be able, within some finite span

of time, to do what the other can, though not necessarily just where and how the other does. *Talent* is the capacity to make a contribution to a given discipline. It is a matter of experience, interest, ingenuity, and good fortune. As a rule we judge that it is present when we discover men making improvisations and showing aptitude with respect to the more developed branches of a discipline. No one who has not spent weary years at the barre can exhibit the talent demanded of a ballet dancer. But the initial talent that one dancer may show can be met by a lesser talent backed by a greater concern. Where two with unequal talent show the same persistence, training, interest and the rest, the superior talent will be exhibited in a superior result—provided the two compete in the area where the superior talent has been developed. *Power* is talent heightened, given force by current need, individual vigor, and the readiness at the time to accept what is being offered. To have power is to have the capacity to make a conspicuous contribution to an art. This is a matter almost as much of luck as it is of virtue. He who has been denied power today may be favored tomorrow. This fact makes power in principle open to all. A *gifted* man makes contributions to a number of disciplines. He has a malleability, an ability to use a number of aptitudes so that they can be effective in a plurality of ways.

The lines between these various capacities of men must not be drawn too rigidly; otherwise one will blur the commonality of man and neglect the inherent capacity each has to be as creative in his own area as others are in theirs. With this caveat in mind it would not be amiss to characterize *genius* as the capacity to make a number of radical contributions in a discipline. If multiplied, made evident in many fields, it is a many-sided genius with many gifts. In either case, it is talent intensified and sustained by creativity.

He who has genius leads or perhaps even forces other workers either to take a new direction or to devote themselves to playing variations on his achievements. He does not make use of some mysterious, transcendent power. Those who fail to bring about superlative beauty may be inherently as able as those who do, but they may not have had the time, the energy, the opportunities those others had. Or they may not have been as fortunate in finding the field of art appropriate

to their native aptitudes and talents. The genius masters, dominates, affects the nature and promise of a field; what he does in one place another could do elsewhere, were he willing to step outside the conventional area, where risks and successes are minor, to where they are stupendous.

To make beauty be, only aptitude is needed. Talent, power, gifts, and genius multiply its opportunities and examples, enabling one to overcome difficulties otherwise insuperable in a particular field or on a particular occasion. The beauty which results from the exercise of any one of these has the power to touch the core of our beings. It also forces to the fore the question of the power of a beautiful work to open up the universe for us. This question comes into sharp focus in the problem of representationalism.

9. REPRESENTATIONALISM

ART purges emotions which seem to have been provoked originally by objects in daily life. But how could it do this unless it somehow represented those objects? Yet not all arts seem to provide such representations. Music, architecture, and poetry apparently do not. Sculpture or painting need not represent familiar things. We seem at once driven to say that art must be and that it need not be representational. Part of the difficulty lies in the fact that the idea of representation has a number of distinct meanings and applications, not always distinguished in the literature. Ordinary men, philosophers and artists use the idea in somewhat different ways. If one of these meanings is dealt with as singularly pertinent to one place, it obviously does not remove a need to consider the other meanings in other places.

The ordinary man usually demands of an art that it duplicate or portray particular items of his experience. If a work departs from direct representation, he wants the fact of this departure to be made so evident that he can recover a duplicate if he so wishes. Even artists sometimes assume this position with respect to arts they do not practice. Neil Welliver tells of his encounter with a jazz musician who said that he "never could dig this abstract art. A picture ought to be about a girl and a boy, a tree and a sky." Welliver smiled, "I see what you mean. I listen in music only for the sound of kisses, birds, and wind." Strictly speaking, however, neither ordinary men nor artists, when dealing with arts other than their own, want duplicates of objects as they actually are. They do not ask of a building that it duplicate anything unless it be buildings seen before. If it be true, as some maintain, that all buildings portray the caves, tree tops or sacred groves of a presumably unsophisticated life, the fact is ignored by common-sense men. Paying little attention to

details, they quickly approve or disapprove of a building, depending on whether the building does or does not disrupt their usual image of what a building is. In lesser degrees, this is what common-sense men do in connection with every art. What they look for are not representations but copies of the kind of works with which they are familiar. Even in connection with painting, where they insist most stridently on representation, they are in fact asking that today's painters keep to the old forms. In the Western world men want paintings to follow laws of perspective, to make use of luminous colors, to maintain proportions which have been persistently exhibited in the past. But in the East they make none of these demands. The common-sense man in both places wants artists to repeat the familiar in the world of art. In effect, for him, creativity had rights only in the past.

Plato and Aristotle spoke of art as an imitation. It is not by any means clear that they had the same idea in mind. But what does seem to be the case is that they, unlike the ordinary man, did not want the artist to produce only the kind of art with which they were familiar. Nor did either want him merely to duplicate ordinary objects. Both were acutely aware of the artists' creativity. Aristotle, though, apparently thought that there would be no further innovations in the history of art and seemed to hold that all one had to do thereafter was to exhibit in new contexts and ways what had already been mastered. Plato, who thought that the artists' innovations were dangerous to the welfare of the state, showed a better grasp of the adventure of art. What both of them were most concerned with was the recapture, through art, of some basic reality. Plato thought that this reality was a realm of forms, perfect and complete, which the artist imitated at some distance. Aristotle was more realistic; he thought that the reality which art was attempting to imitate was the very nature of human life, and that it imitated this directly. Both saw that what was being imitated was something more real and better than what is daily encountered.

Plato, though often less sympathetic with art than Aristotle, usually understood it better. He was, I think, mistaken in supposing that it imitated ideal forms. It does, as Plato said, imitate some-

thing ultimate. It does use and exemplify ideals. One can follow Plato even when he says that art is twice removed from ultimate reality, for art does make use of material separated off from the rest of the world and then alters this in the course of the production of a substantial work. But this does not mean, as Plato thought it did, that art therefore fails to do justice to what is real. By turning away, the artist is enabled to get to the real by an indirect but most effective route. The substance which he creates is a simulacrum of existence, exhibiting its nature and tonality. One can then justly say that art imitates, provided one adds that it does not imitate exactly what or in the way the old philosophers said it did.

The reaction against the theory of representationalism has gone so far in recent times that the claim that art imitates something will surely awaken the ire of those who take themselves to be at the forefront of modern trends. There has been a vigorous insistence, in recent years particularly by students and practitioners of painting, that there be no attempt to portray, imitate, represent or symbolize any objective thing. The position has been given a number of names —nonrepresentationalism, nonobjectivism, nonfigurativism, abstractionism, constructivism, nonlikeness—which only occasionally differ in their reference or stress; what they have clearly in common is the thesis that art has both the need and the right to forget the familiar world outside it.

To suppose this trend to be characteristic only of painters and then only of our times is to make a double mistake: it is to suppose that it is not to be found in other arts and that it has not long been known. Yet music and architecture, Etruscan and African sculpture, Chinese calligraphy, Indian rugs, mythologies such as Hesiod's, some of El Greco's paintings are nonrepresentational. In some of these cases an attempt seems to have been made to symbolize rather than represent something, but in others, e.g., in African sculpture, not even symbolization seems to occur.

Five types of nonrepresentationalism in art can be profitably distinguished, all of which have analogues in other disciplines. One type of nonrepresentationalism is concerned with conveying the nature of an experience rather than its content. The Platonic dialogues,

the *Confessions* of Augustine, the *Meditations* of Descartes, the musings of Pascal, exhibit the nature of a quest or inquiry rather than the results or outcome of these. They convey the flavor of an activity, not the content over which this plays or which it may help us eventually to master. Similarly, Pollock and Hofmann attempt to exhibit in their paintings the experience they undergo when engaged in the production of art. They portray the process of creativity rather than some object. What they produce are obviously not pure nonrepresentational works, but in fact good representations of activity. Such representations should make evident the peaks and valleys of the activity. To do this best it is desirable to have foci in the work which can serve as indices or clues. Just as there are truths present in Plato, Augustine, Descartes and Pascal, so there are clues portraying familiar features of things even in a Pollock. Perhaps de Kooning has seen this point more clearly than others today; he is an abstract painter who offers rather clear indications on how his works are to be read.

A second type of nonrepresentationalism seeks to present the analytic components of objects. Those components are not necessarily evident in these objects, as they stand apart from us. Husserl's phenomenology recognizes that what is obtained from experience will not have exactly the form it has in experience; strictly speaking, and therefore in opposition to some of Husserl's own pupils, his phenomenology is essentially nonrepresentational. It was his hope that the essence of the initial experience could be reconstructed out of the purified elements his analysis achieved. Even if he succeeded in doing this, the result would not be identical with what he had begun. It would not even represent it. The approach has been hailed as a great novelty; actually it offers only a new way of doing what has always been done in philosophy, religion, and science—constructing explanatory elements and combinations for what otherwise would remain confused and distortive.

The analysts of the Husserlian or other schools do not represent things or experiences. But they represent something. If their products are things or experience in a purified form they are evidently representing things or experience as idealized. Even this need not be done.

One can ignore experience. With an Albers, Engman, Gabo or Cage one can follow the lead of a mathematics or a science and try to create, away from all contact with the world. But the combination or union of the resultant elements yields a result which either conveys the meaning of the initial experience or of some ideal version of it. Once again we have a representationalism but of the real idealized, the real as it truly is or might, in a better world, become.

A third type of nonrepresentationalism, like the second, concerns itself with what in fact is not experienced. But unlike the second, it makes no claim to get the essence of what is experienced. It seeks instead to refer to something which would clarify or explain what is experienced and which, presumably, is more real than what is experienced. The great philosophers in this spirit refer to powers, souls and gods. These are invoked to enable one to explain otherwise obscure areas of experience. Many, particularly in America, at Ithaca and Cambridge, and in England, at Oxford and London, deplore this fact. They think one ought to do nothing more than report what all can observe, or at least speak of it only in the way the common man does. But like everyone else they too transmute whatever they experience into words and memories and forge explanations to account for the way the items of their experience hang together. Recently these thinkers, having belatedly examined what they themselves were doing, have become somewhat self-critical. It is apparently becoming unmistakably clear to them that cosmological science, history, and the law courts, in order to make evident just what it is that was encountered, have recourse to items that themselves never were encountered, conventionally spoken of, or found by analysis.

Analogously in the arts, newly made colors, shapes, sounds, beats, rhythms, perspectives and harmonies have been used to lay the ground for a grasp of what would otherwise have to be accepted as a single, somewhat unclear and unmanageable idea. If there be nothing in the world answering to these, they will evidently be nonrepresentational in import. But the whole they constitute can be representational, and they themselves may not be entirely disoriented from what is then represented. Only if they are without any bearing on

the world, either directly as so many parts of it or indirectly via the whole they constitute, will they prove to be elements in a non-representational art. But the whole they constitute, precisely because it is produced to clarify an idea, will portray something real— the prospect to which the idea refers.

A fourth type of nonrepresentationalism claims that art, in fantasy and paradox, opposes the supposedly real and objective. Men tend to look on the discarded philosophies of the past, the gods of other religions, and the myths and stories of other societies as so many different exercises in fantasy. The art of even the most primitive groups often contains no evident representations of familiar things. But students of Freud and Jung have been at pains to show that at root they are really representational and even iconic of fundamental powers in man or the universe. Instead of being nonrepresentational, they are, these men say, excellent representations of the reality that lies beneath the transitory and obscuring surfaces of daily life. Surrealists such as Dali and metaphysical poets such as Donne merely challenge the associations we usually make. Through odd juxtapositions and combinations, paradox and metaphor they try to lead us to what lies beyond the appearances and convention. In all these cases, behind an apparent nonrepresentation, a genuine representation is to be found.

Finally, there is the claim that art makes reference to nothing. The artist is thought to reject all concern for internal as well as external appearances, experiences and objects and to attend only to problems of composition. This is a strict nonrepresentationalism. A painting is abstract, says Seuphor, "when the absence of any other form of sensible reality compels us to regard it purely as painting and as nothing else, and to judge it according to values which have nothing to do with representation, or with imitation or reproduction of some other things. It follows that a transposition of nature even when it is very far-fetched, remains figurative and is *figuration*." This surely is extreme. It supposes that it is possible to avoid all possible trace of objective reality; it denies any "nonfigurative" value to what is, by virtue of its transposition in art, altered from its original shape and is therefore "nonfigurative" in fact; it forgets that to

enter the domain of art we must make our beginning with common experience and therefore inevitably come out with some "transposition of nature"; it denies that a work of art, properly termed "abstract," can provide guides to the world beyond. Strictly speaking, it denies that it is right for the abstractionist De Stael to call one of his works "The Footballers."

It is good to have someone insist so vigorously that art must be taken on its own terms, isolated from all need to serve some other function. But it is misleading to suppose that it could ever be non-figurative in this extreme way—or that it ought to be. To say that no aspect of the real world, even if it is a point of departure, should remain recognizable, is to say in effect that there can be no genuine nonrepresentational art. Yet everything is made and seen by men who have multiple associations, ready to make references to familiar things.

Picasso was pretty near right therefore when he said, "There is no abstract art." Even Seuphor admitted that one cannot prevent "the imagination from discerning objects"; at times he was even content merely to say that this exercise of the imagination had "nothing to do with the painter's own intentions." It is not clear whether it is the artist's explicit or implicit intentions to which Seuphor refers. Artists do not usually have clear and evident intentions, nor do they know any better than the rest of us just what in root they do intend. It is not necessary that an interest in ordinary objects be alien to their hidden intentions; often it is not alien to their explicit intentions. Still it is true that ordinary objects are not the artist's primary concern. He is more interested in his creative activity, its outcome, and the reality which lies behind the common-sense world than he is in familiar things.

When Seuphor says "The abstract painter must do all he can to avoid . . . representational accidents" he makes the artist concern himself too much with matters outside his interests. He who occupies himself with the avoidance of outcroppings of representational items is forced, in his attempt to avoid and reject, to turn his attention away from art to the world. Inevitably he will exhibit the vices of the crassest representationalists. Seuphor does more justice to the

nature of art when he says that the artist's basic task is "to follow the very process of composition step by step, apprehending it from the inside as an orchestra interprets music." No restriction should be put on the artist's subject-matter or method. All we have a right to ask is that he be competent, honest and creative.

Evidently, then, we must take both sides of the discussion as to whether or not art is or should be representational. In one sense we cannot avoid making it nonrepresentational. A change occurs even in the most sympathetic faithful copying of an external object. The object, when caught within our words, paint, metal, music, movement, is not the object as it exists in fact, and cannot be matched with this object if we do not first make a number of assumptions and corrections. On the other hand, no matter how desperately we try to escape the world, our product will express something of it. Even our rejections reflect the nature of that which we disown. When we move away from ordinary and specialized activities to live within the orbit of some such basic discipline as art, we learn not only something of the daily world we put aside, but of the existence that underlies these.

Too soon we become routine in our appreciation of what art is and what it can do and fail to see that it does not reproduce what was experienced. The nonrepresentationalist has made many more aware than before of what art has always been doing—subjecting experience to quite radical transformations. We are so accustomed to make these transformations that we forget that we make them, just as we tend to think that only certain sounds are appropriate to certain things because we have so often applied them to those things. "How foolish of the French to call a cabbage a shoe," said the sailor, "when they know it is a cabbage."

Occasionally one hears of a politician or businessman suddenly coming across the work of a Miró or a Klee and commenting, almost without reflection, that a six year old could do as well. Nothing could be more absurd. What was seen perhaps was the presence of a genuine spontaneity in both works. Neither provided evident clues or guides as to how they are to be read or what they portray. But the child has no proper control over its brush or fingers; it smears rather than draws. Its work is actually a set of discontinuities put down without

self-discipline and without concern for the production of beauty. Looked at carefully, it will show little nuance and only an occasional simple-minded recurrent theme. The painter may have produced his work in a moment of frenzy, half-drunk, and despairingly. But he readied himself for the moment of creation over a long period. The child acts without preparation; the artist is well-prepared. Chinese painters pride themselves on the ability to complete a scroll of calligraphy in one use of the brush. In the course of the production, the brush is subject to countless variations in pressure and direction, few of which are clearly intended but all of which are nevertheless genuine and essential parts of an act of creation made possible by long training, practice and discipline.

It is simply not true that children can paint, if painting is what Klee or Miró do. Nor can they compose, philosophize or pray. They can assume the postures which adults exhibit; they can and do discern something of the underbelly of the world; they can free themselves more readily than most adults from the conventions of everyday. But an imitation of a posture is not yet the duplication of the act expressed in the posture; it is at best a preparation and stimulation for the production of the act after the child has become more aware of prospects, has been disciplined and guided, and has a meaning to express through his various acts. A child's awareness of the dark recesses of being, which lies at the root of its terrors and fears, its quick smiles and pleasures, is not mediated by art, but had directly across the barrier of common things. And its freedom from convention is a natural consequence of the fact that it does not yet entirely fit inside its society. At its best such freedom could yield an aesthetic object; it cannot bring about the production of a work of art. And the aesthetic object which it might isolate cannot have the value possessed by the aesthetic object on which a mature and sensitive artist might concentrate. A child does not know enough of the object in its context and does not attend long enough to the qualities of the isolated object to be able to do more than begin to see in it what the artist can. When Duchamp hung up a shovel in a museum, he tore that shovel away from its usual context and made one attend to its texture, structure, and space in a way no one had before. That very

shovel hung up by a museum attendant or by a child would be just a shovel in the world, kept in an odd place. Only if it were hung in the museum with an awareness of the difference made by dislocating the shovel from its context, would the child or attendant approximate what Duchamp did.

It is possible to fool unpracticed critics and lead them to affirm that a Klee was a child's drawing, or a child's drawing was a Klee. But it is most unlikely that any student of Klee's works would ever be fooled. It is even doubtful that any historian of art, even without a knowledge of Klee's works, would make the mistake. The politician's or businessman's comparison of the child's work with that of an artist is comparable to a possible artist's claim that a boy who led his scout troop across a stream was a statesman, or even a leader of men.

There are no widely-acknowledged prodigies in architecture, sculpture, painting, musical composition, stories. No child seems to have made a story or a poem which is a work of art; none is an actor or a dancer in the sense in which men are. The only thing a child apparently can do at a fairly early age is to play a musical instrument or sing. But does it then do anything more than exhibit a virtuosity, a readiness to adapt itself to the prevailing customs of the art world? I don't really know, but it would certainly make more sense to suppose that a child musician is, like all the other very young practitioners of the arts, mastering a technique, showing power in a craft, not yet engaging in the creation of a work of art. The child has to pass over the hot desert of adolescence before it can hope to occupy the promised land. Training, discipline, preparation will help it; but in the end one must be able to provide a creative power, directed at a prospect and serving to open up reality to the sensitive observer.

Young children whom I have observed gravitate in their paintings towards the production of what could be called "abstractions." They put colors and occasional shapes down more or less at random. Given clay or asked to take a role in a play, they tend to make something which reminds one of the familiar. I don't know whether this difference between what they do with color and clay is a function of culture or reflection of faulty observation on my part. In any case it would be a mistake to speak of children making either representational or non-

representational works of art. The state of disorientation produced by the shock of new art, for which clues are not readily evident, has betrayed many into believing that children must do one or the other. But if I am right, children do not create at all in the sense in which an artist does; their works are not works of art, representational or nonrepresentational.

At the present moment, there seems to be a greater interest in abstraction than in the evident portrayal of familiar things. But this is just a phase in the history of art. Different periods deal with different specific problems and offer distinctive solutions. As Wölfflin made evident, the problems and stresses of the classical period are not those of the baroque. In place of the classical planes, baroque art stressed recessions; in place of symmetry, asymmetry; in the place of unity, plurality; in place of people and scenes, decorative effects; in place of frontal approaches, volumes.

The classical outlook can be said to have emphasized the dominance of the whole, while the baroque tended to give the parts more distinctive roles and values. Modern art, in good part because its practitioners studied the classical forms and reacted against them, has much in common with the baroque. But it does not revive the baroque. It accommodates it, while also allowing some room for classical emphasis, trying to make the parts and wholes define one another. Modern art's stress on process, its tolerance of different types of technique, and the influence of such great experimenters as Wright, Rodin, Pollock, Stravinsky, Joyce, and Graham, made it have a nature quite distinct from the classical or baroque. There are conspicuous exceptions to all these generalizations. In any case, these differences, though important for history, are less important for understanding art than are the similarities.

The color (or analogously, the shape, gesture, sound, etc.) used by an artist need not duplicate anything in nature. Still, it is a color. It therefore has something in common with the colors of nature. But the painter ignores this fact. He seeks to make the color a part of a single work which points not to colors or even to those substances which the colors might decorate, but to the reality that underlies even these. The painter's colors are somewhat like metaphors; they

are juncture points where the external world meets and infects his expressions and our interpretations. They evidence him and ourselves as surely as they do something outside. Since works of art transform what was experienced through the use of emotional energy in a creative act, they offer clues to the being of an artist or to ourselves. If we take the very act of reading to be a kind of exposure of what the work is, that work will also provide a guide to the nature of the creative process. Only if we read it as a substance, do we let it tell us about what is outside.

The basic difference between a "representational" and "nonrepresentational" art lies in the fact that the former provides more evident or usable clues for reading a work than the latter does. These clues indicate appropriate divisions and stopping points; their familiarity enables us to move inside the work towards parts which will support, intensify, contrast with, and play variations on those initially acknowledged. None of them really duplicates what is in the artist, in the world, or in the process of creation. To treat them as such duplicates is not only to miss their distinctive natures but it is also to tear them away from their role in the work as a whole. The parts of a work do not and ought not to imitate anything; but the whole they constitute does and ought to imitate a reality beyond and below all encountered things. The similarity of those things with parts of a work of art enable those parts to function as resting places, climaxes and elements in an articulation of reality.

The role of the parts in a work of art is not unlike the role which qualities have in perception. Those qualities are dislocated from their settings when we perceive. Perceptual judgment separates them from their neighbors and relates them in new ways. From the very beginning of our perceptual life we are engaged in forging nonrepresentational judgments having components distinct from but affiliated with what we experience. We isolate shadows and lights, we sharply distinguish colors, we focus on the centre of a sound and neglect the surrounding overtones. The orienting nonrepresentational role of the parts of a work of art is the result of a more persistent and original way of dealing with the content of experience than is carried on in judgment. It does not demand an entirely new role for the parts to play.

Perceptual judgments and works of art provide conditional contrary to fact * accounts of what is taken to be a matter of fact. In ordinary experience such conditionals are used to connect antecedents with consequents within the frame of laws of nature. It is the constancy and endless potentiality of the laws, as at the core of substances, that is then exhibited. We then show that the laws are unities which can be specified in multiple ways.

There is really no difference between the formulation of a law under one condition and its formulation under another, providing that each condition is related, along the lines of the law, to an appropriate consequent. All report the same external unity, all say the same thing. "If this ball is dropped it will fall at such and such a rate," and "if this ball is thrown with this force, it will move at that rate," articulate the very same law of acceleration of bodies, as operating under different conditions.

We never adequately express a law of nature except by using variables. But we then lose a purchase on the actual world. If we say $V = \frac{1}{2}gt^2$ we are dealing with abstractions. If we see a ball fall 64 feet in a second, we can bring the particular fact under a law by turning its condition into an antecedent connected with an appropriate consequent in a way which parallels other connections of other antecedents and consequents. In effect, we then read a particular categorical case as itself a conditional on a footing with an endless number of contrary to fact conditionals. Each of the conditionals tells us about the nature of the unity of the law as that which can be expressed an endless number of particular ways.

If ordinary experience is taken to be a matter of fact, a work of art can be interpreted as a contrary to fact conditional for it. If a nose is painted green then, as Matisse showed in the portrait of his wife, the hair should be violet—or conversely, if the hair is violet the nose should be green. The result is a unity telling us about the real world, as mediated by a visible woman. Though the hair and nose are portrayed in contrary to fact ways, they, by virtue of their similarity

* Contrary to fact conditionals start with what is not the case, such as, "Were I King of America," and go on to draw a consequent, "I would have a small standing army." The unity of the two assertions is offered as a report of a unitary being, whose nature my actual activities never exhaust.

with the familiar tell us how to analyze the painting which, as a whole, speaks not of them or of a woman, but of what is manifested in and through these. As Jenkins observed,

> Works of art seem, on immediate acquaintance to make a compelling reference beyond themselves, to embody a content that they have gathered elsewhere, and to be in some sense symbols of the antecedently real. Yet works of art make it equally clear that they are not copies of what is already and otherwise known, that the meanings with which they are burdened can be conveyed only by themselves and in their own way, and that the content they assert of reality is often at variance with our familiar notions of what is real.

Works of art express not laws of nature or ordinary experience, but the existence behind these. Nature carries out only some of the adventures possible to this existence. The contrary to fact conditionals of art show that existence is capable of adventuring in ways other than those which nature has already pursued. Were we to neglect art's reference to this existence, we would make the work of art completely opaque. We would treat it as a mere design, a syntax, a significant form. To avoid such consequences we must live through the work, using familiar points as momentary perches and pivots. If we do this, we will at the same time redefine our emotions, enabling us thereafter to act in ways we had not before.

A work of art is a shored up item inside a larger existence. The work, ourselves, our experience, common-sense objects, and known substances are all in, limit, and allow for the manifestation of this existence. The artist is an emotional maker who represents the existence through the agency of his creations. His works possess their own space, time, or mode of becoming, enabling them to iconize existence as pertient to man's destiny. But then how can they fit into the world about? Is that not already filled up with other objects having their own space, time and dynamics? Where could works of art find a place to be?

10.THE BEING OF THE WORK OF ART

Works of art are created works, with their own space, time and dynamics. They have distinctive implications, excellencies and careers. They are also encounterable. Made by working over common-sense things and derivations from these, they can never escape the thrall of nature's laws. No matter how odd the art, no matter how "unnatural" its message, it is rooted in the "natural" world. That world is the world of common sense purged of cultural accretions. It is known when the strands of perception, science, events and importance are abstracted from common-sense objects and then purified and reintegrated.

Known or not, natural substances exist over against us. If they did not, either the world of common sense alone would be real; or the abstracted strands from that world would not give us genuine knowledge; or different strands could not constitute one object. But were the common-sense world alone real, the real world would change with changes in culture. It would be without clear boundaries, its objects would be somewhat disorganized, and our judgments of them would not be altogether coherent. The common-sense man is a creature of society; he lacks proper intellectual discipline, with the consequence that his world is not well-organized, altogether coherent, or consistent. If, on the other hand, the strands abstracted from common-sense objects gave no genuine knowledge, whatever we won from a study of perception, science, events and values would be erroneous or fictional. We would be baffled by the fact that the life of the common-sense man is effectively directed, controlled and predicted on the basis of what is learned from the different strands. If, finally, the strands did not belong together, the real would be unlike the world of common sense, and common-sense evidence might well be irrelevant to it. One would have to deny that what was learned in

one strand has anything to do with what was learned in another, despite the fact that they have a common origin. We would have to say that a man, as he is in himself, could not be known by unifying inquiries which originate in common sense and are pursued by disciplined specialists who follow through some one method and stress. These unwanted consequences are to be avoided. We must affirm that there are real, objective, natural substances, which are at least as real as common-sense objects and are knowable through a use of a number of strands.

There are some who would maintain over against this view that the only significant assertions which can be made must be in the language of some science. Those who take this extreme position usually think that all languages (even those of such exemplary sciences as geology and biology), if they are to be precise and adequate, ought to be reduced to the language of the physical sciences. There seems to be no warrant for the view except the historic fact that in the last three centuries physics has offered most illuminating, all-encompassing hypotheses. But even if sciences other than physics be granted an automony and irreducibility, it will not do to identify their truths with all the truth that pertains to this world of ours. We make nonsense of what we do and know if we can find no place for nonscientific discourse and realities. The dualistically-minded recognize this fact and therefore try to keep the two types of discourse and their objects forever separate. The normal way is to take scientific discourse and its objects to be public, objective and exact, and to put the nonscientific discourse and its objects in the mind of men, society or civilization, where it apparently will not intersect or interfere with the scientific world. But if we do this we will leave unanswered the question of the relationship of the two realms. We will be unable to understand how engineering and medicine are possible—for these combine the two types—or to see how it is that works of art can be hung on walls, bought, sold, burned, and the like—for these are surely "natural" occurrences open to scientific inquiry.

We live in a world in which things impinge on one another, where men are coerced, and works of art are produced. These activities, at least in part, make use of energy, go through a space, and take up a

time whose features do not change from culture to culture. These activities must be resident in or manifest substances distinct from those of common sense. The space, time and dynamics of these activities and substances are at least as real as common-sense activities and their substances. And they are distinct from the space, time and dynamics that men create in art.

One of the main difficulties in seeing this is the darkness spread by the doctrine that objects in nature, apart from anything man might do, are completely determinate entities. What a man makes, on this view, is either something in nature or something outside it. If the former he is said to have merely restructured, rearranged things, and not to have created anything. If the latter he is said to have produced unrealities. Neither of these alternatives makes much sense. Both dismiss society, state, and civilization and all their works into the limbo of non-being. The former in addition denies there is a world of art; while the latter, in the face of the fact that art requires men to work, and on things in nature, says that art objects are not palpable. To escape these alternatives we must give up the idea that objects which have not yet been worked over by man are completely determinate.

To maintain that an object is completely determinate is to claim that it either has or has not each and every specific character that can be conceived. This view seems to be held in some form or other by most modern thinkers. For them this thing here must either be round or not round, red or not red, and so on throughout the range of whatever characters there be. The classical position on this question is that of determinism, the view that natural objects are not only determinate, as here and now, but determinate forever, tolerating no change or addition in any way or at any time. This result is achieved by treating all the relations—spatial, temporal, comparative, evaluative—into which objects enter, as either irrelevant to the objects (atomism), or as already taken into account (La Placian mechanism). On this view, nothing really adventures or becomes through time.

Bergson, Peirce and Dewey, together with many modern sociologists and anthropologists, think this view cannot be true of "natural" objects. It is their contention that all the entities in nature are incomplete, partly indeterminate, needing to be supplemented by others.

Going further than any other pragmatist, Mead affirmed that not only present and future objects but past ones as well were incomplete, to be completed and thus made fully determinate in future experience. Whitehead avoided this extreme to maintain that both the objects in nature and nature itself were indeterminate, needing completion by beings beyond them. For the most part, though, he was content to describe; shunning dialectic, not stopping to reduce his categories to a manageable yet adequate set, inclined to subscribe to the views of the post-Cartesians, he could do little more than hint at a position which, without derogating from the reality of nature, found room for other beings.

Even thinkers who are willing to accept the essentially modern thesis, that genuine novelty comes to be in the course of time, often slip into accepting the deterministic position, as is evident from the fact that they treat all changes and novelties not as part of physcial nature but as occurring either inside a private self or inside some separated realm such as society or civilization. Since for them nature is exhaustively determinate they can find no place in it for the common-sense, economic, historic, aesthetic or religious objects with which they are so concerned and about whose reality they are convinced.

It is possible to accommodate the facts that determinism cannot and at the same time avoid the extreme of a radical indeterminism which denies there is determinacy anywhere. To do this we must distinguish the determinateness of an object in itself from the determinateness it has in relation to others. It is possible to be determinate in one of these respects and not in the other; I can be determinate as a man and indeterminate in my role of parent, indeterminate as a person but determinate in my role as citizen. Characters which exist for but still are not applicable to me as parent or person may not exist for me as man or citizen. Because I have not decided certain questions, I am a person who cannot be said to be religious or irreligious. What is applicable to me now is "having-or-not-having-a-religious-faith," in which the components, "having a religious faith" and "not having a religious faith," have no distinctive natures. This general character can be made determinate either as "having a religious faith" or as "not having a religious faith" when, through some action, I am made relevantly determinate in the course of time. Neither of these components has

relevance—and thus existence—in relation to myself now. Yet I can be determinate all the while, as a citizen or as a father.

Objects then can be determinate in themselves and indeterminate in relation to others; they can be determinate in the present and indeterminate as objects involved in the creative advance of nature. There can be more complex objects than the physical and there can be new truths and characters produced in the course of time, and this without in any way affecting the integrity or relative determinateness of the physical objects or the realm in which they dwell.

A substance can be determinate in a momentary segment of present time. Without in any way losing its relative determinateness, it is capable of functioning in a wider spatial region and over a longer temporal span. As in the wider region or span, it is indeterminate, acquiring further determination from the other items in the context. An object's capacity for spatial connection with other objects and for adventures in time show it to have an indeterminate, general character which is to be made determinate in this way or that. Only because a being can be determinate in one respect and indeterminate in another is it possible for chemistry to have application to things which are physically determinate and as such exhaustively dealt with in physics. Only because it is possible for an object to be determinate in one area and indeterminate in others is it possible for it to have a determinate magnitude and an indeterminate color. And only because determination in one way does not exclude indetermination in another is it possible for a piece of wood to be capable of being made into a statue.

In recent years we have fortunately become aware that nature is richer, more variegated than it was once thought to be, that there is freedom, growth, complexity, a plurality of dimensions in it, in no way incompatible with its being determinate in this aspect or that, at this time or another. To see this most readily it is, I think, desirable to distinguish four distinct modes of determination, and this whether it be a physical or a nonphysical entity, a work of nature or of art, body or mind, private or public. These four are most readily comprehended in different disciplines under somewhat different heads. Most appropriate to the art object are the actually *compositional*, the existentially

situational, the ideally *representative,* and the unitary *accretive.* A work is all four of these at the same time.

These four ways of approaching a work of art contrast with the four ways of transforming objects into strands (discussed in chapter four) and with the four-fold demand in terms of which we previously understood the nature of beauty. Strands are abstractions from common-sense objects, obtained by our approaching these objects in terms reflecting the nature of various modes of being. Demands are conditions provided by the modes of being which a work must meet if it is to be beautiful. Modes of determination are conditions produced by contexts that modes of being provide. The strand which is the event, e.g., is what a common-sense object becomes when we use existence to enable us to *abstract* an aspect of that object. Unification is an *ingredient* feature of a beautiful thing when it lives up to a demand imposed by existence. A natural object becomes a situational one when, in addition to the nature it has in and of itself, it is affiliated with others through the action of existence. Since a beautiful created object is one made determinate in the realm of art, and since a strand is an object made determinate in the realm of knowledge, both demands and strands can be treated as special cases of modes of determination. There can, though, be modes of determination having nothing to do with art or knowledge.

Compositional: Atomism is the view that there is no other way by which actualities can be together than by external connection. The only reality it acknowledges are beings occupying and moving about independently in an indifferent spatial receptacle. These beings can, according to atomism, form only aggregates, which have no careers, power or observable characters, and no element in them has an effect on any other. Emergent evolutionists, who are so aware of the reality of other kinds of unity than the aggregational, who acknowledge the reality of chemical molecules, cells, plants, animals, men and God, as well as of atoms, also accept the atomistic thesis that in physical nature, at least, there are only independent simples, forming numerical aggregates. Consequently, like the traditional atomists, they have been forced to say that whatever unitary characters there be exist on an entirely different plane from that of physical things. Yet the ad-

ventures of the one are inseparable from the adventures of the other; to move one is to move the other.

There are aggregations of entities. To find them we need not attend only to the objects of physics or limit our attention to supposedly simple entities. This pencil, the man across the street, and the house on the corner together make up a mere aggregate of three objects. And that particular group of three undoubtedly has a property peculiar to it, a property which is a function of the number and nature of its elements. But it is a property without its own integrity, without implications or consequences in the world, the outcome of a momentary external juncture of the properties of the elements of the aggregate.

There are other types of complexity besides the aggregational. If there were not, we would never have any empirical evidence one way or the other. Scales and clocks, the instruments and measures of science are all complex unities with characteristic empirical implications and careers, different in kind from those characteristic of any parts or aggregates of parts. Such nonaggregational complexities contain aggregates of parts within them. There are atoms within molecules, molecules within cells, cells within animals; the existence of simple modes of combination is compatible with the existence of more complex, more intimate modes of combination of the very same elements. The complex modes of combination possess properties not possible to an aggregate. If the result is inorganic, I term it a "whole"; if organic, an "individual." Stones, shoes, stars are wholes; you, this cat, that plant are individuals. All are in the universe. They do not exist on different planes of being, entirely outside of and indifferent to aggregates of their parts. They are those parts, united in a nonaggregational way. To see how this is possible we must distinguish the nucleus and the penumbra of a being.

All beings in nature have a nucleal and a penumbral side. The nucleus is at the centre, surrounded by the penumbra, spreading endlessly outward in all directions. The endless spread of the penumbra of one inevitably overlaps the penumbrae of all others. Such overlapping constitutes a space between the nuclei, and these nuclei are in turn identifiable as the objects we normally locate as in space. If the penumbrae overlap to a minimum degree, they constitute an empty space, the space between aggregational elements. Any two objects, no

matter how far apart and no matter how irrelevant to one another, constitute at least an empty space between them. If they overlap to a greater degree, if their different penumbrae support one another, are mutually intensifying, they constitute more complex actualities, a filled space. If a complex actuality not only has a character of its own, with empirical implications and career, which no addition of its parts will enable us to estimate, and has a power of controlling its parts, dictating to some degree how and where they are to act, the actuality is an individual; otherwise it is a whole.

We and other complex organic beings are individuals. One can distinguish within us wholes such as legs and arms. We also contain aggregates of cells and molecules. Those wholes and aggregational parts are owned by us. We have just so many organs and limbs, such and such weight and size because we encompass such and such wholes of such and such aggregates of parts. But we are more than these as well; we control and infect them. Neither aggregates nor wholes can walk. This is the work of organic beings, of individuals, within which there are legs, arms, etc. The individual as a single being determines the direction and even the rapidity of the movement of the atoms, molecules, cells and organs of that body in a way no law of aggregates or wholes determines or would allow us to predict. It is conceivable that the decision to walk, the very movements in which we engage are triggered by and are simple functions of the interplay of the aggregated parts. The fact remains that after the triggering has occurred, the individual acts in characteristic individual ways.

An individual partly confines and controls what lies within its boundaries. But its parts also have natures and boundaries of their own. That is why an organic unity falls as a whole and as an aggregate at the same time; the laws governing its fall are the laws of an aggregate, and the behavior of that aggregate limits and affects the behavior of the including wholes and the organic unity. To know where the parts of the individual are and why they behave as they do, we must take some account of him since he governs the activity of those parts; to know all there is to know about the individual we must take account also of the nature and behavior of the aggregates and wholes within him.

Artifacts are complex actualities. At the very least they are wholes,

existing in the very same world, within the very same space-time nature as their aggregational parts do. They are as objective, as brute, as root as any other entities recognized by common sense. The art object is an artifact having distinctive properties. Compositionally viewed it is a reality with a nature, a being of its own, existing in the very same world where "natural" things are. Its existence raises no new problem not already to the fore in any discussion of the existence of compositional beings of any type.

Situational: A situation is a whole which lacks tangibility but has predictable, definite consequences not deducible from a knowledge of the elements in it. Its parts are involved in adventures which they would not suffer were they outside that situation; they acquire from it a promise, a set of implications and dimensions they did not have before. A body falling in a crowded street falls in a situation and thereupon entrains expectations, fears, consequences whose nature is to be grasped only by one who knows what that situation is. The situation determines that the body will have a destiny and meaning it did not have before. The falling of the body in the crowded street has social repercussions; it falls physically as a social thing or, if one likes, it falls socially at a physical rate.

Yet the rationalism of Descartes, Spinoza and Leibniz denies that there are situational objects. All things, for them, are definable in the same neutral terms. Reference to a situation and the characters peculiar to a situation, it holds, are the product of confusion. Consequently, rationalism dismisses the objects of practical wisdom and the world of common sense as not being genuinely real. Nominalism takes the opposite view. For it all occurrences are situational. Things outside situations—universals which can appear without change in many different contexts—are for it empty abstractions or useless fictions, and as a consequence it has no place for the objects or truths of the exact sciences.

The opposition between rationalism and nominalism is so old as to seem part of the substance of civilization. We find it in full force even today, separating the two dominant schools of language analysis: the Oxford school which, on behalf of a strong nominalistic concern with individuals and common sense, tends to ignore or reject the world of the

sciences, and the Viennese school which, on behalf of logic and mathematics, tends to ignore or reject the world of every day. That there need be no incompatibility between them is evident once they are freed from their dogmatism and approached from a fresh perspective which includes them both. The objects of common sense have the meanings that mathematics and logic make clear and precise; the objects of reason exist in limited situations where they are subject to situational conditions.

Natural substances, as the rationalists remark, are cosmic entities. Each is on a footing with the rest, under the governance of the same laws. One and the same physical and chemical laws apply to what is happening here and what happens anywhere else. But it must not be overlooked that these very cosmic entities show natural affiliations and repulsions towards some of the others, while continuing to have cosmically definable relations to them and all the rest. A chemical combines with some others but remains inert with respect to the rest; a quantum jump occurs at certain times and takes a definite direction, against the background of the whole universe.

Positively or negatively affiliated items make up a natural situation for which the rest of the world forms a background. If an item in that background is used by a member of the situation, the used item becomes an intermediary or means for it with respect to the other members of that situation. The use here need not be deliberate or conscious. The hole shared by a family of gophers functions as an intermediary for them, enabling the family to be and act together. The gophers have a natural direct affiliation as gophers and an indirect affiliation as residents of the hole. Such an indirect affiliation may be all the affiliation that there is in a situation. Beings may act on one another primarily as caught within a single context, because they are neighbors or because they are possessed by some single being. The various distinguishable parts of the body, particularly on the submicroscopic level, are indirectly affiliated by that body. The body limits their behavior, affects the way in which they can act; it qualifies and specializes the cosmic laws to which the parts are subject to make them into the local laws for that situation.

Items are indirectly affiliated through the agency of an intermediary.

The affiliation is objective, though of course it exists only so far as there is such an intermediary. The relation of the affiliated items is the counterpart of the intermediary. The gophers are in the hole together because of the hole; the parts of the body are interrelated amongst themselves in a distinctive way because of their presence in the same body. If the intermediary is not active in a situation which it defines, the items in that situation are just structurally affiliated, achieving a vital, a dynamic affiliation only when the intermediary is actually functioning.

Affiliated items make a situation. Situations occur in nature, below the level of the organic, and below the level of consciousness, purposiveness, and the like. They can also be deliberately produced by acting on a few items, forcing them into an interrelation denied to others. The producer here becomes an intermediary, facing a situation in which items are objectively but indirectly affiliated. All aesthetic objects are made up of elements indirectly affiliated by the consciousness of men. All artifacts, and thus all works of art, are made up of elements indirectly affiliated by actions as well as by the consciousness of men.

A work of art is a situation whose elements have a value and an import they otherwise could not have. They have affiliations there which they owe to the artist and which are discernible by the sensitive spectator. The art object is an island interrelating its inhabitants in a distinctive way. As such it stands over against all other substances, each of which provides a situation for its parts. The parts of all substances, natural or created, are also cosmically interrelated by relations which transcend the situational relations and meanings.

The statue which has endured over a period of time is no more and no less real than the block of marble from which it was hewn. To assert that the statue is merely a form is to assert that, strictly speaking, it could not be located, purchased, abused, destroyed; we could not say it could crumble or that it had a weight or a size. It is the shadowed area of marble here that the sculptor relates to a shadowed area of marble there—not a mere shadow to a shadow or a bit of marble to a bit of marble. The marble in the work of art is genuine marble and continues to behave as such. But that behavior is dominated by the role it has been made to play within a work whose intent is to express not the

nature of marble, the nature of man, or the nature of the artist, but what is behind them all.

The cosmic interrelationship of all entities allows for limited situational connections among them, produced through the presence, thought or action of some intermediating being. The work of art is one such production, the outcome of a creative action. There is then no more mystery in the objective existence of a work of art than there is to the existence of any substance or any situation.

Representative: All beings face a common ideal. This ideal measures and is partly embodied in all things, and all point towards it as their common future. Each being specifies this ideal in a distinctive way. Each is a representative of it. The more excellent the being the more suited it is to represent it. Since an art object is an excellent object, offering a splendid exemplification of the ideal, it is eminently suited to represent that ideal.

A beautiful work of nature, though not necessarily situational in character and though capable of existing outside a humanly defined area, has characteristics which are not present everywhere, and depends in part for its excellence on the presence and co-operation of other beings. Without in any way losing its footing in nature, it stands out over against other things as a fine representative of the ideal.

No examination of an object as here and now, palpable and brute, a mere thing in neutral space and time, will reveal it to be a representative of an ideal. No such examination will show therefore that it is beautiful. One who looked at works of art as brute realities, would see nothing in them but combinations or sequences of colors, sounds and movements. He would also be one who would be unable to explain why it is that all beings, the fast as well as the slow, keep abreast in time, moving into the future at the same pace, and why it is that the prospects which concern one object have relations to those which concern others.

Natural substances, common-sense objects, and works of art are all representatives of the ideal. Because they are all under the aegis of the ideal, all have a value that cannot be understood by those who refuse to see beyond the immediate here and now. The work of art, though, as was made evident in connection with the situational sides of things,

achieves its excellence only through the actions of men. The excellence is ingredient in it, and is measured by the ideal which continues to be outside it and all other things. The excellence does not therefore vanish when it is not noted. It does, however, vanish if it is torn away from the milieu of human affairs. There are no poems in nature; poems exist only in a world where men play the essential definitory role of providing new connections between item and item, reflecting something of man's interests and appetites. At those times when the poem is not read it neither vanishes nor becomes a sheer object in nature; it continues to remain in being as a work of art, as the counterpart of man's aptitude to attend to created excellence.

Accretive Unities: All substances have a finality to them. Each is an opaque unity beyond which we cannot go. Each occupies a portion of space and time and goes through a process that is as final as itself. But with the exception of substances which we ourselves create, we never directly encounter substances as they are in themselves. The cat is perceived, scientifically conceived, lived with, and evaluated—or more usually, faced as a common-sense object having a perceptual, conceptual, eventful and evaluative side. What kind of being has this common-sense object or its derivatives? How are they related to the natural substance which is the cat in reality? The questions place us at the centre of a perennial problem of philosophy: the question of the relation of appearances to reality, of the phenomenological to the subterranean, the object as in relation to users and knowers to the object as in itself. Nothing short of an extended study can pretend to do much more than touch the surface of the issue. But for our purposes (understanding what kind of being an art work has), we need remark on little more than the fact that the problem regarding the being of a work of art is but a special case of the problem of the relation of the being of common-sense objects and their derivatives to natural substances. The solution for both lies in the recognition that art objects, aesthetic objects, common-sense objects and their derivatives, are real objects as subjected to special qualifications and limitations. The qualifications and limitations are real and often objective, and the properties which are produced through their means are real and may be objective too.

Let us suppose that in and of myself I am an honest man, i.e., I have a disposition. let us say, to tell the truth. Suppose, too, that what I intend to communicate is best done by putting the matter in a somewhat distorted way. When a child asks me questions about sex, religion, and politics, I rightly answer it, not by statements which an adult would recognize as the truth put clearly and well, but by statements which fudge this truth somewhat, in order to convey to the child what is in fact the truth.

If I am honest in and of myself I am so in a different sense than I am in relation to other beings. My inherent honesty can sometimes come to expression in conventional honesty; but it also can be expressed in other ways. Precisely because the conventional honesty is but one form of expression, not always desirable, it must be sharply distinguished from inherent honesty, the source of that and other expressions. The failure to make such a distinction lies behind a good deal of the confusion that arises on reading Freud. For him the libido is a power behind all expressions, but it is also sometimes identified with the sexual appetite, which is but one of the libido's possible expressions. The sexual appetite as a possible expression can be repressed; the libido as the power behind all expressions never can be repressed. Nor can any one channel or mode of expression be considered most appropriate to the libidinous power; different circumstances and situations require different types of expression.

The space, time and dynamics of the common-sense object or its derivatives is the real space, time and dynamics of a natural substance inchoately grasped and partly affected by human concerns. The relation of the qualified features to those which the object has in and of itself is a relation of what is defined by entities outside the object to what exists independently of what is outside. Just so, the relation of the created space, time and dynamics of a work of art to natural space, time and dynamics of the material of that work is the relation of an emotionally produced excellence to what remains when the artist's contribution is abstracted from. The work of art is a natural material possessing new features acquired by being subjected to new conditions.

But might it not be the case that the new conditions make no difference to the features which material possesses in fact, but merely

veil them, distort them, subjectify them? This is a position often taken in the name of realism. It supposes that what a thing is in and of itself alone is real and objective. The view is no better than its supposed alternative, the doctrine that things are real only in contexts and never in and of themselves. The former forgets that, though I have a magnitude in and of myself, I am also small, and that this is because there are others who are tall. The latter forgets that if I did not have a magnitude in and of myself there would be nothing which could accrete the character "small." I cannot say what my size is, to be sure, without bringing in some measure. But the measure measures a magnitude. Let us call it 5′6″. It is I as having that size over against another that accretes the character "small." I am not both 5′6″ and small, subjectively; I am not 5′6″ objectively and small subjectively. I am both 5′6″ and small objectively, the one in and of myself, the other in relation to a being who extends beyond 5′6″. Just so, the work of art, without losing its natural space, time and becoming, acquires through the action of the artist a new space, time, and becoming of its own. These acquired features are as objective as the natural ones; in addition they are more valuable, and more revelatory of the existence in which all substances, created and natural, are imbedded.

Natural objects are at once wholes, parts of situations, representatives, and accretive unities. Art objects function in these guises more conspicuously, more significantly, with more directness, completeness and effectiveness, by virtue of the mediation of man. Through his appreciation, man lives through a different space, time and becoming than any instrument can. The different parts of a work of art show one kind of relation to the instrument and another to a sympathetic being. What is straight, short or sluggish for the one may be curved, long or quick for the other. It takes a sensitive man to know that every art object is a created substance having distinctive features not to be found in any other kind of substance.

II. SPECTATORS AND CRITICS

A work of art can play many roles. It can serve as a reminder of what had been experienced before or while it was being created. It can be looked to as a model, or made to fill out a boring interval. The work of art can be used or abused in an endless number of ways. But only if it is participated in, enjoyed, is it treated as a work of art. This is what the true spectator seeks to do. He does not merely observe. If he did, the art object would be just an object in his experience—a framed colored canvas on a wall, a series of sounds in a room, a sequence of movements on a stage. A man might start with such objects. Until he accepts them as something more, however, he is not a spectator but only a plain man making detached observations of a commonsensical sort. The spectator may not be very perceptive; his judgments may be awry; but he has an entirely different attitude from one who merely observes, no matter how acutely and how well.

This difference between observer and spectator makes it possible to deal with a point made earlier but which had to be put aside in order to examine the nature of creativity and its product. I refer to Burke's remark that the theatre at which a great tragedy was being performed would be emptied at the news that a distinguished prisoner was being executed in the next square. Burke thought he had thereby unmistakably shown that men are fascinated by evil, the acted tragedy being presumably pleasant and the actual execution horrible. It is surely not true that an enacted tragedy is all pleasurable. It is bitter-sweet. It is far from clear that the execution is horrible. One might find satisfaction in the fact that justice was being done. The announcement of the execution might make many spectators leave the theatre, but it is doubtful if it would lure many actors, directors or others interested in the theatre. The supposed incident does not show what Burke thought it did.

Since some of the spectators would undoubtedly leave the theatre to see the spectacle, Burke certainly makes his point at least with them. It is to be noted, though, that those spectators do not then move into nature; they do not participate in a natural tragic situation. They continue to be spectators and at a controlled death. In short, they give up one artifact for another. The difference between these two cases is that the theatre shows a highly developed and subtle form of art and involves the spectators to a comparatively low degree, where the execution allows for an actual involvement of spectators in a situation provoking the expression of raw emotions.

If we could envisage natural tragedy as being the product of a divine or necessitating power—and this is the way in which the tragedy of Christ is often viewed—we would have the analogue of what happens in the theatre. We would then have our emotions controlled under the conditions of an artistic production, thereby enabling us to express them to the proper degree. We would rather see such an actual occurrence than any theatrical performance. Indeed, we could not reproduce this on the stage. We are not skillful enough to make a play equal a genuine dramatic event of this magnitude. At most we could stage only a memento, a foreshortened version, a kind of report of it, having less value than the actual occurrence.

There is something dramatic about a hanging. It has its growing period of tension, its terrible climax, and its painful close. So far as it is attended to in detachment from all else, it is an aesthetic object. It will still, though, be involved with countless irrelevant incidents occurring at the same time. While the man is being hanged, birds will fly unconcernedly overhead, the clouds will pass, dogs will bark, and so on through the motley acts and sounds which make up the stuff of every day. These are ignored by those who attend to the hanging; they are not present at all in the theatre. A theatrical performance occurs outside and over against the world. The coughing and sneezing, the movements of the ushers, the rustling of programs and the like are not abstracted from the performance; they occur in an entirely different realm. When we turn with indignation to our coughing or rustling neighbor, we leave the work of art to attend to his cough or rustle. We do not as a rule enjoy it, have an aesthetic experience of it. But a lover might, or a doctor. They, hearing a sound alongside, might enjoy its

quality as an isolated occurrence in the world. They will then, like those who have left the theatre to concentrate on a hanging, have abandoned art for an aesthetic object.

The tragedies of daily life, even when of great significance, are rarely very dramatic. If there is a divine power which produces them, it is one which lacks finesse, for it does not present them in such a way that the emotions are controlled, reorganized, and well purged, and the spectators, as a consequence, made the better for having seen these tragedies. If spectators are willing to leave the theatre for any spectacle, contrived by state or God, or to attend to any event in the world, designed or accidental, they will, more likely than not, exchange an opportunity to participate in a work of art for an opportunity to attend to an aesthetic object, will give up a participation in a full-fledged drama for one which is only occasionally or partially dramatic, and will forego a sensitive controlled expression for an explosion of feeling.

To be sure, no one can and no one ought to remain with art all the time. Everyone has strong impulses and insistent needs which tend to make him alert to matters outside the province of art. Everyone becomes readily fatigued when he looks at works of art, even rather superficially. The most casual approach to art requires considerable concentration of attention and a restraint on multiple tendencies to engage in other activities. Also, the larger world is constantly impinging on art, spoiling the enjoyment and adding to one's fatigue. To be a spectator one must be able to maintain an interest in art despite distractions.

Frames, hedges, pedestals, and costumes help one remain inside definite boundaries; they act as barriers keeping out the rest of the world. The spectator uses such boundaries even when he attends to progressively produced works, such as plays, dances and music, and to those which, like skyscrapers, cathedrals and planned cities, cannot be taken in at a glance. In these cases the spectator starts at the boundaries at one point and expectantly moves to the others. Did he stop here, though, he would have only a vague apprehension of the art object. He would enjoy the fact that he was dealing with a work of art, but he would not yet have begun to enjoy that work.

Enjoyment of a work of art requires that one live with it. In enjoy-

ment the parts are grasped as well as the whole. Various points are concentrated on by the spectator, treated as pivotal, as resting places, as foci, inside the initial bounded whole. The spectator moves through the art from focal point to focal point within accepted boundaries, thereby traversing step by step the very whole which he initially covered in one glance or in one moment of expectancy. He relates the various points, intensifies that initially accepted whole, articulates it, while making it into an enjoyed work of art.

The spectator usually tries to isolate as pivotal those points which he thinks the artist provided, in the hope that he may be able to enjoy the very work which the artist recognized himself to create. There is no reason why this hope should be satisfied. Genuine appreciation does not require one to focus on the clues provided by the artist or to move through the work along the lines which the artist himself followed. The spectator need not find in the work what the artist does, what he intended to put there, or what he intends others to find there. The artist may have put in more or less than he intended. He himself may not be a good spectator of his own works and may even want others to find in it much less or other than they ought or can. An artist is not necessarily the best judge of how a work of art is to be best appreciated.

There can be many appreciations of the work, all equally legitimate, making use of quite different focal points and interrelations between them. It is most unlikely that anyone, artist or spectator, ever saw in an outstanding work all that is there until after he had sensitively lived with it over a considerable period of time. A single experience of a work of art is restricted to the use of one set of focal points and one way of relating them. If we want to recapture the flavor of that experience, it is necessary to recapture that way of dealing with the work. But one flavor soon palls. That is why we speak highly of works which offer many different focal points and relations, enabling one to have many other experiences.

Since the spectator reconstructs the work of art he is a kind of artist who separates and then interrelates parts in an independent, creative way. Since he makes use only of the material which another provides and then only in an act of appreciation, he is only a derivative artist.

But the core of what he notes and interconnects is what the artist initially produced. He may not stress what the artist did, though he usually will stress what an artist wants him to.

The outcome of the spectator's adventure in the work of art is a judgment. This judgment, like those we usually make in perception, is rooted in an encountered object. Torn away from that object it becomes merely a memory or an element in discourse or logic. But unlike the judgment of perception, which concentrates on distinguishing an indexical and a universal term to be synthesized to constitute a unity answering to the source from which those terms were derived, the spectator's judgment is one in which the various indexical terms are united in a specific appreciation. The perceiver forges a judgment over against an object; his judgment is the object articulated at a distance. The spectator constitutes his object in the judgment; his judgment is an appreciated object, an enjoyed object of art. The perceiver can be in error. The spectator never. We can say that he has missed something, done a poorer job than could have been done; we can note that he is insensitive, perverse or blind; but what he ends with is the work of art reconstructed. When we criticize him it must be in terms of some other spectator's subtler, more complex, reconstructed work.

The work which the artist produced allows for an endless number of reconstructions. Each of these is final, something enjoyed, and yet measurable as richer or poorer than some other. The work exists apart from spectators, not only as something which can be perceived, known by scientific methods, and so on, but as that which can be the occasion for a number of spectator judgments. Its reality is that of any substance. It is never fully caught in any perception, science, or other specialized mode of observing or discoursing.

No one can be said to appreciate a work of art fully who, when he articulates it, is not also aware of the nature of existence. It is this fact which distinguishes iconographers and art historians from spectators. The first two may be and usually are good spectators; but, taking them solely in their professional capacities, they are not primarily concerned with enjoying the work of art. They want to use it to ground a nonaesthetic judgment. The iconographer cuts into the work to isolate various symbols in it; the art historian attends to the technique

and to the subject matter in order to determine just where in history the art work might be placed. When, in the light of their discoveries, the iconographer and historian articulate the art work, they learn something of the nature of existence. But their grasp of existence is then an intellectual one, not one lived through as a consequence of the appreciation of the work of art itself. The spectator, in contrast, establishes focal points inside the work which he then and there interconnects, thereby becoming aware of existence's texture and character. He becomes alert to it as a power which all things illustrate and none exhausts, a power which holds the answer to man's deepest hopes and fears.

The work of art from the very start provokes an emotion of wonder, fear and joy, some tension, and a vague surmise. It troubles the spectator, arousing in him a feeling that there is something larger than himself elsewhere. By articulating the work that he confronts he is enabled to redefine his emotion somewhat. His original emotion of wonder, fear and joy is too amorphous and too large for him to handle. Some of it he spends in the course of his appreciative reconstruction of the work, ending with his emotion quieted by virtue of the fact that he has found in the art a place where the emotion can be properly expressed, and through the agency of the art, a place at which it can be properly directed. In the ideal case the spectator ends as a man adjusted, enriched and chastened.

The ordinary spectator does not fully enjoy the texture of the work. It is the connoisseur, the unusually sensitive spectator, who does this. He alone recovers the work of art as at once sensuous and ordered, opaque and translucent. He is a man of discrimination, of taste, who is particularly alert to the subtleties and nuances of the work enjoyed.

Again and again it has been said that there is no disputing of tastes. As a piece of advice this observation has value for one who seeks to calm tempers. As a report of facts it is mistaken. As usually understood it tells us not to do what we really ought. What would be better to dispute than tastes? Throughout our lives and throughout history the tastes of men have been rightly criticized. We remark again and again on the fact that they have overlooked nuances, have liked the wrong things, have brought in irrelevancies. We have been rightly disturbed

and dismayed by the fact that some men take certain things rather than others to be excellent. Every one of us puts his own tastes forward and offers them as tests, criteria, and standards for others, refusing to accept those which others might present in their place. We know that men need to be sensitized, trained and educated before they can claim to have tastes on a footing with our own. He who says that the *Rape of the Lock* is superior to *Paradise Lost* shows little sensitivity. If he finds more pleasure in the one than he does in the other, he but compounds his failure with a temptation to overlook it. If he insists that Pope is always superior to Milton, he adds to his failure, supporting his bad taste, nourished undoubtedly by insensitivity and an inability to read, by a misunderstanding of what a poet's powers are.

The theory that there is no disputing of tastes has appealed largely because it makes evident that an enjoyment of art exhausts the appreciated work, leaving over in it nothing for dispute; that tastes occur in the private recesses of men and cannot be made avaliable for comparison; that they occur below the level of cognition and quantative measures and thus below the level where many of our comparisons are made; and that taste is an absolute in terms of which things are judged. But of course it is not privately experienced, uncognizable tastes, functioning as finalities in experience or judgment, that are to be disputed. It is only taste as publicly expressed and oriented in publicly available works of art.

A standard of taste, though expressed by an individual, is actually cultural, conventional in nature, expressing the position of a community. The experts define what that community's sensitivity is like. It is to be hoped that all men in a community will agree, but until they do, one measures all by the standards set up by the few. The connoisseur's taste is better than the ordinary spectator's because it has been cultivated, refined, subtilized. Sometimes we ourselves recognize that we need training, that the taste of the expert is better than our own. His taste deserves to measure the excellence of our tastes and the tastes of others. Since the expert's taste is only the expression of a delicate sensitivity characteristic of some limited culture, it will not necessarily outlast his epoch. Later we may find that the expert disdained excellent works. But that would not show that those who had

disagreed with him had better taste than he. Usually they had worse taste, though this did not prevent them from seeing something good in the work. Taste is not itself a measure of excellence. It measures only sensitivity, the ability to attend to excellence, the readiness to see and appreciate it. But one can remark on the excellence without having good taste.

The critic is an expert connoisseur, who not only has taste but a standard or measure for it. He shows others how to appreciate a work. And he has a standard of excellence in terms of which a work of art can be evaluated. He is a connoisseur who is willing to act as teacher and guide, making evidence the primary clues which one is to follow in order to obtain an eminently satisfying reading of the work of art. He takes what other arts have produced and puts it in a new setting. He no more destroys or affects the work he deals with than an artist destroys or affects nature when he paints a landscape.

The critic is like an art historian who knows what the different parts of a work symbolize, differing from him in not being primarily concerned with symbols or with points of orientation and efforts at articulation. But he is no historian, any more than the historian of art is a critic. The historian tells us what the critics of the past saw in works of art and reports how they thought those works should be read. He rejects or accepts those critics, depending on which of these approaches enables him to place the work in its proper temporal position. Unlike the historian, the critic attends to what the work as a whole may reveal; he evaluates it too, and states his preferences. He faces the work as here and now; the historian deals with it as having been made at some other time.

Different fields of art and different works of art set different problems for the critic. But since the practice of criticism has been subjected to much closer scrutiny in connection with literature, an examination of the literary critic's role will make possible a more ready understanding of the task of criticism anywhere. Such a preference for literary critics seems to confirm a rather common suspicion that criticism (and consequently the philosophy of art) may have a place in connection with literature but is irrelevant to other forms of art. One hears it said that we can talk about literature because it contains

words, and that we cannot or ought not to talk about painting or music, for these are nonverbal in nature. But the words of poetry are not the words of prose; the words in a novel or a play are distinct from those used every day. It is just as hard to speak of poetic usages of words as it is to speak of painterly treatments of color. But more important, it is not necessary for words to have only words as objects. We can speak intelligently of trees and snow and wind, though none of these is verbal. It is no more difficult to speak of a painting than it is to speak of any object. To be sure—and this perhaps is what was meant—no discourse will exhaust or reproduce a work of art. But no one, I suppose, ever thought it did, just as, I suppose, no one ever thought that one reproduced the wind or snow by talking about them in communicable prose.

Stanley Edgar Hyman, in his most erudite *The Armed Vision*, has placed modern critics of literature in ten categories. He has to nudge some of his specimens a little to make them fit inside the scheme, but on the whole he has shown that there are at least ten distinct critical routes one can take to and through a work of art. There is a moral way; another through tradition; a third through biography; a fourth looks to folk lore; and a fifth makes use of psychoanalysis. There are those who trace the images from work to work or in the previous reading of the poet; others who study the historical and cultural values of the material used; still others who concentrate on the tension which ambiguity produces. There are critics whose primary concern is to understand what and how a work communicates; others stress the role of metaphor even to the extent of taking every item in a work to be a metaphor. All have warrant. If we accepted them all as equally good critical positions, we would end with little more than an indigestible eclectic bolus. Any one of them can lead us into a work, but some do this more directly, while others, though following a more indirect route, start or end a little nearer to the place where the spectator in fact is. Taken as a final critical stance each is inadequate, as the supporters of the other positions have quickly observed. But taken as offering ways for approaching or reading a work, they are alternatives, sometimes usable together but usually appropriate at different times and occasions, for different types of work and readers. We need no

biography to help us with a short simple poem; we need something more than a study of paradoxes to help us with a long complex one.

Criticism is a distinctive enterprise, evaluating what it studies. This requires it to stand both inside and outside the work. Most critics do only one or the other, with a consequence that they teach one how to read it but not how to evaluate it, or teach one how to evaluate it but not how to read it. The former obscure this fact for themselves because they tend to make use of an unexpressed standard; usually they assume that an intricate, complex, difficult work is superior to one which is simple. The latter obscure the need to get inside the work because they deal with it too much in terms appropriate to such questions as to whether or not it can be part of a good life or psyche. A marriage of the two types of criticism would be one in which there were many quarrels and bickerings over priorities, possessions, and favored children, but it should prove as successful over the long pull as it is desirable.

Critics tend to teach by means of models, seeking to point up the excellence of masters of an art. As a result they incline not only to urge the achievements of an age just passing from the scene but to hinder men from taking seriously approaches which have not yet fully proved themselves. Critics do a great service in helping us learn from established men, but it is regrettable that they do not usually help us discern and profit from those just now appearing on the scene. Like so many teachers, critics are too often content to introduce, communicate, direct, when they should also, as good teachers do, learn while teaching, adventuring into new areas of creation together with creative men. Particularly in the performing arts of music, dance and theatre, the critic does not usually associate with the creative worker in the field, especially those who are most experimental and not likely to get a public hearing at the time.

In the course of his production the artist often adopts the role of a critic. He stops again and again in the course of his production to see his work from a critic's perspective. Where the critic makes an art the topic of a teaching and a judging, the artist uses criticism as an agency in the process of learning and making.

The critic evaluates. His evaluations are often an occasion for the

exhibition of prejudice, ignorance, or for the use of arbitrary or traditional standards. Properly employed they point up the excellence and limitations of a work of art. Recognizing that each work has its own rationale and internal justification, the critic nevertheless measures it by means of a universal, neutral standard. That standard is excellence, perfection as pertinent to art. He obtains it by abstracting a structural unity from some long-established, widely approved works —Shakespeare, Michelangelo, Bach, and the like—generalizing this, and then correcting it in the light of his knowledge of the ideal. The result is a prospect which every work of art ought to embody in a sensuous form. Held apart from every work of art, that prospect is indistinguishable from the Good; made to measure a work of art, and thus restricted to the area where materials must be permeated by the ideal, it offers a standard of a prospective beauty; satisfied, exhibited in some work of art, the standard appears as a beauty then and there manifest.

A true critic demands of all works that prospects permeate their appropriate materials; he evaluates them in the light of the criterion of a major work, which is to say he both enjoys the prospect in the work and the nature and import of some basic division or aspect of the Good, such as a beginning, a crisis or an end. Like the connoisseur he is sensitive to the texture of the work in which the prospect is imbedded. Like the historian he sees the work in its relation to others. Like the iconographer he notes the signal pivotal points within it. And like the ethical man he is alert to the reality of the ideal. A link between the aesthete and the ethicist, he inclines toward the former, not the latter.

The ethicist is a critic upside down. He measures all things by the ideal Good. The censor is an ethicist concerned with the ideal Good as qualified and sanctioned by society or state. Since he is also primarily interested in the nature and promise of what is, he is antecedently critical of every work of art. Every artist, because not occupied with fulfilling the promise of things, fails to act with ethical justice. That is why the censor condemns him. When most generous the censor is at best tolerant of art, recognizing that the beautiful work, at least incidentally, realizes the Good and that a work of art need not seriously disrupt man's interests in or his efforts to realize the Good. But the

censor is not a critic, though he criticizes. He lacks an appreciation of
the work of art itself. The spectator and the critic differ from him in
their concern for the work itself and in their approach to the Good in
terms which embodied prospects provide.

As is already evident, the present work has not assumed the position
of a critic. It offers a philosophy of art. Instead of seeking to judge
works of art, it tries instead to make evident art's nature and reality,
to indicate what it is that can be found in it, and to expose some of the
principles which a sound criticism should use. This does not mean that
it occupies a position superior or inferior to that of a work of criti-
cism. Philosophy has its own dignity and role; it does something which
critics and artists cannot do or do less adequately. But these in turn
have a dignity and role of their own, doing something worthwhile
outside the province or competence of philosophy.

INDEX